# LANDSCAPE PAINTING

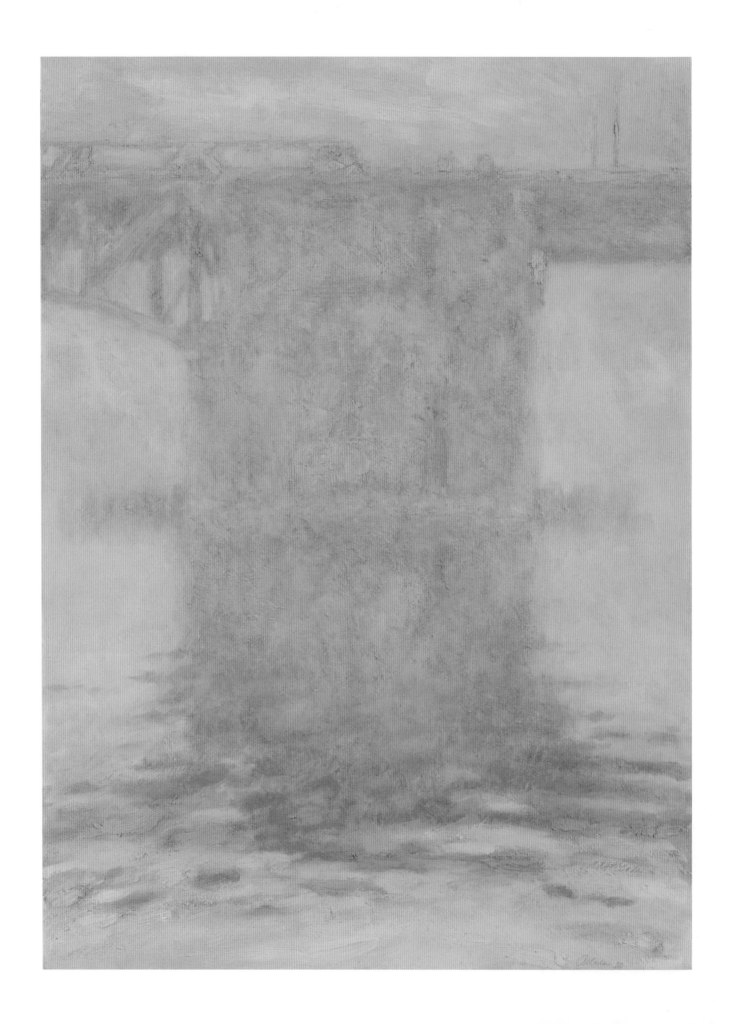

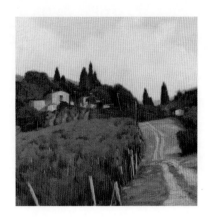

# LANDSCAPE

*Essential Concepts and Techniques for Plein Air and Studio Practice*

# PAINTING

## MITCHELL ALBALA

WATSON-GUPTILL PUBLICATIONS / NEW YORK

Page 2: Mitchell Albala, *Ballard Bridge*, 2000, oil on canvas, 29 x 22 inches (73.66 x 55.88 cm)
Page 3: Jim Lamb, *Tuscan Hill Farm*, 2007, oil on board, 15 x 15 inches (38.1 x 38.1 cm)
Page 4: Russell Chatham, *Bare Trees and Hayfields in November*, 1991,
    oil on canvas, 40 x 72 inches (101.6 x 182.88 cm)
Page 8: Kathleen Dunphy, *Winter Light*, 2007, oil on linen, 24 x 24 inches (60.96 x 60.96 cm)
Page 10: Roger Bechtold, *Tree Rhythm 1 and 2* (right panel), 2008, oil on canvas,
    20 x 20 inches (50.8 x 50.8 cm)
Page 11: John McCormick, *Western Wind*, 2006, oil on canvas, 60 x 60 inches (152.4 x 152.4 cm)

Design by RD Design

Published in the United States by Watson-Guptill Publications
an imprint of the Crown Publishing Group
a division of Random House, Inc., New York
www.crownpublishing.com
www.watsonguptill.com

WATSON-GUPTILL is a registered trademark and the WG and Horse designs
are trademarks of Random House, Inc.

Library of Congress Cataloging-in-Publication Data
Albala, Mitchell, 1956-
  Landscape painting : essential concepts and techniques for plein air and studio practice / Mitchell Albala.
    p. cm.
  Includes index.
  ISBN 978-0-8230-3220-4 (hardcover)
  1. Landscape painting--Technique. I. Title.
  ND1342.A42 2009
  758'.1--dc22
                    2009007429

Printed in China

13

# ACKNOWLEDGMENTS

No endeavor as monumental as writing a book and populating it with over two hundred images could be done without the generous support of many talented and skilled colleagues and painters. Their contributions and insights are woven into the words and images of every page.

I would first like to thank my publisher, Watson-Guptill, for having the vision to imagine a different kind of landscape book. I am also indebted to the Gage Academy of Art's executive director, Pamela Belyea, and artistic director, Gary Faigin. Were it not for my long tenure with that energetic bastion of creativity, I might never have been in the position to write this book at all.

I surveyed the work of hundreds of artists for inclusion in the book and ultimately selected those whose paintings were not only distinctive in style but also had the power to clearly demonstrate the book's many lessons. I am indebted to the many artists who generously allowed their paintings to appear in the book and to those institutions who granted permission to reproduce paintings from their collections: The Metropolitan Museum of Art, The Toledo Museum of Art, George Stern Fine Arts, and The Lisa Harris Gallery in Seattle.

I had the patient and skillful support of several talented editors who reviewed the manuscript before it was ever submitted to Watson-Guptill. Their keen insights challenged me and helped me fashion the book into a more accessible and accurate work: my deep appreciation to Margaret Davidson, David Dwyer, Alexis Mohr, and Joyce Prigot.

There were also many talented painters who lent their considerable visual and technical expertise to many important sections of the book: Rebecca Allan, Suzanne Brooker, Patrick Howe, Michael Stasinos, and Scott Gellatly, technical consultant for Gamblin Artist's Colors, who helped ensure the accuracy of the information in chapter 2.

I have been fortunate to have been surrounded by many creative souls whose keen eyes have helped me see better and more clearly: Rebecca Allan, Sharon Hager, Donald Paggeot, Michael Stasinos, and the members of the Sole Proprietors. Special thanks to Joyce Prigot for her unyielding encouragement and support throughout the project.

I have had the privilege of working with many enthusiastic students over the years. Their curiosity and openness have helped me become a better teacher and see the world in new ways.

I am grateful to my earliest instructors: Sampson Engoren, my high school art instructor, who impressed upon me the need to differentiate myself from my art; and Robert Birmelin and Arie Galles, my college art instructors, for showing me the underlying abstraction within nature.

Lastly, I would like to thank my father, Max Albala, who bought my first art materials and who, to this day, looks at my paintings and still asks, "What is that?"

Della Albala, *Postcard*, 1949, oil on canvas,
10 x 14 inches, (25.4 x 35.56 cm)

For my mother,
Della Albala,
my first and most
patient teacher.

# CONTENTS

# INTRODUCTION

I have always been fascinated by the challenge of painting the landscape, not simply out of a pure love of nature, but because of the benefits it affords me *as a painter*. When nature is my inspiration and subject, I am witness to an extraordinary range of color and every imaginable atmospheric condition. I find a wealth of interesting shapes, patterns, and textures, and, above all, an ideal opportunity to play with the inherent abstraction within nature.

These qualities are what make the landscape such an alluring subject. However, they are also the qualities that make painting the landscape so challenging. Because nature is so extreme in its expansiveness and complexity, so varied in its range of light, landscape painters often have to look further and more deeply to find what all artists seek—form and structure, value patterns, and an organized arrangement of shapes.

When I first began to work from the landscape, my efforts were met with frustration. I had studied art in college and could draw and paint reasonably well; yet, when I made my first forays into the "field" (Central Park in New York City), nothing seemed to work as it had in the college studios. It was as though I needed to learn painting all over again. Landscape was more variable and more complex than other subjects. It seemed disorganized and rambling, and I couldn't arrange my subjects or control the lighting as I had in the studio. Over time, I cultivated a set of practices to deal with these challenges. When I organized these practices into a coherent system—that I applied every time I approached the landscape—I got consistently better results. Those concepts and practices are the subject of this book.

After many years, the landscape still continues to inspire and challenge me. I see more than rivers and skies, water and trees. I see *visual opportunity*, a chance to explore the kinds of aesthetic experiences that excite me most. This is as it should be. Artists, in whatever their chosen genre, should be excited by its particular challenges and be inspired to see the world in new ways.

In any book such as this, there are certain fundamental precepts that underlie all the lessons, and they are outlined here:

**DIRECT OBSERVATION.** The foundation lessons of landscape can only be learned through a direct observation and experience of nature. Even when creating paintings in the studio, painters can do so competently only by calling upon a practiced interpretation of nature, in all its many moods and colors.

**REPRESENTATIONAL ORIENTATION.** Lessons in this book are based on a representational goal: What is seen in nature is the basis for creating the illusion of a three-dimensional space. This is not to say that modern traditions that abstract or flatten the pictorial space don't come into play (abstraction is addressed in chapter 11); rather, that the fundamental lessons of painting the landscape are more easily demonstrated through an interpretation of reality.

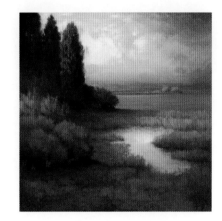

**MULTIPLE MASTERS.** Approaches to landscape are so varied that no single style could ever demonstrate everything one needs to learn. The works of different painters, therefore, are used to best demonstrate particular lessons, providing greater inspiration and exposure to a wide variety of styles.

**OIL PAINTING.** Because I am an oil painter, many of the techniques and demonstrations in the book are oil-based; however, the theories and principles are universal, and can be applied to acrylics, pastels, and drawing.

**PAINTERLY TRADITION.** I advocate a direct, painterly style of realism as opposed to an indirect, glaze-oriented approach. The direct approach lends itself to capturing the freshness found in nature, particularly when painting outdoors. It is also more conducive to making changes (which I strongly advocate!).

**PHOTOGRAPHY.** Photographs are used in some lessons. Completed paintings tell a lot about how the artist solved a visual problem, but a photograph, so allied with reality, is sometimes a better way to reference the place from which you will need to start making your choices.

By necessity, this book presents specific ideas and practices. My hope is that they are not seen as strict rules or formulas to be followed to the letter but instead stimulate an *observation-based* attitude that helps you think like a landscape painter. Then, when you are standing amidst the mystery and vastness of nature, with brushes and colors at the ready, you are able to apply what you've learned on your own.

No matter how important knowledge gleaned from books and lectures may be, there are no words or pictures that can ever substitute for the hard work of actually *doing* it. As the motto of Seattle's Gage Academy of Art says, "Artists are made, not born." It is my sincere hope that the essential concepts and practices offered in these pages will speed you on your journey and make the trip more enjoyable. And, if along the way, you are also inspired, then I will have been successful.

**Mitchell Albala**
Seattle, 2009

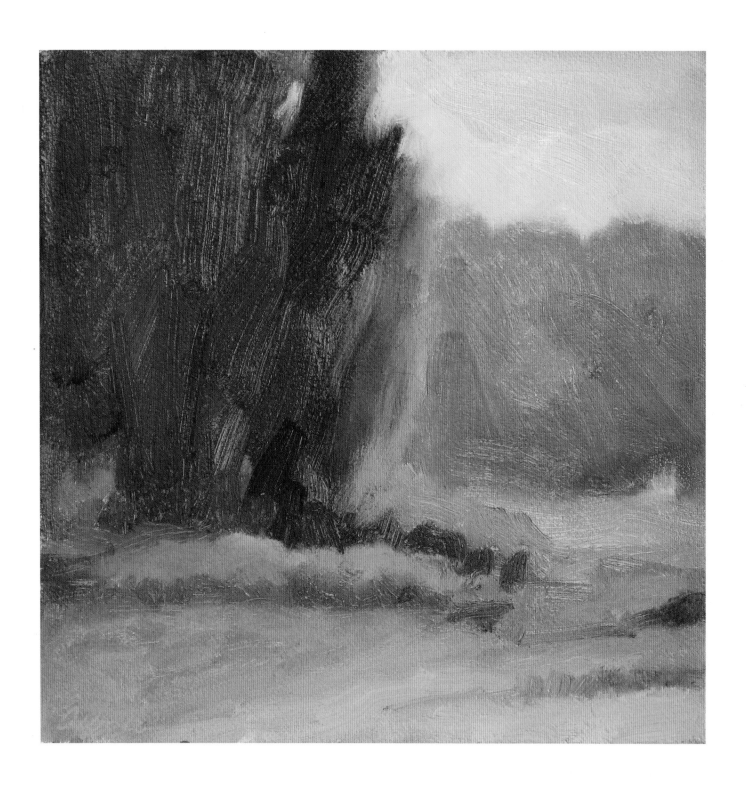

CHAPTER ONE

# THE SPECIAL CHALLENGES OF LANDSCAPE

He would be a poet who could impress the winds
and streams into his service, to speak for him.

—HENRY DAVID THOREAU

The landscape is unique among subject matter—in its grandeur, complexity, atmosphere, and color dynamics. Landscape painters are continually challenged to translate these qualities into paint. They do this by working with the same aesthetic principles all artists use—shape, value, color, composition, and the paint itself. But nature doesn't reveal her secrets so easily. Because she is so vast and complex, so varied in her range of light, landscapists must go further and dig deeper to find what they are looking for.

If I wanted to begin painting the human figure, I would need to start learning *genre-specific* knowledge: anatomy, proportions of the human form, and certainly how light and color act upon the skin. Similarly, the landscape presents a unique set of challenges that demand a genre-specific approach. In all the years I have been painting the landscape, I have found that the many challenges ultimately fall into three areas. Put another way, I think about these issues continually. They are simplification and massing, site selection and composition, and color and light. And as we will see, they pervade every aspect of our practice.

Mitchell Albala, *Discovery Sunset*, 2001,
oil on panel, 10 x 10 inches (25.4 x 25.4 cm)

Simplification is not an isolated act but is interwoven into the consciousness of landscape painting. At every step—through conception, site selection, composition, color, and even technique—the landscapist's eye is bent to this purpose. *Discovery Sunset* demonstrates simplification in action. Complex forms, loaded with surface detail, such as the trees and grasses, are not picked over with a small brush; instead, they are reduced to their fundamental shapes and planes. Everything is rendered with an economy of brushstrokes. The size of each stroke also fits the shape it is describing.

# SIMPLIFICATION AND MASSING

Any good landscape painting I've ever done was also simple. Whether it was a plein air painting that took an hour or a large studio painting that took months, I had to find a way to translate the vast amount of detail into a coherent statement that made sense not only to me but to the viewer. This is never a matter of copying nature; that is not possible. Rather, it's a process of seeing the world through a painter's eyes. It's a process of creative distillation, of extracting the most essential elements of the landscape and organizing them into a coherent whole.

Landscape painters, of course, don't have an exclusive on this process. Still life, figurative, and abstract painters also simplify. However, because the landscape is so vast and filled with so much information, and at times terribly disorganized, the landscape painter is forced to simplify in more radical ways. Simplification can

be likened to a special language designed for describing the landscape. Nature provides painters with so much detail, so much color, and so much space that it becomes impossible to capture it all. The painter can never paint every leaf or blade of grass, every branch or every stone. That's a job best left to the camera. Instead, a way must be found to translate a living and complex scene into a set of simpler shapes and patterns that stand in for the original scene. Landscape painters learn to use shorter sentences and simpler words, perhaps even creating new words to take the place of ten others.

A painter continually searches for the lowest common denominator—the single "word" or brushstroke that will convey meaning in the most economical fashion. The symbols or marks the painter chooses can never *be* the actual landscape, but they can communicate the same emotion

and serve as an analogy to the impression. Simplification and massing is not just a stylistic preference; it's a visual imperative. It is not a single idea imposed at one stage of a painting but a way of seeing the world that is fostered at every stage.

Learning how to simplify, however, is not a simple thing. Nor is it something the beginner or novice does naturally. It is a process that evolves through conscious observation and practice. The maxim "Less is more" was brought into the popular lexicon by architect Mies van der Rohe. It speaks to the integrity, beauty, and soundness of a design that eliminates all but what is essential to the solution. The maxim applies just as readily to art— and particularly well to landscape painting. Landscape painting insists that artists learn to see the world in a new way, in its most basic, essential forms. Chapter 5 will explore this attitude in depth.

The ability to simplify means to eliminate the unnecessary so that the necessary may speak.
—HANS HOFMANN

Kathleen Dunphy, *Before the Sun*, 2006, oil on linen, 16 x 12 inches (40.64 x 30.48 cm)

The sense of serenity and quietude in *Before the Sun* is achieved not only by the choice of subject matter but through the simplified way Dunphy describes the forms. This reductionist interpretation of reality often gets at the sense of a subject better than details or narrative content.

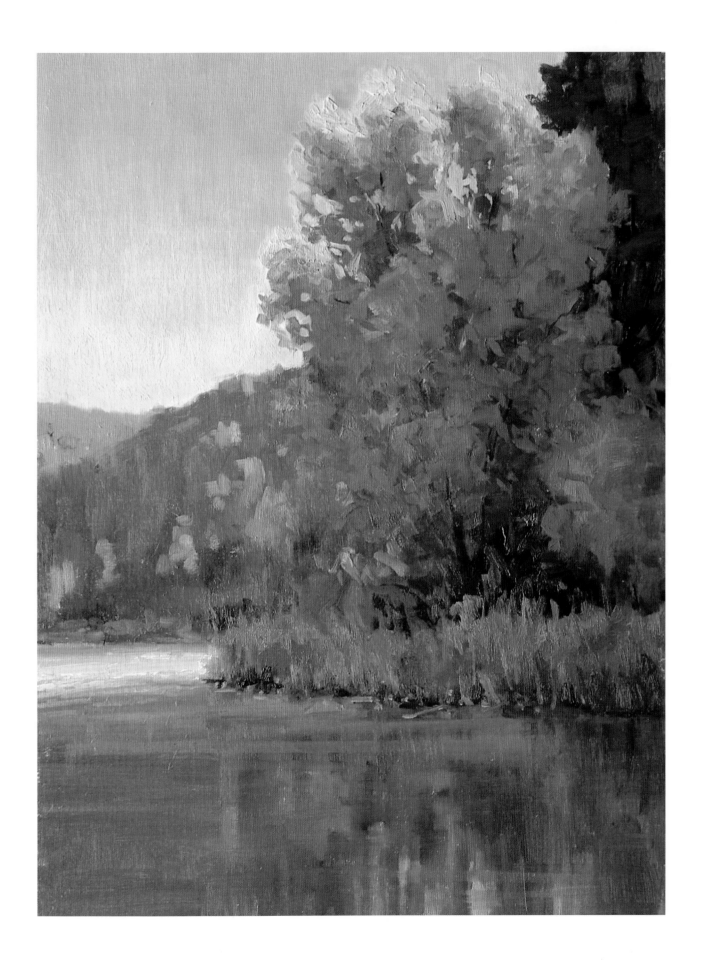

# SELECTION AND COMPOSITION

The landscape also presents challenges in the areas of selection and composition. Unlike with still life or figurative subjects, in which the subjects can be prearranged to best advantage in the studio, with the landscape the painter has no control over the lighting or the arrangement of the scene. The landscape painter must take the landscape as it is. The color of the light and the density of the atmosphere change from minute to minute, hour to hour. Shadow patterns, which are integral to the composition, never remain fixed for very long. Nor do landscape painters have the luxury of moving a tree, a mountain, or a farmhouse so that it catches the light better.

These constraints make it harder to find scenes that will translate successfully into painting. To create an illusion of depth within a two-dimensional canvas, artists work with certain visual cues: light and shadow, volume, scale, overlap, and perspective. Finding and working with these cues in the landscape can be elusive. If the artist paints at the wrong time of day or doesn't know where to look, the cues can be hard to discern. If the artist selects scenes that don't present the cues in a clear way, it will be a struggle to achieve a sense of depth. One of the most essential skills of the landscape painter, therefore, is *selection*—the ability to evaluate a scene beforehand and discern

whether or not it contains the types of subject matter and conditions that will make for an effective translation.

Selection and composition in landscape are also concerned with the *amount* of information in the landscape. The landscape presents all of itself, from east to west, north to south, and ground to sky—entirely unedited. And because it's so beautiful, the tendency is to want to include *everything*. When attempting to paint the landscape for the first time, however, students can find this amount of information overwhelming. But if we are to follow our essential maxim, "Less is more," then we must narrow our field of vision and limit our focus.

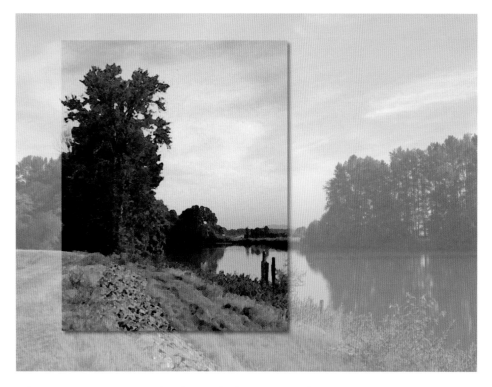

When it comes to compositional real estate, landscape painters discover that more is not necessarily better. By making considered choices as to what portion of the greater landscape will be *excluded* from the composition—a limited focus—they can change the focus of the painting or suggest different degrees of intimacy or expansiveness. In this example, eliminating portions of the overall scene allows for a simpler composition, built with a few large shapes and values.

# LIGHT AND COLOR

Perhaps the most defining aspect of the landscape is its light and color. It would not be an exaggeration to say that this is what draws so many artists to landscape in the first place. There is an inherent brilliance to life under the sun that is unmatched in other subjects. And only the landscape has atmosphere—an *envelope of light*—that surrounds everything and tinges it with a unifying color. What's more, the light source itself, the sun (as filtered through the atmosphere), is part of many landscape compositions, making landscape light a combination of illuminated light and reflected light.

The landscape painter soon finds that these beautiful effects cannot simply be copied onto canvas. The extremes of light and color found in nature cannot be reproduced within the much narrower range offered by pigments. Artists cannot get their paintings to glow with the same intensity of a sunset or make viewers squint at the glare of sunlight reflected off water. Instead, they adopt value and color strategies that allow them to simulate the effects they see in nature.

As we will see in chapter 8, there are many strategies and approaches to color, drawn from established color theory and both classical and contemporary schools of thought. Some landscape painters rely primarily on strong value contrasts to suggest the drama of natural light (value priority), while others rely more on color contrasts (color priority). Some painters choose naturalistic color schemes, in which they try to capture the colors of nature as faithfully as they can, finding a delicate balance between bright colors and the many beautiful neutrals observed in nature. Others choose expressive color models, in which color intensity (brightness) is raised beyond what is observed in reality. These strategies, and the color theories that support them, become the landscape painter's closest allies.

Mitchell Albala, *Yakutat, Mid-Morning,* 2004, oil on canvas, 30 x 30 inches (76.2 x 76.2 cm)

There are no pigments that will glow with the same brilliance as sunlight dancing on snow-capped hills, but manipulating color and value in specific ways can simulate the effect. In *Yakutat, Mid-Morning,* I avoided overly dark and overly light colors and instead used relatively pure colors to simulate the glare of the sunlight. The sky was tinted blue, but the intangible glare of sunlight was yellow. By combining the blue and yellow in small touches of color, I was able to create a visual metaphor for the effect I saw.

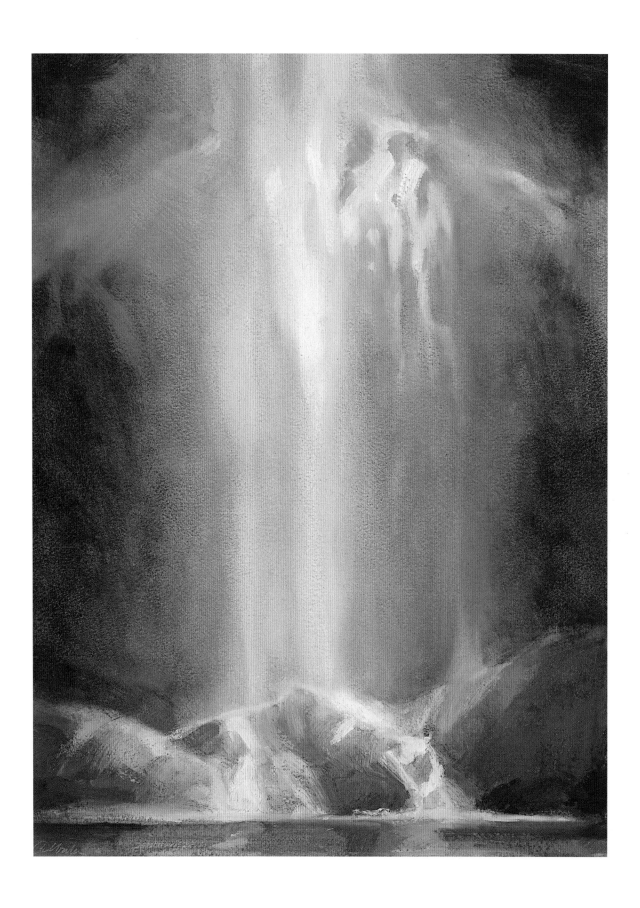

CHAPTER TWO

# MATERIALS

What counts, in making art, is the actual
fit between the contents of your head and the
qualities of your materials.

—DAVID BAYLES AND TED ORLAND

Materials matter. They are the means through which your creative thought is channeled, and therefore, they influence your creative outcome. Each choice—be it the type of paint (acrylic or oil), a surface that is rough or smooth, brushes that are soft or stiff, old or new—produces different effects that influence your work in specific ways. The nature of a material—its properties and behaviors, its benefits and limitations—becomes intertwined with the artist's process. The artist selects and guides the material, but the material also guides the artist.

One need only compare a painting done on paper to one done on canvas, or one done in acrylic to one done in oil, to see the ways materials affect the outcome. Michael Ferguson, whose work is featured on pages 60 and 82, incorporates the characteristics of acrylic paints into his style. Acrylic's tendency to produce hard edges is adopted into his method, directing the way he defines his shapes. John McCormick's *Western Wind*, on page 100, achieves luminosity both in the lights and in the shadows through a glaze method, in which transparent layers of paint appear to glow from within.

Mitchell Albala, *Del Ascending*, 2008,
oil on paper, 21 x 15½ inches (53.34 x 39.37 cm).
Courtesy of Lisa Harris Gallery

Material choices have a profound effect on the outcome of a painting. *Del Ascending* uses a range of paint textures, from transparent to opaque, to assert the physical differences between rock and water. The thickest paint is applied to the cascade of water and the rocks, while thinner, semitransparent paint is reserved for the background. Furthermore, the surface itself (cold press Arches watercolor paper) asserts a texture of its own. Thus, when the brush is dragged across the surface, the texture of the paper reacts with the texture of the paint to create even more interesting variations.

# THE LIMITED COLOR PALETTE

It's easy to look at all the beautiful colors in nature and feel compelled to purchase a tube of paint for each and every one. However, fewer colors are easier to control and force you to mix more, which, in turn, helps you see the interrelationships among colors. Artists often work with a limited palette, a set of colors that are few enough in number to encourage mixing and discovery but flexible enough to mix any color they want. The most limited palette uses only the three primaries—red, yellow, blue—and white. (Primaries and other color classifications are discussed more in chapter 8.) A somewhat broader palette, recommended here, is also based on the three primaries but includes a cool and warm variety of each primary. This helps the painter begin to see temperature differences among colors.

There is no such thing as the perfect landscape palette. Landscape painters' palettes will have certain hues in common, but they may also contain less commonly used colors that suit each artist's coloristic preferences. Begin with the palette suggested here; then, over time, experiment by adding new colors to see what effect they have on your color mixes.

## CONSISTENT ARRANGEMENT

The palette is more than just a place on which to squeeze out colors. It can be a roadmap for thinking about color and color mixing. Always lay out your pigments in a consistent and logical order; this will allow you to work faster and smarter. Avoid the "spotty palette syndrome," with colors randomly placed in different spots each time you paint. Arranging the colors in the order of the spectrum (with the exception of green, which we'll get to next) will help you evaluate colors chromatically and see them as interrelated aspects of a color continuum. Place the colors along the sides and top of the palette, not along the bottom. You swipe paint in a downward motion; if your paint is on the bottom, you will swipe it right off the palette. Develop a strategy that makes sense to you, and *use it consistently. Note:* Each of the colors shown is described as leaning toward the cool side of the spectrum (blues and violets) or the warm side of the spectrum (reds and yellows).

**Titanium white.** A versatile, all-purpose white. Very opaque, with the ability to strongly influence mixtures. **TIP:** Replace the oil-based white with an alkyd-based white to speed up drying time. (See Alkyds, page 24.)

**Phthalo blue (warmer blue).** A relatively warm blue (as compared to ultramarine) with a shift toward green. Straight from the tube, it's fairly dark. It is one of the few colors whose brilliance is heightened by the addition of white. **CAUTION:** Phthalo is so intense that it easily overpowers any mixture unless used *very* sparingly. **TIP:** Premix phthalo with a little white, as it is here, to help distinguish it from ultramarine on the palette.

**Ultramarine blue (cooler blue).** Among the landscape painter's most essential colors. A strong, transparent blue with a subtle shift toward violet. Straight from the tube, ultramarine is fairly dark. It is one of the few colors whose brilliance is heightened by the addition of white.

**Alizarin permanent (cooler red).** A magenta-like color, leaning closer to the violet side of the spectrum. As a transparent color, it needs to be mixed with other colors to achieve adequate covering power. Traditional alizarin crimson is not lightfast and has a tendency to fade. Instead, use Gamblin Artist's Oil Colors alizarin permanent, a lightfast alternative to traditional alizarin crimson.

**Cadmium red light (warmer red).** Compared to alizarin, cadmium red light leans toward the yellow and orange side of the spectrum. (Cadmium red *medium* is also warm but is darker than cadmium red light.) Naphthol red or cadmium red substitutes, often labeled as "hues," serve as alternatives to cadmium red should you wish to save money or avoid cadmium. Both have strong covering power and hold up well in mixture.

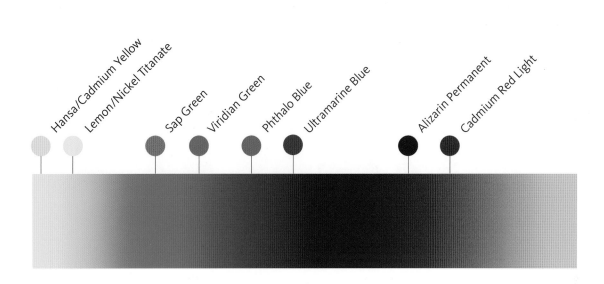

**Mapping pigments to the spectrum.** To understand the cool and warm varieties of each pigment, it is helpful to see where each falls along the color spectrum. The magenta-like alizarin permanent, for instance, lies closer to the violet end of the spectrum, while cadmium red light is relatively warmer and leans toward the yellow end of the spectrum.

**Yellow medium (warmer yellow).** Cadmium yellow medium or hansa yellow medium are warm yellows. They lean toward the red side of the spectrum more than the cooler lemon or nickel titanate yellows. Hansa yellow is a good alternative to cadmium if you want to save money or wish to avoid cadmium. Both are very opaque and hold up well in mixture.

**Lemon yellow or nickel titanate yellow (cooler yellow).** Compared to warm yellows, cool yellows have less of a red component, with an ever-so-subtle shift toward the green end of the spectrum. Lemon yellow is the traditional cool yellow; however, the cool attributes of nickel titanate (a pigment with which many artists are unfamiliar) are more apparent than those of lemon yellow. Both are also very opaque and hold up well in mixture.

**Yellow ochre (neutral yellow).** Yellow ochre may be considered part of the yellow family. If you add violet to its complement, yellow, you can get a color similar to yellow ochre; thus, it can be considered a neutral yellow. (Mixing two complements together results in a neutral color.) Yellow ochre is a pigment that is similar to raw sienna, which is a bit darker and redder. Raw sienna is a particularly good color for underpainting.

**Burnt umber (warm neutral).** This is a versatile earth color, used not so much as a generic brown but as a neutralizing color to be mixed with other colors. It has a subtle reddish tint, which is revealed when lightened with white. When added in relatively equal parts with ultramarine blue, it makes a rich, neutral dark.

## GREENS

There are many green pigments available; however, you can learn more by mixing your own greens from various yellow and blue pigments. If you want to include store-bought green pigments in your palette, you should have both a cool green (viridian) and a warm green (sap). If I were going to choose only a single green for my palette, however, it would be chrome oxide green. It is neither cool nor warm and can easily be modified with the yellows and blues in your palette. What's more, it holds up so well in mixture that it can handle being manipulated in a variety of ways.

**A diet of mixed greens.** Mixing your own greens from blue and yellow pigments generates richer and more nuanced greens than using a lot of different green pigments from tubes. The greens in this chart are a random set of greens mixed from the blues and yellows of the limited palette: hansa yellow, nickel titanate yellow, ultramarine blue, and phthalo blue. The neutral greens were made with the addition of cadmium red light or alizarin permanent.

**Viridian (cooler green).** A relatively cool green with less of a yellow component, viridian is particularly good for starting mixtures for the cool, dark-green shadows sometimes seen in nature. It can also be warmed with yellow pigments. As a transparent pigment, it needs to be mixed with more opaque pigments to achieve covering power. When lightened with white, it reveals a mintlike hue.

**Sap green (warmer green).** A warm green with a shift toward the yellow end of the spectrum. As a transparent pigment, it may need to be mixed with other, more opaque pigments to achieve covering power. When lightened with white, it reveals a yellowy-olive hue.

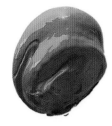

**Chrome oxide green (cool/warm green).** Out of the tube, chrome oxide green is a medium-value, somewhat neutral olive color. When lightened with white, it reveals a pale yellowy-olive hue. It holds up well in mixture, so it can be easily manipulated by other pigments.

## ADDITIONAL COLORS

There are a number of other colors that many landscape artists enjoy using. Although it is not absolutely necessary to purchase them separately (they can all be mixed from the red, yellow, and blue primary pigments in the limited palette), they can be quite handy when working outside when there is not as much time to premix colors. Many of these colors are also richer in intensity than their mixed equivalents. When any two primary colors are mixed, there is some reduction of intensity. For instance, hansa yellow mixed with cadmium red light does not produce an orange as vivid as cadmium orange.

**DIOXAZINE PURPLE.** Mixing ultramarine or phthalo blue and either of the two reds listed on page 20 can easily produce violets; however, this mixture will be more muted; dioxazine purple is such a strong and "perfect" violet that it is a handy way to quickly access violet, especially when working outside.

**NAPLES YELLOW.** When mixing greens, it is good to have a few extra yellows on hand. Naples yellow is less intense than the hansa, cadmium, and cool yellows, but it has a lovely warm golden hue. It might be considered an "earth" yellow. Naples yellow pigment traditionally contained lead, but most brands now produce lead-free formulas, which is often designated by the word "hue" in the name— e.g., Naples Yellow Hue.

**CADMIUM ORANGE/MONO ORANGE (GAMBLIN).** Oranges can readily be mixed from yellows and reds; however, they don't have the same richness or purity as cadmium or mono orange. Gamblin's mono orange is an excellent substitute for cadmium orange if you want to save money or avoid cadmium.

## TRANSPARENT, SEMITRANSPARENT, AND OPAQUE PIGMENTS

Pigments are rated as transparent, semitransparent, or opaque, which describes their covering power. Transparent pigments, such as alizarin permanent or sap green, have low covering power. When these are spread thinly on a surface in their unmixed form, one can see through the paint to the surface below. This transparent quality makes these pigments ideal for glazing. To boost their covering power, transparent colors must be mixed with more opaque colors or white. Opaque pigments, by contrast, such as cadmium red or chrome oxide green, have strong covering power. When spread on a surface, one cannot see through the paint as readily.

### MINERAL VS. MODERN COLORS

There are many colors available today that painters did not have historically. Traditional pigments are mineral and metal based, such as cadmiums, earth colors, viridian green, and ultramarine blue. In the hands of artists like the Impressionists, these pigments were used to brilliant effect; however, they have a tendency to gray down in mixture more than modern "organic" colors. Modern colors are made from carbon-based pigments and retain their intensity in tints and mixtures better. Naphthol red, hansa yellow, and phthalo blue are examples of modern colors.

Oil paint is sensuous and I find it highly seductive. Like life.
—ANN DETTMER

# CHOOSING YOUR MEDIUM

One of the most important materials choices a painter makes is which type of paint, or medium, to use: oil, acrylic, or alkyd. The choice is often based on the incorrect assumption that acrylics are safer and easier to use. Acrylics are not, in fact, easier to use than oils. Improvements in product safety have made oils safe enough to remove those concerns from the equation, freeing artists to base the choice of medium on what matters most—how a medium's particular properties support their creative intentions.

Note that in painting, the term medium refers to two different things: (1) It can mean the type of paint. For example, "What medium do you work in?" "I paint in oil." (2) It can refer to the mixtures added to paint to alter its consistency—to thin it, to improve its flow, or to produce glazes. For example, "What medium do you use with your oils?" "I use an alkyd-based medium."

**OILS.** Oils are a classic medium commanding a respect and popularity that is indisputable. Their primary advantage is their buttery (delicious!) consistency and their remarkable ability to be manipulated in a variety of ways, from transparent glazes to impasto. No other medium offers such versatility with a similar feel. Their slow drying time is a double-edged sword, though. Oils permit a wet-into-wet approach (see page 142), which is a great advantage when patient blending or extended work time is required; however, that "benefit" can cause problems for the novice when overworking wet-into-wet leads to muddy colors.

Not all oil paints are created equal. Student-grade brands have more fillers and are less potent than their professional-grade counterparts. Even among professional-grade paints, different brands have different consistencies. The higher the oil content, the softer the paint; the lower the oil content, the firmer the paint. Winsor & Newton, Old Holland, and Williamsburg, for example, tend to be firmer (and more expensive). Rembrandt tends to be extremely soft. If at all possible, buy professional-grade paint such as those just mentioned or Gamblin, M. Graham, Daniel Smith, Holbein, Sennelier, or Mussini.

## ARE ACRYLICS EASIER TO USE THAN OILS?

No. It is a misconception that acrylics are easier than oils. Acrylics have earned that reputation because they are water based and dry faster, which allows them to be more easily reworked without muddying the colors. However, their fast drying time makes blending and handling edges more difficult. Plus, acrylics dry darker than when wet. Learning to compensate for these traits is just as challenging as learning to work wet-into-wet with oils.

**ACRYLICS.** As a water-based medium, acrylics have a great deal of versatility in their own right—but in different ways from oils. They have a fluid range that permits everything from transparent washes to opaque impasto. Plus, there are many types of texture-enhancing mediums and gels available that can alter their behavior in interesting ways. The disadvantages, however, are notable. Acrylics are the opposite of oils in terms of their drying time. They dry very quickly (and even quicker when painting outdoors), which gives them a hard-edged quality.

They also dry darker than when they are wet, as much as 10 or 15 percent with certain colors, which can make it tricky to match a color after it has dried. Acrylics also have a plasticlike feel that some artists do not like.

**ALKYDS.** Fewer painters are familiar with alkyds. In many ways they are a compromise between oil and acrylic. They dry much faster than oils but slower than acrylics. Alkyds usually remain workable for many hours, but sometimes less than that, especially when working outdoors. If the wet-into-wet characteristics of oil are too demanding, the faster-drying alkyds let you work wet-into-wet or work over partially dry areas within a single painting session (depending on how much medium or solvent is used). Alkyds have a slightly sticky feel, which some may find objectionable after working with oils. They can be mixed with oils and used with the same solvents and mediums as oils are.

TIP: Speed the drying time of oils with alkyds. You can speed up the drying time of oils by using an alkyd-based medium or by replacing frequently used oil colors (such as white and ultramarine blue) with alkyd colors. This is particularly helpful in one-session plein air work, in which it may be desirable to work wet over semidry within a single session.

## PAINTING MEDIUMS AND SOLVENTS

Mediums are added to paint to alter its consistency: to make it flow easier or dry faster or more slowly, or to make it transparent for glazing effects. The type of medium used, or whether it is used at all, depends entirely on one's style and intention. Traditional *oil mediums* are made from natural resins in combination with various oils and turpentine. *Alkyd-based mediums* for oils have become increasingly popular. They are versatile and convenient to use. Three popular alkyd-based mediums are Gamblin's Galkyd and Galkyd Lite, Daniel Smith's Painting Medium for Oil and Alkyds, and Winsor & Newton's Liquin. All can be used to enhance flow, speed drying time, or create glazes, depending on how much is used. There is also an ever-growing variety of acrylic mediums for acrylic paints, from fluid mediums to thicker gels and pastes, which control transparency, viscosity, and surface sheen.

It is impossible to describe exactly how a medium will feel under your brush. Try one and see how it affects your painting. As a general rule, to maintain the integrity of the paint layers, oil mediums should not make up more than 20 percent of any paint mixture. This isn't the case with acrylics. Because both the medium and paints are made from 100 percent acrylic polymer, they can be mixed together in any proportions.

In the earliest stage of an oil painting, solvent is typically used to thin the paint for the initial block-in. Beyond this stage, however, don't get in the habit of using solvent as a medium. It is not a medium. It does thin the paint, but too much solvent breaks down the binding property of the oil. Mediums, which are a combination of solvent and oil, give the paint a more desirable oil-like consistency and a more flexible and long-lasting paint film.

What if the opposite effect of a medium is desired (to thicken the paint)? For oils, Sennelier's Thickening Medium is a puttylike medium, in essence a "reverse medium," that adds body to the paint and speeds drying time. Alternatively, you can thicken paint manually by spreading it onto cardboard and letting the excess oil be absorbed by the board. With acrylic paints, thickening gels and pastes may be added to firm the body of the paint.

### SOLVENT AND PIGMENT SAFETY

The safety issues surrounding oil paint stem largely from solvents like turpentine and mineral spirits. These solvents contain harmful aromatic compounds (which account for their noxious odor) that can be inhaled. The solvent itself can also be absorbed through the skin. However, modern formulations such as Gamsol by Gamblin Artist's Colors have eliminated the harmful aromatics, rendering the solvent odorless and less able to be absorbed through healthy, unbroken skin. Traditional turpentine or mineral spirits should *not* be part of your studio (the only exception being as an ingredient in paint mediums that contain damar varnish). Oil paint itself contains no solvent and has no toxic fumes. Its odor is that of an aromatic vegetable oil (linseed, poppyseed, or walnut), which is harmless. Even though today's solvents are less toxic, one should always take reasonable precautions against exposure and wear vinyl or latex gloves when necessary.

In terms of pigment safety, cadmium and lead-based pigments have traditionally been the major concerns. It's worth noting that exposure to cadmium in acrylics is just as great as it is with oil paints. (Lead is not used in acrylics.) Most painters regard cadmium pigments as toxic, although today's cadmium pigments contain a low level of bio-available cadmium metal—only five parts per million as compared to the cadmium pigments of yesteryear, which contained one thousand parts per million. Gamblin Artist's Colors writes, "American manufacturers of cadmium pigments have developed production systems that yield cadmium pigments that are relatively insoluble in the human digestive system. . . . Cadmium pigments can still be hazardous if they are inhaled, however, so use a NIOSH dust respirator if you are spraying cadmium-based pigments or sanding surfaces made with a high percentage of cadmium colors." If cadmium pigments cause concern, they can be replaced by modern counterparts; for example, naphthol red replaces cadmium red, hansa yellow replaces cadmium yellow, and mono orange (Gamblin) replaces cadmium orange. Certain pigments such as Naples yellow and Cremnitz white still contain lead (as indicated on the label) but can be replaced by lead-free equivalents.

# BRUSHES

Brushes are important. As the primary conduit between you and the painting, they have a profound effect on the language of your mark-making. They are your friends. Choose them wisely, and treat them well.

**SHAPE AND FLEXIBILITY.** Different types of brushes—brights, flats, filberts, or rounds—make different-shaped strokes. The length and flexibility of the bristles determine how much paint they hold and how the paint is laid down. Longer, more flexible brushes, like *filberts*, hold more paint and can be used to lay down thicker strokes. Shorter bristled brushes, like brights, are stiffer and press through the body of the paint more. Hog bristle brushes or synthetic equivalents are suitable for oils. Acrylic painters generally prefer synthetic brushes because they resist the water better than natural bristles. With acrylics, hog bristles tend to splay out from the water and not last as long because paint quickly gathers in the ferrule (the metal band joining the bristles to the handle). *Note:* Some synthetic brushes are strictly for acrylics, while others are rated for both acrylics and oils.

**SIZE.** Brush size is important and should be targeted to the size of the area being painted. Novices often fall into the habit of working with overly small brushes or even a single brush. Larger brushes are the landscape painter's best friends. They are more compatible with the shaping and massing that are fundamental to landscape painting. For plein air painting, I suggest sizes of 4, 6, and 8 filberts, with at least one larger bright for blocking-in during the initial underpainting stage. A small #2 round or filbert is handy for the occasional detail. In the studio, those same brushes are good, but you will also need larger ones. As your work increases in size, your brushes need to scale up proportionately. *Note:* Although most manufacturers use the size and numbering scheme shown here, be aware that some use a different standard.

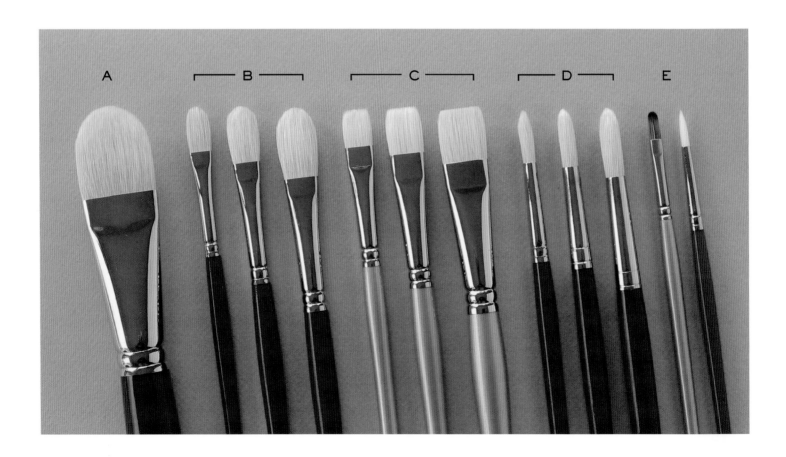

# PAINTING SURFACES

The type of surface you paint on will respond to the paint and to your brush-strokes differently. Does the paint slide across the surface or does the surface offer some resistance to the brush? How readily is the paint absorbed into the ground (the surface to which it is applied)? How does the texture of the surface interact with strokes? How is your response to flexible, stretched canvas different from a hard panel or board?

**CANVAS.** Canvas is a traditional surface woven from either linen or cotton. Its natural weave provides a finely textured surface. Canvas may be stretched or mounted to panels. The flexibility and "bounce" of stretched canvas has a different feel from rigid panels or boards. Preprimed canvas, which can be purchased by the yard, can save you hours of preparation: When stretching your own canvases, you are spared the step of priming with gesso. When working outside, you can precut the canvas to different sizes and then tape it to light cardboard or foamcore backboard. (If you decide the painting is a keeper, you can stretch it after it is dry or leave it unstretched and mat it.) Canvas panels are lightweight and inexpensive, making them convenient for outdoor work. Panels should be flat (not warped), with a surface that is not too slick. Choose a quality brand, such as Fredrix.

**PAPER.** Artists have painted on paper for centuries. It's inexpensive, light, and convenient, making it great for outdoor work. It also comes in a wide variety of textures. Hot-press watercolor paper (smooth) or cold-press (textured) in 140-pound or 300-pound varieties are favorites. Paper should be primed with at least one coat of gesso. Tape the paper to a board with low-tack masking tape. After gessoing, the paper will buckle but will dry flat. Always choose acid-free archival paper.

**BOARDS AND PANELS.** At one time, to paint on panel artists had to purchase wood from the lumberyard, have it cut to size, and then gesso the surface themselves. Now, prepared gesso boards are readily available in smooth or textured surfaces, in a full range of sizes, such as those from Ampersand. They are more expensive than those you prepare yourself but are a big time-saver and far less labor-intensive. If you do prefer to gesso panels yourself, avoid overly thick and streaky strokes that leave visible tracks. These will interfere with your paint surface. Alternatively, using a small sponge roller creates a soft, pebbled surface that is a good starting texture.

**GESSO.** Gesso serves as a ground. A surface primed with gesso becomes an archival surface by making a barrier that prevents the paint from being absorbed directly into the wood, paper, or canvas. A good-quality gesso allows for the right amount of absorbency for the initial layers of paint to "bite" into the surface. Be wary of cheap grades of gesso, especially in prepared canvas panels: If there is too little absorbency, the paint will not adhere well; it will slip and slide on the surface. If there is too much absorbency, the initial layers won't be workable.

**A range of hog bristle brushes is most suitable for oils.** From left to right: **(A) SIZE 14 OR 16 (SHOWN) BRIGHT OR SHORT FILBERT.** At least one large blocking brush is essential for toning the surface and blocking in large shapes during the initial stages of a painting. Brights or short filberts are good for this purpose, as they are firm enough to allow for some scrubbing. Flats, rounds, or regular filberts are too long and flexible for this purpose. **(B) SIZE 4, 6, AND 8 FILBERTS.** Filberts are the most versatile type of brush. They can be used to make rounded (less squared) strokes as well as thin strokes when used along the tip. With longer bristles, they hold more paint than brights. (Flats, not shown, are similar to filberts in length and flexibility but have a square tip that creates a more chisel-shaped stroke. With a good range of filberts, I don't find flats essential.) **(C) SIZE 6, 8, AND 10 BRIGHTS.** Shorter-bristled brights are naturally less flexible and hold less paint. Their stiffer bristles resist the paint more readily than long-bristled, more flexible brushes. **(D) SIZE 4, 6, AND 8 ROUNDS.** Rounds are shaped to make round strokes. They are ideally suited for making calligraphic strokes, as one might find in an Impressionist painting. **(E) SIZE 2 DETAIL BRUSH.** A synthetic #2 filbert or round is good for the occasional stroke of detail. These brushes should not be too soft or flexible, otherwise they will not be able to manipulate the paint.

# PALETTES AND EASELS

## PALETTES

Palettes are usually made of wood or glass. Wood has a natural middle-value tone that makes it easier to judge values of color mixtures against. Disposable paper palettes, on the other hand, are white and provide too high a value contrast for color mixing. The edges of the palette pad also tend to curl up, and the entire sheet eventually dislodges from the pad. For outdoor work, a wood palette is ideal. French easels come with a portable wooden palette, and some of the pochade-type easels have a palette built in to the lid.

In the studio, and even outdoors, many artists prefer a glass palette. They are easy to scrape clean, and mixing colors on the smooth glass provides less resistance and a pleasing feel beneath the brush. The "color" of the palette can also be changed by placing different colored sheets of paper underneath the glass that correspond to the overall color tone of the painting on which you are working. A glass palette for use outdoors should be small, about 9 x 12 inches, and 1/4-inch thick with beveled edges. Tape it to foam-core or cardboard to help prevent it from shattering should it be dropped.

## EASELS

There are many professional easels for the indoor studio, from compact and lightweight to multifeatured deluxe models. If space and cost are factors, Stanrite offers a classic: Their model 500 is a lightweight, sturdy aluminum easel that can handle all but the most enormous paintings. It can be collapsed and stored against the wall or behind a door. For the outdoor studio, the painter can choose from traditional French easels, in both half- or full-size, or compact pochade boxes.

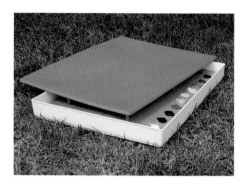

**Sealable palette boxes.** A sealable palette box helps keep paint from drying between sessions, making it extremely handy when painting outdoors regularly. It also allows you to use the same palette at home, on location, or in classes, which saves a lot of paint. The palette box by Masterson (shown) holds palettes up to 12 x 16 inches. There are palette boxes specifically designed for acrylic painters as well, such as the Sta-wet by Rowney, which use a wet sponge liner that keeps the paint wet for weeks.

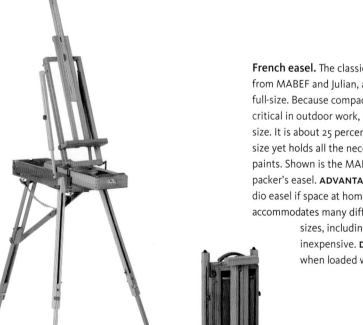

**French easel.** The classic French easel, available from MABEF and Julian, are available in half- or full-size. Because compactness and weight are critical in outdoor work, I recommend the half-size. It is about 25 percent lighter than the full-size yet holds all the necessary brushes and paints. Shown is the MABEF M/23 half-size backpacker's easel. **ADVANTAGES:** Doubles as a studio easel if space at home is at a premium; accommodates many different types of canvas sizes, including very large; relatively inexpensive. **DISADVANTAGE:** Heavy when loaded with supplies.

---

TIP: Seal your palette. Most wood palettes do not come ready to use. They must be sealed with a few coats of polyurethane or shellac, or saturated with several coats of linseed or walnut oil before use.

---

**Space-saving "wall easel."** If square footage in your studio is in short supply and you can permanently dedicate wall space, you can forgo an easel altogether. A large piece of 1/2-inch-thick insulation board mounted to the wall acts much like an all-purpose wall "easel." Use nails to hang your paintings. Reference photos and studies can be pinned up alongside. Be sure to give the insulation board a few coats of white primer. The boards come in standard 4 x 8–foot sheets but can be trimmed down to fit the space available.

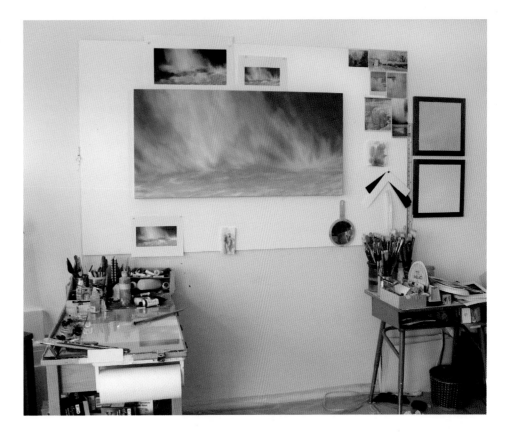

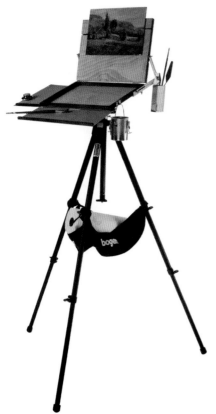

**Pochade box with easel.** As outdoor painting has grown in popularity, many types of pochade-style easels with tripods have been introduced in recent years, such as those from Open Box M and Artwork Essentials. Open Box offers 8 x 10–, 10 x 12–, and 11 x 14–inch pochade boxes, as well as extremely compact "palm" boxes for even smaller work. Shown here is their 10 x 12 box with front palette extensions. **ADVANTAGE:** Extremely compact and lightweight. **DISADVANTAGES:** Palettes tend to be small, holds fewer supplies, more expensive than French easels.

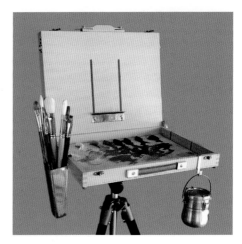

**Pochade box.** Artwork Essentials offers models ranging from 8 x 10 to 12 x 16 inches, with the advantage of being able to hold larger paintings than some other types of pochade kits. Shown here, the 12 x 16 Versa can hold paintings from 4 x 6 inches to 20 inches in height and no limit in width.

# ADDITIONAL SUPPLIES

In addition to the basics, there are a number of other supplies that are extremely helpful. Remember, whether indoors or outdoors, your aim is to make your workflow as easy as possible.

**DRAWING TOOLS.** The drawing tools most suited for the landscapist are those which push you toward simplifying the scenes before you with broad and bold marks.

Use a tool that makes a commitment, such as a Lyra graphite stick, an ebony or a 2B–6B pencil, or a bold marker. (Very light pencils, such as H and 2H, or fine-point pens foster a linear orientation, the opposite of what is needed when you are exploring the landscape's values and shapes.) Erasing is good, so also have a hard plastic eraser and a soft kneaded eraser on hand.

**RAGS AND PAPER TOWELS.** Rags are essential for the underpainting method shown in chapter 9. Always use a lint-free, T-shirt-type rag on painting surfaces. Paper towels are good for general cleanup but not for use directly on the painting.

**DISPOSABLE GLOVES.** Vinyl or latex gloves are a great way to protect your skin from paint as well as the solvents used with oils.

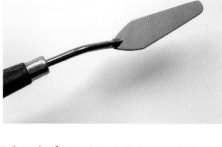

**Palette knife.** A palette knife is essential for mixing colors, scraping the palette, or applying paint directly to the canvas. A wide array of sizes and shapes are available but not necessary. A 2-inch spade-head type, shown here, as opposed to the single-blade long and flat type, is a versatile all-purpose knife.

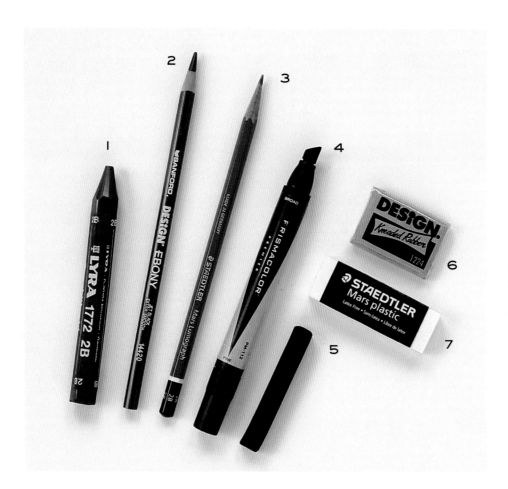

**Drawing tools.** When exploring the landscape's values and shapes, use a tool that makes a commitment: **(1)** Lyra graphite stick, **(2)** Sanford Ebony pencil, **(3)** 2B through 6B pencils, **(4)** a broad-nib marker, or **(5)** compressed charcoal. Also have some erasers handy: **(6)** a kneaded eraser and **(7)** a white plastic eraser.

**PALETTE CUPS.** Palette cups are a convenient way to access solvent or medium on your palette. The open-top variety that clamps to the side of the palette is easier to work with than plastic or metal types with a screw-cap lid and a small mouth.

**VIEWFINDER:** A viewfinder is essential for selection and composition. You can make your own out of cardboard or purchase an adjustable, plastic ViewCatcher, shown on page 89.

**TAPE.** A ¾- or 1-inch-wide roll of masking tape is extremely handy for attaching loose canvas to a backboard or cropping paintings on the fly.

**ARTIST'S UMBRELLA.** Nothing beats an umbrella to protect you and your painting from the sun. The umbrella should be white or neutral colored; colored umbrellas will create a color cast over the painting. Look for a collapsible artist umbrella that is neutral colored and has ventilation slits to reduce the umbrella's wind-catching abilities.

**BABY OIL.** Baby oil is a safe and easy way to get oil paint off your hands without exposure to solvents.

**MIRROR.** Viewing your painting in a mirror gives a fresh perspective. In the studio, place a mirror opposite your easel. For plein air, keep a small pocket mirror in your pack.

**CAMERA.** A camera is an essential tool for the landscape painter, allowing you to record fleeting effects and gather reference that can be used back in the studio.

**CREATURE COMFORTS.** When working outdoors, having all the right materials won't do you much good if you're getting eaten by insects, dehydrated, or distracted by thoughts of lunch or dinner. You need not suffer from a lack of comfort or safety. Bring these items with you when you paint outdoors: water and food, insect repellent, sun protection (sun hat, sunblock), wind and cold protection (extra clothing), cell phone, and a portable first-aid kit.

When we speak of the perfection of art, we must recollect what the materials are with which a painter contends with nature.

—JOHN CONSTABLE

**Solvent bottle.** A small 8-ounce plastic bottle with a flip spout is ideal for holding solvent, both in the studio and outdoors. It is lightweight, and its tiny spout reduces exposure and spills. **TIP:** Use a small 2- or 4-inch plastic funnel to transfer solvent from the can to the bottle.

CHAPTER THREE

# INDOOR AND OUTDOOR STUDIOS

The artist has a twofold relation to nature;
he is at once her master and her slave.

—JOHANN WOLFGANG VON GOETHE

Unlike most painters who work exclusively indoors, landscape painters must be comfortable in two "studios"—in *plein air*, where they receive their initial inspiration and foundation lessons from nature, and indoors, where they develop the most full-bodied expression of their original vision.

Landscape painters divide their time between these two studios in different ways. Some only work outdoors. A direct and immediate response to nature is, for them, the very definition of landscape painting. Others work almost exclusively indoors yet often return to nature to keep their translation skills in good form and to gather inspiration and source material. Most landscape painters, however, work in both studios. They know from experience that indoor and outdoor works are different expressions of the same language, each suited to a particular type of visual statement. Outdoor work is typically small and infused with a spontaneity and fluid brushwork that is less common in larger indoor studio works. But in larger works, the artist is capable of accomplishing feats that are unattainable in a quick plein air painting.

Since all landscape painting begins outdoors at the source, we will first examine the plein air experience as a foundation for landscape painting and review several practices that make the experience easier. Then, with a move indoors, our focus will turn to the challenges of studio painting.

Daniel W. Pinkham, *An Artist's Poem; Location Sketch, Utah*, 1986, oil on panel, 14 x 11 inches (35.56 x 27.94 cm). Courtesy of American Legacy Fine Arts, LLC

Pinkham's location sketch wonderfully captures the luminosity of colored light within shadows. Working outdoors is the formative experience for the landscape painter. Only through the experience of translating nature's colors and values into paint does the artist learn how to comprehend the landscape. Outdoor works can stand alone as complete works of art, or they may be used as the basis for a larger indoor studio painting, as was the case with *An Artist's Poem*.

# PLEIN AIR: BEGINNING AT THE SOURCE

The study of landscape painting necessarily begins at the source. Under the sky, in the caress of a cool breeze with clouds gliding overhead and wide-open spaces in every direction, landscape painters find their initial inspiration and take their foundation lessons. Just as a figure painter cannot hope to realize the human form without referencing live models, the landscape painter cannot hope to comprehend the landscape without observing and painting it firsthand. Only in an experiential, one-to-one relationship with nature can the student learn how landscape forms and colors translate into paint. Even landscape painters who work primarily in the studio—as many do—continue to return to the source to gather inspiration, color notes, sketches, and photographs.

The outdoor painting experience—*en plein air*—stands alone as the artist's direct response to nature. If for no other reason, this makes work done on location special. It is where the painter's initial inspiration is realized, the vision that will carry them through a two-hour plein air session or through a thirty-painting series like Monet's *Rouen Cathedral*. Because of the limited time available as the painter "chases the light," plein air works are usually smaller and painted more quickly. As such, they are often infused with an expressiveness and immediacy that their larger studio siblings may not have. Plein air paintings can be used as reference for larger paintings developed in the studio, but they can also stand alone as complete works of art.

The demands of plein air painting, and its shorter time frame, call for a different standard of success. Some of the loveliest paintings I've ever done were plein air sketches completed in less than an hour, yet most of my "failures" have also been in plein air. Most successful plein air painters will confess that 50 percent or fewer of their efforts outdoors are actually worthy of framing or selling. This is said not to discourage but to put your efforts "en plein air" in a realistic context. If my goal is to produce a masterpiece each I time paint outside, I will be frequently disappointed. But if each "failure" is used as a learning event, then it is a worthy endeavor that can reveal another clue in the ongoing mystery of painting from nature.

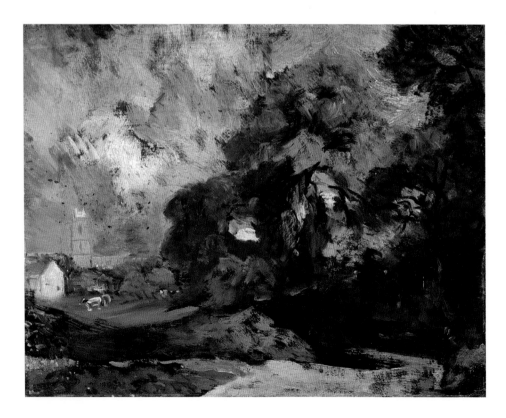

John Constable, *Stoke-by-Nayland*, oil on canvas, 11⅛ x 14¼ inches (28.25 x 36.19 cm). The Metropolitan Museum of Art, Charles B. Curtis Fund, 1926 (26.128). Image © The Metropolitan Museum of Art

John Constable (1776–1837) was among the earliest painters to adopt the then unorthodox approach to landscape of working directly from nature. *Stoke-by-Nayland* exhibits an astonishing level of painterliness, a testament to the fact that, in any age, working in the open air prompts an immediate response to nature that is reflected in the vigor and directness of the brushwork.

## THE PLEIN AIR TRADITION

The term *plein air* (pronounced plen-air) derives from the French term for *open-air*. It was coined in the mid-nineteenth century in France, when the Barbizon and Impressionist painters popularized the practice of working outdoors; however, outdoor painting had its origins with a group of international artists in the late-eighteenth and early-nineteenth centuries, who painted in the Campagne region of Italy. Artists like Thomas Jones (1742–1803) and Pierre Henri de Valenciennes (1750–1819) fully embraced working directly from nature as a necessary part of the creative process, yet they did not intend these works to be shown[1], as is the custom today. It is the English and French artists of the nineteenth century who are credited with elevating plein air painting to a status equal to that of studio painting. John Constable (1776–1837), working in the English countryside, abandoned notions of a cultivated, stylized landscape and began to work from life. Across the channel in the Forest of Fontainebleau, the French Barbizon painters like Camille Corot (1796–1875) and Charles-François Daubigny (1817–1878) also worked on location. They laid the groundwork for the Impressionists, who would grant license for painters to work with palettes of purer color and lighter tonality. Today, landscape painting readily conjures images of artists poised before their portable easels, but in the nineteenth century that approach was considered a radical shift in methodology. These early plein air painters were responsible for ushering in a style that not only created greater respect for the genre but also established a tradition that has lasted to this day.

Photo: Maddine Insalaco

## SLOW AND STEADY WINS THE RACE

The popularity of the painterly, *alla prima* (all at once) style of plein air painting makes a compelling case for working fast. Instructors admonish students: "Work quickly! Don't hesitate! Be bold!" However, making correct choices in the field (and in the right sequence) is hard enough without having to rush! I recommend that plein air painters take their time. A painting that is incomplete but well thought out and organized is ultimately superior to something that is "finished" but rushed and unrealized. An unfinished painting can easily be completed indoors because it has a solid foundation. And if left unfinished, it can offer a revealing look at the artist's process. The ability to do a rapid-fire plein air painting, infused with all the right alla prima energy, is something that takes years to master. Have realistic expectations, and be patient.

The truth is in nature, and I shall prove it.

—PAUL CÉZANNE

[1] Phillip Conisbee, Sara Faunce, Jeremy Strick, *In the Light of Italy: Corot and Early Open-Air Painting* (Washington: National Gallery of Art; New Haven: Yale University Press, 1996), 15.

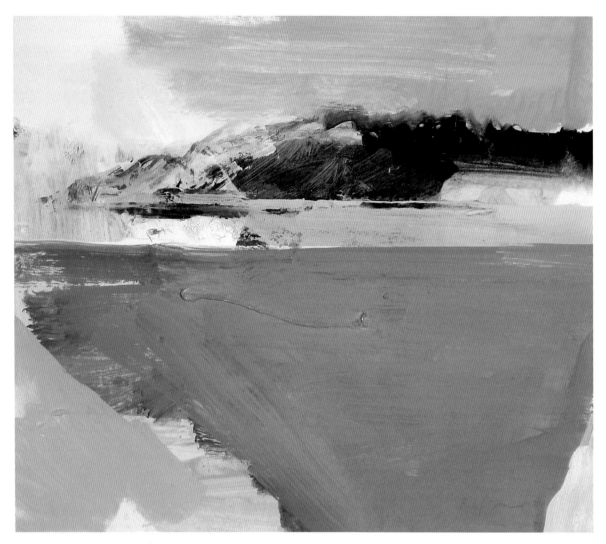

Rebecca Allan, *Nestucca Bay, Oregon/Evening*, 2003, acrylic on paper, 6 x 7½ inches (15.24 x 19.05 cm)

Contemporary plein air painters continue a long tradition of open-air painting. Although their palettes tend to be brighter than those used by the open-air painters of the early- to mid-nineteenth century, their commitment to capturing a momentary impression of light is still paramount. Rebecca Allan finds the essential beauty of *Nestucca Bay* in simplified but highly energized patches of color. A few broad shapes direct the composition, and alternating areas of thin transparent color (upper left) and opaque color (blue water) help complete the illusion of evening light.

Plein air painting is not about quickly executing a scene and slinging thick paint around just to have it on the canvas. Maintaining control of all the art principles at all times is an imperative.
—KENN BACKHAUS

# PLEIN AIR PRACTICAL

The outdoors is the world's most demanding studio—where heat, cold, wind, rain, inconsistent lighting, and interference from creatures, human and otherwise, are all in a day's work. Although painting outside can be an invigorating experience, it is never as convenient as working indoors. In fact, it is that inconvenience that prevents many artists from attempting plein air painting in the first place. Fortunately, much of the difficulty can be avoided with some commonsense organization and eliminating all but the most essential supplies.

## TRAVEL LIGHT AND WORK SMALL

With the exception of a portable easel, the supplies for painting outside are no different from those used in the studio; however, *the plein air experience demands that you travel light*. In the studio, you are free to spread out and get as messy as you want. Outside, you have to be efficient and organized. Carry only the bare minimum of supplies. If your portable easel is of the French variety, consider the half-size version. It's more compact and lighter (by about 25 percent) than the full-size version but still has plenty of room for all your paints and brushes. Full tubes of paint

also add to your load. Put aside half-used tubes from the studio for your outdoor kit. They take up less space, as well. Don't carry every pigment you have, just the essential ones that make up your limited palette, and never carry large 150 mL tubes.

Do not carry a full can of solvent into the field. Transfer solvent into a small 8-ounce plastic bottle with a flip-down spout.

---

TIP: It is easier to pour solvent into the small-mouthed bottle with a tiny 2- or 3-inch plastic funnel. Warning: After an outdoor session, be sure to take your dirty solvents with you. Never pour them out onto the ground.

---

Everything you need should fit into two "carry items": a portable easel and a supply bag. There are many artists' totes and satchels available with lots of compartments and pockets. A knapsack-style bag can be carried on your back, freeing up your hands. Hard plastic art boxes, with their many trays and compartments, are not as convenient as they appear; they can be quite bulky and cumbersome. You should be able to carry everything you need in a single trip from your house to

the car or from your car to the site where you'll be working.

If you work outdoors frequently, consider having an entirely separate plein air kit from your studio supplies. If you have to sort through your studio supplies every time you go out to paint, it will slow you down, and you are more likely to forget an essential item.

Also note that it is no accident that most plein air paintings are small, between 5 x 7 and 9 x 12 inches. To be sure, there are painters who take much larger canvases out into the field and work on them for many days, but the changing light and shorter time frame make smaller surfaces ideal for outdoor work. What's more, because the painting is smaller, the brushstrokes are bigger and more fluid relative to the size of the canvas, lending an expressive quality to the brushwork.

---

TIP: Don't forget to take care of yourself when working outdoors. Be sure to take sufficient drinking water, extra layers of clothing, a sun hat, sunscreen, insect repellent, food, a first-aid kit, and a cell phone for emergencies. If you need to sit, be sure to take a portable folding stool.

---

**Wet canvas carriers.** If you do several oil paintings per session, or are on excursion and will have many paintings drying simultaneously, a wet canvas carrier is a must. OpenBoxM, Guerilla Painter, and Wind River Arts all offer carriers of different sizes. Shown is the Wind River Arts wood ezPORT carrier with adjustable inserts to accommodate different-size panels. They also offer a lightweight and inexpensive cardboard option, Handy Porter.

## REWORKING PLEIN AIR PAINTINGS

There's no getting around the fact that the light outside is in constant flux. Shadow patterns change, colors change, and cloud formations last but a few minutes. The goal is not to keep up with the change, constantly revising as you go. You'd never finish the painting! Strike in the shadow patterns or cloud shapes you see at the start. If, later in the painting, the patterns and shapes become more desirable—if they will improve the overall composition—then it may be worth making the revision. If it's too difficult at that stage, then keep the original design.

Another consideration is whether a plein air painting should be reworked or finished in the studio. Will the spontaneity be lost? If you feel that the momentary impression will be lost, or that the painting will look overworked, then leave it. It will stand as a record of your experience on that day, in that moment. If you are not satisfied with the painting, then you have nothing to lose by continuing to work on it in the studio. It may lose some of the immediacy of the initial outdoor session, but you can potentially learn from your corrections.

## DRAWING

Drawing is an essential foundation skill because it trains your eye to render things accurately. It gives you the ability to place shapes and lines with intention—where you want and when you want. Instruction on the keys to drawing—gesture, line, measuring, proportion, and negative space—are outside the scope of this book, but make no mistake, drawing is an essential skill for the landscape painter. It is true that some elements in the landscape offer considerable latitude in the precision with which they can be rendered. If the tree tilts a little more to the left in the painting than it does in life, will it matter? Perhaps not, but the better your drawing ability, the better able you will be to translate your perceptions onto the canvas. If you have the necessary drawing skills, then you will know why the proportions look off or why the perspective isn't true—and you will be able to correct the problem. You will not be impeded by drawing concerns and will be freer to deal with the issues of painting.

If you find that your drawing skills are holding you back, then take the time to get the necessary training. It will be worth every minute. Classes are a great way to improve drawing skills with the one-on-one guidance of an instructor. There are also two excellent books I recommend: Betty Edwards's classic *Drawing on the Right Side of the Brain* and Brian Curtis's *Drawing from Observation*.

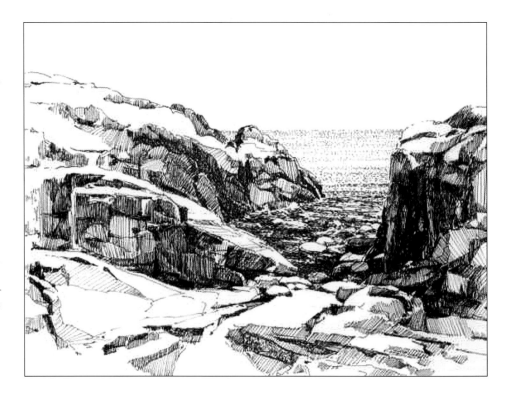

Richard McDaniel, *Squeaker Cove*, 1994, ink on paper, 8 x 11 inches (20.32 x 27.94 cm)

Drawing is very much a formative part of the plein air experience. Through drawing, a finished art form in itself, the landscapist can explore a subject without the added complexity of color—and revel in the exploration of elemental shapes and value patterns. In *Squeaker Cove*, McDaniel uses crosshatched strokes to build distinct patterns of light and dark that define the many planes found in the subject.

## PLEIN AIR CHECKLIST: FORGET ME NOT!

If you don't have a dedicated painting kit for outdoor work, and you gather your materials together each time you go out, it's easy to forget an essential item. Refer to this handy checklist when preparing your supply bag so that you'll have everything at the ready.

- Portable easel
- Paint (check for each color)
- Painting medium
- Palette
- Solvent in small plastic bottle
- Solvent jar for cleaning brushes (small, with screw-top lid)
- Palette cup
- Brushes
- Palette knife
- Painting surfaces

- Backboard (old canvas board or 1/2-inch foamcore)
- Masking tape
- Small sketchbook and sketching tools
- Viewfinder
- Rags and paper towels
- Disposable plastic bag for dirty rags
- Camera
- Umbrella
- Disposable gloves
- Plastic mat or tarp for wet ground
- Compact mirror for looking at paintings in reverse
- Standard and/or mini bungee, as needed
- Small pliers and screwdriver
- Creature comforts (water, food, insect repellent, first-aid kit, portable stool or chair, and sun protection such as sunglasses, wide-brimmed hat, and/or sunblock)
- Cell phone

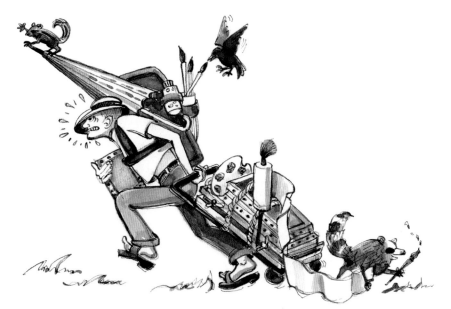

Illustration: Jennifer Carrasco

**Don't let this happen to you!** The landscape painter doesn't need to transport an entire studio to paint outside. Think of painting outdoors as an art picnic. You don't bring your entire kitchen when going on a picnic, nor should you bring your whole studio when painting outside. A smartly organized supply bag with a compact portable easel is all you need. Weigh your pack and make a game out of seeing how much you can reduce the weight.

## ESTABLISHING A CONSISTENT LIGHT ON YOUR PALETTE AND CANVAS

A single color will appear different under lights of varying brightness. This simple fact is crucial to controlling your color mixing. Imagine your difficulty if every time you mixed a color and applied it to the canvas, it appeared either darker or lighter than you intended. This is exactly the problem faced if the light on the canvas and palette is not the same. The following examples show various lighting arrangements of the easel and palette, from worst to optimal. In any given situation, the easel needs to be turned to achieve the most balanced light possible. Part of finding a good location is making sure that the light that falls on you, your palette, and your painting works *for* you, not against you.

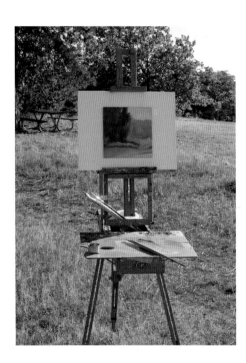

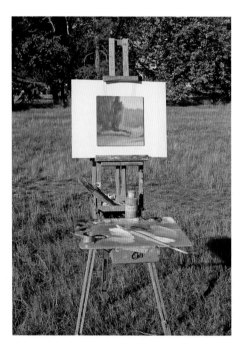

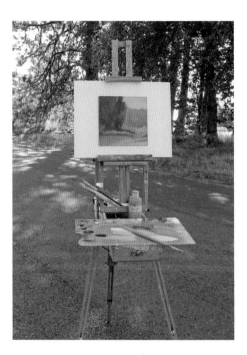

**Severe imbalance.** In the worst possible arrangement, the palette is sunstruck while the canvas is in shadow, or vice versa. This imbalance makes mixing the desired colors almost impossible. Too much of your time will be spent trying to compensate for the difference.

**Canvas and palette in full sun.** Not only is this arrangement blinding to look at, but judging colors in direct sunlight is next to impossible; colors appear overly saturated. Color choices made in direct sunlight will also look *very* different under normal, indoor viewing conditions. Although the landscape you are painting can be under full sunlight, you and your painting should not be. Soft shade is closer to a true viewing light.

**A balanced light in soft shade.** The most balanced painting situation is achieved when palette and canvas receive equal light. This is most easily found in soft, diffuse shade, such as under a tree or in the cast shadow of a building or hill. Colors mixed in a balanced, shaded light are more likely to be the color intended when applied to the canvas. Shade is also closer to a normal indoor viewing light. Overcast or cloudy days naturally offer a diffused, balanced light.

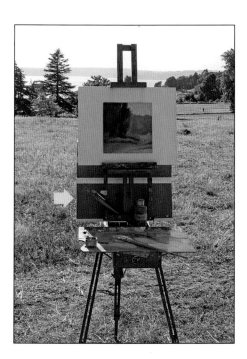

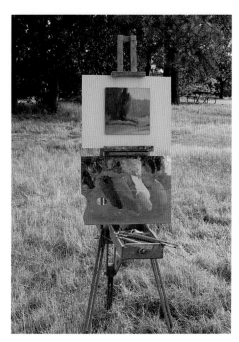

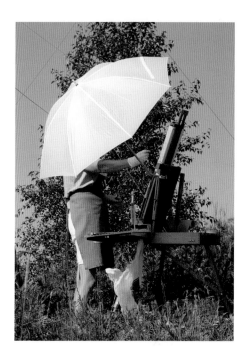

**Create shade by blocking.** Often, you find a beautiful location but can't escape from the sun shining directly onto you and your easel. In full sunlight, the easel can sometimes be positioned opposite the sun so that the painting surface casts a shadow onto the palette. *You* may still be in the sun, but your palette and canvas will have some protection. With French easels, cardboard or an extra canvas panel can be propped vertically behind your painting surface to block some of the stray sunlight.

**Upright palette.** With a French easel, an easy way to ensure that equal light falls on the canvas and palette is to place the palette upright on the same plane as your canvas. Use a mini bungee cord tied from behind to hold the palette against the frame.

**Artist's umbrella.** An artist's umbrella allows you to make your own shade wherever you are. The best umbrellas are white or neutral colored; a colored umbrella will create a color cast over the painting. Umbrellas have their risks. In even moderate winds they can turn your painting session into a sailing session. An umbrella with ventilation slits will reduce this risk.

# IN THE STUDIO: DEEPENING EXPLORATION

Landscapes executed in the studio can be the artist's most full-bodied expression. In the comfort of the studio, the artist has the luxury of time to resolve all the visual problems that fleeting light and short sessions don't permit in outdoor work. Studio paintings do not always possess the spontaneity and painterly bravura of plein air work, but what they lack in immediacy they more than make up for with fully realized visual solutions.

The slower, studied approach of studio work gives the painter *options* to explore issues of composition, color, and paint handling in ways that can bring the visual idea to its most realized state. In my own work, I spend a lot of time doing thumbnails or sketches to determine which compositional variant best supports my idea. I do the same with color, sometimes doing several studies to determine which color approach best suits the subject. In the actual painting, I can take whatever time is necessary to subtly modulate the color. In oil, for instance, glazing or textural brushwork can require several days of drying in between sessions, which is only possible in a multiphased studio process. In the studio, there is time to put a painting aside and gain a fresh perspective days or weeks later. In short, the studio experience embodies everything outdoor work does not: controlled lighting, a comfortable environment, and the time to take a more contemplative approach to the subject.

Nature is my springboard. From her I get my initial impetus. I have tried to relate the visible drama of mountains, trees, and bleached fields with the fantasy of wind blowing and changing colors and forms.

—MILTON AVERY

Sanford Robinson Gifford, *A Gorge in the Mountains (Kauterskill Clove)*, 1862, oil on canvas, 48 x 39⅞ inches (121.92 x 101.28 cm). The Metropolitan Museum of Art. Bequest of Maria DeWitt Jesup, from the collection of her husband, Morris. 1914 (15.30.62). Image © The Metropolitan Museum of Art

In the mid-nineteenth century, a group of artists known as the Hudson River School painters began to extol the beauty of the expanding American landscape. They collected notes and sketches and compiled them into grand-scale masterpieces in the studio. In *A Gorge in the Mountains*, Gifford (a member of the second generation of Hudson River School painters) uses analogous harmony to unify the color of the light and atmospheric perspective to suggest vast distances. In the lower left corner, a mountain climber with his dog can barely be seen, swathed in the shadow of the rock. It was not uncommon for the Hudson River painters to place human figures in their landscapes to demonstrate humans' diminutive stature in comparison to the grandeur of nature. First- and second-generation painters of the Hudson River School—such as Albert Bierstadt, Frederic Edwin Church, Thomas Cole, Thomas Moran, and Gifford—eventually formed what was the first real American school of landscape painting.

## THE PERCEPTUAL AND PHYSICAL EFFECTS OF SCALE

The most obvious difference between plein air painting and studio painting is scale. As a painting increases in size, it begins to change things for the artist, both perceptually and physically. Perceptually, the painting expands into our personal space, changing the way we perceive it. Physically, managing a larger surface area requires an expansion of artistic consciousness—through our expanded body movements and paint handling.

A small painting falls entirely within our cone of vision. We don't need to stand back to take all of it in. In this way, small works exist in an intimate space. As the painting gets larger, we begin to experience it as part of our reality. *Large* is a relative term, but if the artist or the viewer needs to stand back to take in the full picture, it is fair to say that we are involved with the effects of scale. A composition that seems to work in 10-inch-wide format will appear quite different when enlarged five times to 50 inches. We must be aware of this and be prepared to make adjustments to the composition to maintain the intended design.

Standing back and viewing your progress at a distance is always a helpful practice, but in large- to grand-scale paintings, it is a requirement. You simply cannot judge the drawing, proportion, or color of a large painting at close range. Some artists force themselves to stand back by placing their palette tables at the other side of the room. They approach the painting to make a stroke and then walk back across the studio to evaluate the effect of that stroke and mix more color.

In addition to these perceptual issues, scale can have a physical effect on your work. Recently, one of my students, who up to that time had only worked outdoors, told me he was making his first attempts at large paintings. He said he was trying to keep the same level of spontaneity he was able to achieve outside in his small studies, but he seemed to be having trouble. My advice: Don't even try to make them do the same thing.

There are some artists who are able to transpose the spontaneity and expressive brushwork of small works into larger studio pieces, but for most painters, this is not something that comes naturally. In my experience, larger, time-consuming studio paintings and plein air works are different experiences that require different approaches. They are subgenres of the landscape motif. The small work does things the large painting cannot, and the large painting achieves things not possible in the small. Both approaches should be respected for their differences.

Working large also requires an expanded awareness of your paint, your brushstrokes, and your movements. For some artists, considerable inertia must be overcome to do this. While you may use dime-size daubs of paint in plein air work, you'll need to squeeze out half-dollar-size daubs for larger paintings, *especially* if you hope to infuse into the painting some level of painterliness. If 4-, 6-, and 8-size brushes were used for small work, then brushes at least twice that size would be needed for the larger painting. Using more paint and using it generously can take some courage.

### GRADUATING TO BIGGER

As the largest subject in the world, the landscape begs to inhabit a large canvas. In response, students often push themselves to do larger pieces before they are ready and then face technical problems that distract them from fundamental issues like composition and paint handling. The paradigm shift required for large-scale paintings is best approached in gradual steps. Scale certainly holds great sway over a work's final impression, but it is by no means the most defining quality of a painting. A small painting can appear monumental. Whatever the size of your painting, a solid foundation of composition, organization, and color always reigns supreme.

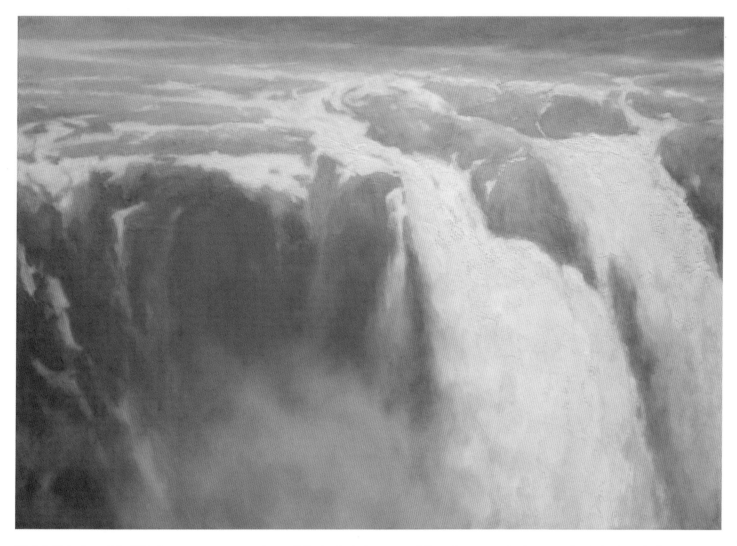

Mitchell Albala, *August Falls*, 2007, oil on canvas, 26 x 36 inches (66.04 x 91.44 cm)

*August Falls* clearly depicts a waterfall, yet from an aesthetic perspective, it is primarily about patterns and shapes. A compositional study was done, but differences in scale between a small study and a three-foot painting are such that final placement of shapes and values can only be assessed properly in the large-scale version. Note the difference between the initial underpainting on page 133 (based on a small study) and this final painting.

A bit of advice, don't copy nature too closely. Art is an abstraction; as you dream amid nature, extrapolate art from it and concentrate on what you will create as a result.

—PAUL GAUGUIN

# STUDIO PRACTICAL

Although the indoor studio is more convenient and comfortable than working on location, it has its own set of challenges. As with plein air painting, there are many practices, from studio lighting to handling larger quantities of paint, that can make the workflow smoother and get you in alignment with the creative process.

## STUDIO LIGHTING

Good studio lighting provides two things: *enough* light and a relatively *balanced* light between the canvas and palette. In a perfect world, we would all have spacious studios with large windows and a steady north light. In reality, many of us, including some of the most successful painters, must rely on artificial light.

The best interior lights are those that produce a bright, diffuse light. Diffuse light remains relatively equal on the palette and canvas. Floodlights or track lights tend to cast a strong beam, which produces shadows and uneven lighting. Daylight-balanced fluorescent bulbs, however, are an economical and efficient way to create natural, diffuse light throughout your workspace.

In lieu of fluorescent lights, a pair of tall floor lamps, with reflectors facing the ceiling, can work well and take up very little floor space. They bounce a great deal of light off the ceiling, thereby creating a diffuse light. Position the lamps forward of the easel and several feet from either side of your position. Keep in mind that with any indoor arrangement, it's important to have light or neutral-colored walls. Colored walls will reflect their color back onto your painting.

## MANAGING PAINT IN THE STUDIO

The way you work with paint in the studio will obviously differ from the way you work with it when painting on location. Just as the size of the painting can scale up in the studio, so too does the palette and the quantities of paint you use.

In the studio, it is good to have as large a palette as possible. This is one of the places in which a limitation of the tool can result in a limitation in style. A small palette with small daubs of paint will inhibit you from the bigger moves (both physically and mentally) you need to make. My own palette is 19 x 25 inches, and some artists' palettes are much larger.

In long-term studio paintings, for which I use certain sets of colors for many weeks, I often mix up a large batch of

color to last me several sessions. After each session, I save the colors on a small 4-inch piece of glass, wrap it in plastic, and store it in the freezer. Larger batches of paint can also be stored in empty paint tubes, which can be purchased at most major art supply stores. An additional benefit: If the painting gets scratched or damaged, I have the exact "touch up" color labeled with the name of the painting.

A studio painting done over the course of days or weeks often requires many changes. If you are considering making a big change to your studio painting, or want to test a new color or value without actually committing it in paint on the canvas, cover all or part of the dry painting with lightweight acetate sheeting. This allows you to test your changes without losing the present version of the painting.

**Stiffening paint.** In the studio you also have more time to manipulate the consistency of the paint. Professional grades of oil paint have a consistency appropriate for most applications; however, many are too soft to be effective for building texture that really holds its shape. You can make the paint stiffer by extracting some of the excess oil. Spread the paint thinly onto cardboard; in ten to fifteen minutes, the excess oil will be absorbed by the board (seen as a darker ring around the paint). The intent is to absorb some of the oil, enough to make it firm and puttylike, but not so much that it isn't workable. To use, scrape the paint off the cardboard with your palette knife and place onto your palette.

## COLOR TEMPERATURE

Have you ever noticed how good your painting looks in one light but then looks very different in another? This is the result of variations in the color temperature of light. Temperature is rated in kelvins. Classic incandescent bulbs are warm yellow, between 2,800 K and 3,300 K. Daylight is considered optimal for artists, ranging between 5,000 K (warm daylight) and 6,500 K (cool daylight). At one time, most fluorescent bulbs were extremely cool and were therefore unsuitable for studio lighting; however, they are now available "full spectrum" daylight balanced.

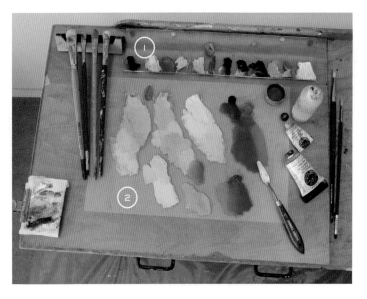

**Invest in palette real estate.** This palette demonstrates two helpful strategies: **(1)** To preserve paint, I don't squeeze colors directly onto this stationary palette; instead, I place colors on a 3 ½ x 18–inch, ¼-inch-thick glass slab. When the painting session is over, I cover the slab in plastic wrap and place it in the freezer. This delays the drying of the oil by many days, if not weeks. **(2)** To customize my palette to my project, I place a square of colored paper beneath it (in this case pale blue); the transparent glass allows me to effectively change the color of the palette by inserting different colors of paper beneath it. Selecting paper that is close to the overall color tone of your painting will make mixing and matching colors easier.

**Use acetate for testing.** A temporary acetate cover allows test changes to easily be wiped away, and once you are satisfied, you can remove it and save it as reference. If you are just trying to match an existing color within the painting, you don't need a whole sheet. Simply hold a small piece of acetate against the canvas and test your color mixes on that.

**Keep a color formula book.** A color mix is a precious thing. You may spend a lot of time mixing the right color or discover a wonderful color that you want to remember how to mix. Write down the name of the painting, or draw a thumbnail, and then indicate to which areas of the painting the color swatches correspond. Next to each color, write down the pigments you used in the mixture.

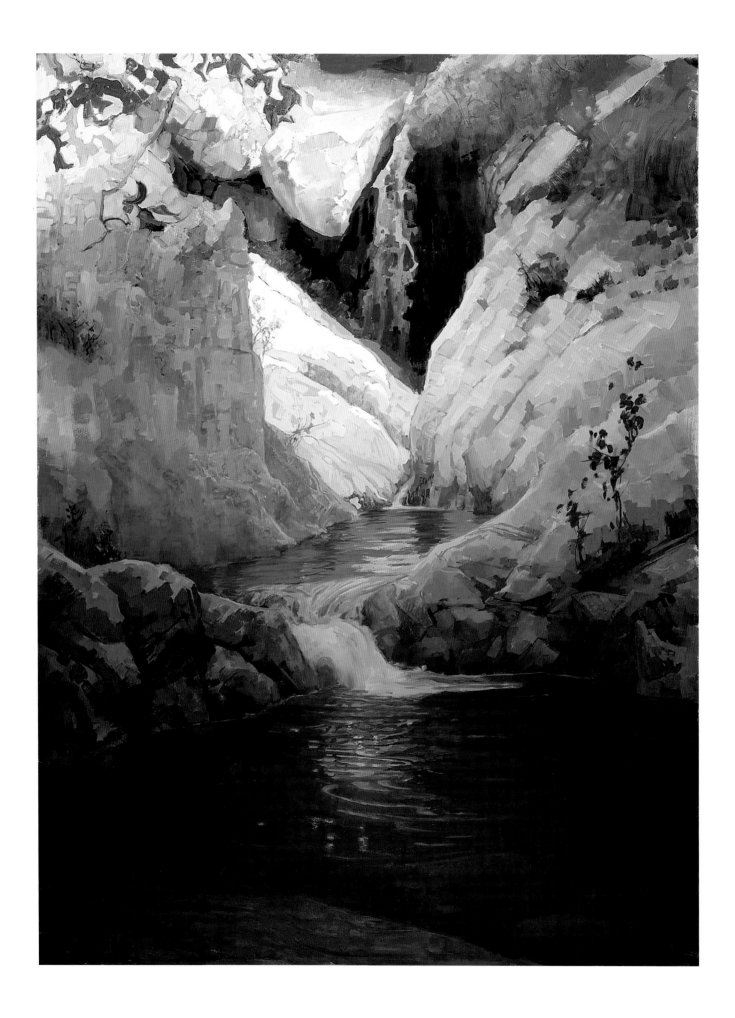

CHAPTER FOUR

# VALUE RELATIONSHIPS

When it is dark enough,
you can see the stars.

—RALPH WALDO EMERSON

Before we begin our exploration of the essential lessons of landscape—simplification and massing, site selection, composition, and color—we must cover one component of the visual language that touches every aspect of our practice: value relationships.

*Value* refers to the relative lightness or darkness of any given area within a drawing or painting. Value relationships are the primary means through which we achieve *differentiation*—the ability to distinguish one shape from another—in both in the real world and in the world of our canvases. The shapes and patterns made by value differences also help form the underlying framework of the composition. What's more, value differences across the surface of a form (light and shadow) are responsible for generating the important dimensional cue of volume. Without the contrast created by value differences, we would see nothing; our drawings and paintings would appear to be flat, formless voids. In this sense, values may be considered the building blocks of form and space.

Peter Adams, *Pools Above Sturtevant Falls—San Gabriel Mountains*, 2009, oil on panel, 40 x 30 inches (101.6 x 76.2 cm). Courtesy of American Legacy Fine Arts, LLC

Value relationships are the building blocks of form and space. They are the essential means by which the painter is able to differentiate one form from another. When properly balanced, value relationships lend a sense of veracity to a painting and contribute to a sense of drama, as they do in *Pools Above Sturtevant Falls*. The light and dark value patterns also form the underlying foundation of the composition.

# VALUE BEFORE COLOR

Among painters there is often a lively debate as to what is of greater importance—value or color? To be sure, some painters use an approach that places a higher priority on value, while others use an approach that places a higher priority on color—*but one is not more important than the other*. (See also the section on value-priority and color-priority systems on page

114.) A convincing illusion of light requires a delicate balance between value *and* color; they are *interdependent*. However, if the value relationships are not properly modulated, it will be difficult—if not close to impossible—to get the color to work. This is why painters typically work out value relationships first. Value can perform without color, but

color always has value as one of its attributes. For instance, a black-and-white drawing or a monochromatic underpainting can create a perfectly readable image even though it has no color in the traditional sense. But a color painting of the same subject has both a color *and* a value identity.

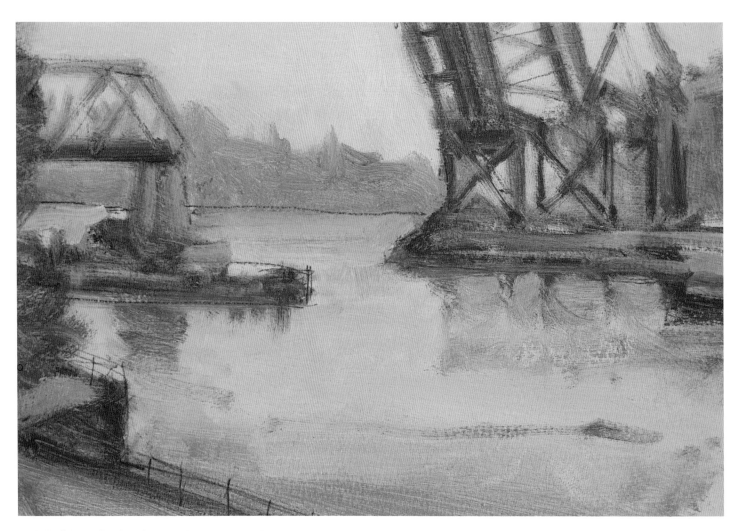

Mitchell Albala, *Trestle at the Locks*, 1999, oil on paper, 6 x 9 inches (15.24 x 22.86 cm)

Neither color nor value alone can achieve a convincing sense of light and space; both are required. In *Trestle at the Locks*, the effect of a sunset is achieved through contrasts of color and value. The darker values of the bridge define its structure and make it stand out against the sky. And the effect of the yellow sky at sunset is heightened because it is poised against the darker values of the bridge.

# LIMITED VALUES, UNLIMITED POSSIBILITIES

One of the most important things to understand about value relationships is that the range of lights and darks found in nature is far greater than what is achievable with our pencils and pigments on a surface. Painters only have the darkest dark and whitest white to express a range that is, in fact, much wider and more brilliant. Artists cannot replicate the actual range of values produced in nature, but they can condense the seemingly infinite choices into a narrower range that is quite capable of expressing the effects of light and spatial relationships. Reducing the number of values and organizing them into groups is key to reducing nature's complexity into more readable shapes and patterns.

## THE ART OF COMPARISON

Values can never be judged in isolation. They can only be judged in the context of other values. Painters are constantly comparing. Is the ground lighter than the trees? Is the hill darker than the sky? How does the light side of the bush compare with the shadow side? How do their values compare to those that surround them? Naturally, we begin assessing the values in our painting by referencing the objects we see in the landscape, but the real fine-tuning of value relationships takes place in the painting itself because it is there that we see all the values relative to one another. Ultimately, judging values is not a matching exercise between subject and painting; it is a comparative exercise among the values within the painting itself.

### PLANES

Planes are an essential key to working with values and simplified shapes. A plane is simply a flat surface. Planes can easily be seen in forms like flat ground, streets, or the sides of a building. However, one of the ways artists try to make sense of more complex forms is to look for planes *on everything,* even the irregular and rounded shapes found in nature. This can require some visual extrapolation because the planes within a cloud, for instance, or a cluster of leafy bushes are not very obvious. Fortunately, planes leave clues: *Where a plane changes, there is a corresponding change in value.* When studied carefully, the value changes reveal valuable information about the structure and shape of the form. Conceptualizing surfaces as having planes embeds a structure that helps us map the patterns of light and dark.

**Value scales.** The human eye is capable of discriminating a large range of values. Trying to choose from among so many values, however, would be nearly impossible. Instead, painters reference a much narrower set of values to make identifying levels easier. The 10-step value scale allows for enough shades to render even the most sensitive subjects, but not so many that it becomes hard to make choices. Of course, in the later stages of a painting, the painter can create intermediate values between each level and end up with more than ten values. A 4-step value scale is particularly appropriate for understanding the basic value divisions in the landscape and a great way to force the eye to see basic shapes.

**The relativity of value.** Trying to control value introduces us to a phenomenon we experience constantly in painting: Everything is relative. In the two swatches above, each of the inner squares is the same value, but when surrounded by lighter or darker values, they *appear* to be different. Because of this perceptual phenomenon, finding the appropriate value is always about comparing two values side by side. This effect can also be seen in the 4- and 10-step value scales to the left. Notice that along the seams, where one value ends and the other begins, there is a subtle dark halo to the right of the seam. Of course, each swatch isn't really darker; it is an optical illusion created by the contrast with the adjacent value.

# VALUE DIVISIONS IN LANDSCAPES

Reading values in the landscape is somewhat different from reading values in other subjects. All subjects have a light source, but the light source in landscape—the illuminated dome of the sky—is *part* of the subject. This often leads students to not establish enough contrast between the land and the sky, which is almost always the greatest value contrast in the painting. This, in turn, leads to an incorrect reading of the ground plane, which is then made too light. If these basic divisions get mixed up, it becomes very difficult to maintain a convincing sense of landscape light.

Landscape values are easier to understand if they are viewed as falling into four major divisions, or *zones*. In his classic *Carlson's Guide to Landscape Painting*, John F. Carlson lays out his Theory of Angles. The theory essentially says that major landscape elements—such as ground, trees, and hills—are on different planes. The angle or slope of the plane in relation to the sun determines how much light it receives, which in turn determines its value. For example, the flat ground, being directly under the sun, receives the most light (after the sky), while other elements that are more upright, like trees and hills, receive less light and are therefore darker in value.

Of course, these value divisions are not at all absolutes. There is some overlap between the divisions. For instance, there are times when the lightest values found on the ground will certainly compete with the value found in the sky; at other times, the light side of a tree will be the same value as the ground. There are also extraordinary conditions that defy the zones entirely: snow or desert scenes, in which the ground can be lighter in value than the sky; the sunstruck side of a light-colored building; or the sunburst that breaks through dark clouds and strikes the ground after a storm. The point is that in knowing how the value divisions *generally* apply to the landscape, the value zones in any landscape circumstance can then be correctly analyzed.

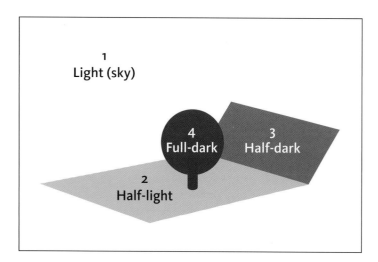

**Value divisions in the landscape.** Landscape values fall into four broad value divisions: light, half-light, half-dark, and full-dark. Although not an absolute formula, the divisions are consistent enough to serve as a reliable way to check value assignments at the start of a painting. There is also some overlap between the divisions, but the *overall* value of the sky remains lighter than the *overall* value of the land. **(1) LIGHT (SKY):** The sky is almost always the lightest value zone in the landscape and accounts for what is usually the largest value contrast in the painting: that between the sky and the land. This holds true even on cloudy or overcast days. **(2) HALF-LIGHT (HORIZONTAL PLANES):** The ground is a horizontal plane. Being directly under the sky, it receives more light than upright elements, like trees and hills, but it is still darker than the sky. **(3) HALF-DARK (SLANTING/SLOPING PLANES):** The next darkest zone is the slanting planes, like hills. Half-dark planes receive less light than the ground and are, therefore, darker than the ground but lighter than more vertical elements. **(4) FULL-DARK (VERTICAL PLANES):** Vertical elements, such as trees and architecture, receive the least amount of light and so are usually the darkest values in the painting. Upright elements, of course, can be made up of two or more values: a light side and a shadow side. Depending on the color of an element, its light side may be close in value to the slanting planes or the ground plane.

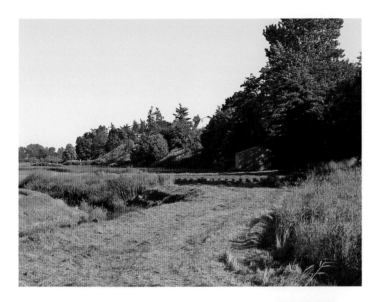

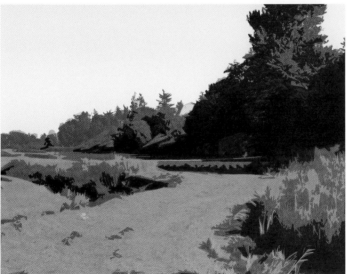

**Value zones.** When a colored scene is converted to black and white, it is easier to see how the overall scene breaks down into roughly four value zones. Overall, the largest value contrast is between the sky and everything land related. The ground plane, as seen in the plowed track that enters at the bottom, is darker than the sky but much lighter than the trees. As upright elements, trees receive the least amount of light and so are relatively darker, especially on their shadowed sides. Observe how the value shifts within each of the major zones never vary so much as to break with the continuity of the overall zone. For example, there are lots of small value differences in the plow track, but they remain contained within the overall value of that area.

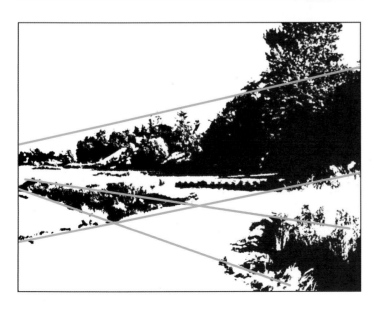

**The value plan.** Light and dark values create shapes and patterns that serve as the underlying framework of a composition. These patterns determine how the major shapes are distributed within the picture plane and how the eye will be directed through the composition. The value plan synthesizes the many values into large, simplified areas of black and white, positive and negative. The overall composition ultimately comprises a few major shapes organized into major and minor passages. The value plan of this scene reveals one large mass and two smaller masses. The green lines indicate the diagonal paths that direct the eye from the lower right corner to mid-left and from mid-left to the upper right. The eye naturally attaches itself to a few large shapes of differing proportions more readily than lots of small, uncoordinated spots of light and dark.

## CONTINUITY WITHIN VALUE ZONES

Another benefit of value zones is their ability to act as *containers*. Although there may be many smaller value shifts within a zone, they never vary so greatly as to break out of the overall zone. For instance, in a grassy field there might be subtle light and dark passages. If those contrasts become too strong, if they separate too much from the *overall* value of the field, then the cohesiveness of the value zone will be disrupted. While there may be intermediate values within the main zone, these smaller value shifts are always subordinate to the overall value zone.

This idea of smaller parts being a subset of a larger part is a principle that can be seen in many areas of painting. In the next chapter, this principle will be applied to shapes: The development of big shapes and masses comes first, while smaller shapes are always subordinate to the larger ones. The principle is seen in color, as well: There can be myriad colors within a plane or zone, but if colors diverge too much, the cohesiveness of that color zone is disrupted.

## VARIATIONS IN LOCAL COLOR

When making value comparisons, be aware that some things are simply darker in color than others. This means that when modeling landscape elements from light to dark, the range of values is not the same for every object. For example, a dark evergreen tree might be modeled using values 7, 8, and 9 (referencing a 10-step value scale). A golden autumn tree, having much lighter-colored leaves, might use values 4, 5, and 6. It is rare that a landscape element would be modeled from extremely light, or white, to extremely dark, or black.

---

TIP: Squinting is a fantastic way to assess value relationships. Squinting naturally eliminates both details and the smaller shifts in value, which helps you comprehend the large value zones. If something disappears when you squint, it is probably not worth including.

---

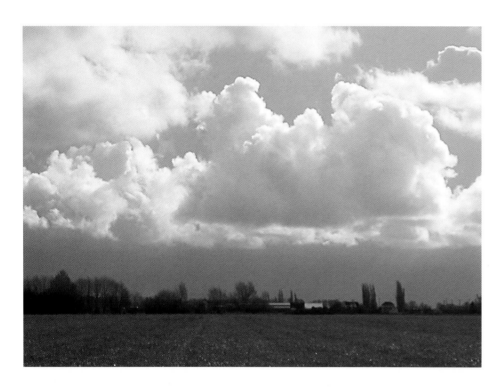

**Value zones in clouds.** There often appears to be a strong contrast between the very light tops and the shadowed undersides of clouds. *Overall*, however, the clouds—even with their strong value contrasts—are still lighter than the *overall* value of the ground.

All artistic discoveries are discoveries not of likenesses but of equivalencies which enable us to see reality in terms of an image and an image in terms of reality.

—ERNST GOMBRICH

**Intensity vs. lightness.** A common error in selecting values is interpreting intense or bright color as a light value. The sunstruck red barn is so intense in color that it gives the false impression of being lighter in value that it is, which might lead the painter to make it lighter in value than the sky. The black-and-white version shows that although its *color* may be intense, its value is darker than the sky. This is why it is important to be able to identify values separately from color.

CHAPTER FIVE

# SIMPLIFICATION AND MASSING

I never succeed in painting scenes, however beautiful, immediately upon returning from them. I must wait for a time to draw a veil over the common details.

—THOMAS COLE

At a recent workshop, several students pointed to a cottonwood tree that was gently swaying in the breeze. "How are we going to paint all those leaves?" they asked. "Don't paint the leaves," I answered. "Paint the large shapes of light and dark that the leaves create." One of the fundamental truths the artist-as-transla-tor learns is that larger, simpler shapes and masses convey the essence of a sub-ject better than its details. In fact, if the essential practices of landscape painting were ranked in order of importance, simplification—the ability to translate na-ture's complexity into fewer and more readable shapes and patterns—would be at the top of the list. As we study the different types of scenes the landscape offers, it becomes clear that, majestic and inspirational though they may be, they can have a lot of detail and appear quite disorganized. Simplification and massing bring visual order out of chaos and create clarity from ambiguity.

Marc Bohne, *Where the Rabbits Are*, 2005, oil on panel, 20 x 18 inches (50.8 x 45.72 cm)

Although a landscape painting may be complex and filled with many details, it is fundamentally an arrangement of simplified shapes and masses. The impact of *Where the Rabbits Are* is achieved in large part by dividing the composition into a few shapes of simplified values. Smaller notes, such as the various spots of color within the trees on the right, remain subordinate to (by being contained within) the larger shapes.

# LESS IS MORE: FINDING ORDER THROUGH SIMPLICITY

Simplification and massing are the ultimate perceptual exercises for the landscape painter. Painting or drawing a shape is not difficult, but *seeing* a shape through layers of surface detail and complexity requires a practiced shift in perception—an ability to see the forest *and* the trees, which is not our natural tendency. As visual translator, the artist must anticipate how all the information presented by the landscape will be compiled within the painting and perceived in the mind of the viewer. This is the most important task for the landscape painter: to reduce *surface story* to its lowest visual common denominator and, in doing so, actually give expression to an aesthetic that transcends detail and story.

Those new to interpreting the landscape often think they are compromising when they reduce the scene to simple components. Yet it is through simplification and the orchestration of a few major shapes that a forceful visual message is created, not through a profusion of detail. By finding and importing basic shapes and patterns into paintings, form and structure become more apparent, and the painting becomes more comprehensible to the viewer. It is easy to paint a thousand points of light with a thousand brushstrokes. It is much more difficult—and infinitely more eloquent—to paint a thousand points of light with only one hundred strokes.

## PLANES: A KEY TO MASSING

An understanding of planes can help painters identify shapes and masses within the landscape. A plane is simply a flat surface. Planes are easy to see on flat ground, streets, and architecture, but they can be harder to discern within the many curvilinear and irregular forms found in nature. Fortunately, planes can be detected by observing that where a plane changes, there is also value change. As you analyze a scene, you not only evaluate value and color, but you consider how each value and each color corresponds to a plane. Look carefully and see if different areas, in part or in whole, fall within a generalized plane. Later in the chapter, several exercises are presented that will help train your eye to see planes and the simplified shapes to which they correspond.

---

TIP: Squint some more. As noted in the chapter on value, squinting naturally groups values together and makes distracting details disappear. Squinting is also an effective way to see basic shapes. The simplified shapes and patterns revealed by squinting are more representative of what you are actually trying to capture. If you are nearsighted, take a peek at the landscape over the top of your glasses. The blurriness has a similar coalescing effect as squinting.

---

## HOW MUCH DO YOU NEED TO SIMPLIFY?

You rarely get into trouble by simplifying too much, but you can easily get into trouble by not simplifying enough. This is not to say that detail should be shunned. When judiciously used in the right amounts, it can be an essential ingredient in a painting. Details can add interest or draw the eye to a particular place. The problem arises when detail is treated as the be-all and end-all, without an appreciation of the underlying foundation. Detail can be used to great effect if it remains subordinate to the overall value relationships and masses.

Tim Horn, *New Day*, 2008, oil on panel,
12 x 16 inches (30.48 x 40.64 cm)

In the tradition of Fairfield Porter, Tim Horn has a keen ability to synthesize the complexity of landscape into flat shapes and planes. Architectural forms naturally lend themselves toward being described with planes, yet Horn converts foliage in the same way and still creates a convincing sense of form and space. Horn reduces forms to their most fundamental shapes, eliminating all but the most essential details. As different as *New Day* appears from Michael Stasinos's *Wintonia Hotel* (page 61), both paintings rigorously maintain clear planes and value zones. Horn simply includes less detail within each shape and plane.

Nature can afford to mix things up. But a picture must be an ordering
of the material into masses. We must have design in a picture even at the
expense of truth.

—JOHN F. CARLSON

Michael Ferguson, *Lila Tarn*, 1999, acrylic on canvas, 45 x 55 inches (114.3 x 139.7 cm)

Michael Ferguson uses the properties of the acrylic medium to his advantage. Acrylics dry fast and have a tendency to create strokes with sharper edges, a quality he uses to create clearly defined, individuated shapes. Like shards of stained glass, his shapes come in all sizes, yet the smaller ones are always grouped with, and remain subordinate to, the larger masses. For instance, in the background trees and in the foreground grasses there are many small, vertical strokes contained within the larger shapes.

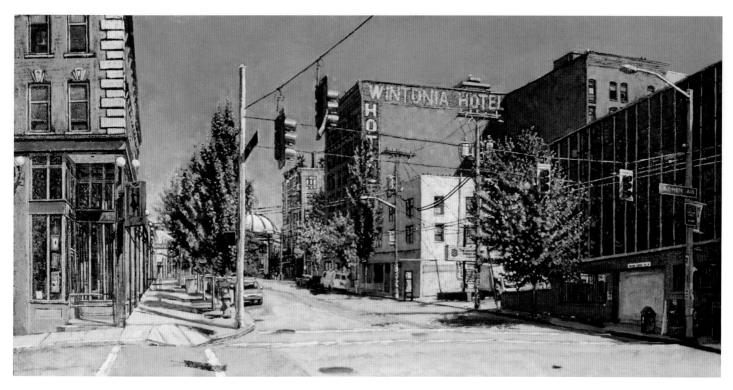

Michael Stasinos, *Wintonia Hotel*, 2003, oil on canvas, 18 x 30 inches (45.72 x 76.2 cm)

*Wintonia Hotel*, with all its detail, may seem like a surprising choice for a lesson in this chapter; yet the painting demonstrates a crucial principle about simplification and massing: Detail is always subordinate to larger shapes and values. Stasinos features telephone wires, windowpanes, letters on street signs, and individual leaves, yet these details are always contained within the bigger shapes and planes. Planes serve as containers for values and colors. There are value and color variations within the planes of the street and buildings, but they never vary so much as to disrupt the continuity of the plane; value zones are firmly maintained. Even the trees, comprised of many small dots of color, group together into general patterns of light and dark.

Art . . . should simplify. That, indeed, is very nearly the whole of the higher artistic process; finding what conventions of form and what detail one can do without and yet preserve the spirit of the whole.

—WILLA CATHER

# INTERPRETING SHAPE AND MASS

Understanding the importance of simplification and massing, even seeing them demonstrated in a successful painting, is not the same as personally experiencing the translation of a complex scene into a simpler set of values and shapes on the canvas. The exercises here provide you with that necessary hands-on practice. Exercise 1 asks you to define basic shapes through lines and contours. Exercises 2 and 3 encourage simplification through the use of a limited set of values. The goal of these three exercises is not necessarily to create realistic renditions but to induce the perceptual shift that is necessary for simplification, which is the basis for landscape painting. These exercises are not easy, but they are extremely valuable. The restrictions they impose force you to carefully analyze the forms you see before you and then figure out how to convey the most visual information with the fewest shapes possible. In many instances, you will have to combine certain elements or values together and eliminate others. The exercises can be done for any subject you want to understand better. You will find it helpful to do more than one of the exercises, as each exercise will illuminate the subject in different ways.

**Source photographs.** It is easier to do these exercises in the studio, using a good reference photograph, than on location. You'll be able to consider your choices more carefully and not have to worry about the changing patterns of light. Use a photograph that has ample value contrasts, with forms that have a clear light side and shadow side. (See chapter 6 for tips on choosing appropriate subjects.) If the original photo is in color, convert it to black and white using image-editing software or by making a black-and-white photocopy.

## EXERCISE 1:
## LINE DRAWING

Lines can offer an effective way to analyze basic shapes. This first exercise asks you to outline the shapes you see, add contour lines, and delineate planes wherever possible. If you have ever studied sculpture or figure drawing, you may be familiar with the way irregular and curving forms can be converted into planes to better understand their basic structure. The same practice can be applied to landscape forms.

Begin by outlining the major shapes with exterior contours. In this example, they are the two trees atop the knoll, the overall ground plane, and the dark grasses in the lower left. Don't try to trace the irregular, foliated edges of the landscape forms; use simple straight and curved lines, and exclude minor details and shapes that would distract from the main masses. Next, try to describe the dimension of the forms using interior contour lines. In each of the two trees, lines are added that describe the volume, or *roundness*, of the trees. There is also a line that roughly corresponds to the division between the light and shadow, which can be helpful in defining where planes change. It is important to note that interior contour lines are often *implied*. You may not actually *see* the line in the scene, but the line you draw attempts to describe your understanding of how the form is shaped.

Although the slope is largely flat, I used lines that act like a grid on its surface. A line isn't drawn for every indentation or bit of foliage on the ground but just the ones that imply the curvature and perspective of the slope as it advances upward.

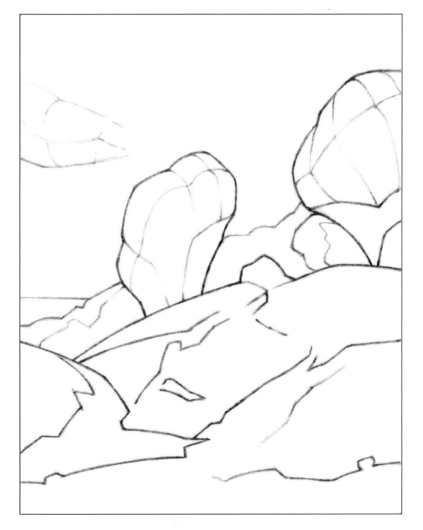

**Strategy.** This exercise is easier if you trace the photograph onto a sheet of tracing paper. This allows you to focus more on actual shape conversion than on accurate drawing. This drawing uses two types of contour lines: *exterior* contour lines, which delineate the outer edges of a form, and *interior* contour lines, which describe a form by plotting a path across its surface, like latitude and longitude lines on a globe.

## EXERCISE 2:
## FOUR-VALUE PAINTING

In the previous chapter, we learned that painters could achieve effective results even when using a narrower range of values than those observed in nature. Now we will see how a limited set of values can help us reduce a scene to its most fundamental shapes and planes.

This exercise uses the four landscape value zones introduced in chapter 4: full-light, half-light, half-dark, and full-dark. White paint corresponds to full-light and black paint to full-dark. Two intermediary values between black and white will also have to be mixed, for a set of four discrete values. *It is very important to mix the two intermediate values at regular intervals between the black and the white. If they are not evenly stepped, you won't achieve the full effect of the few values available to you.*

---

TIP: **If you want to reduce the harshness of black and white paint straight from the tube, add a tiny amount of black to the white mixture to make it a very light gray, and add a little bit of white to the black mixture to make it more like a charcoal gray.**

---

**Strategy.** Work on a surface of approximately 8 x 10 inches. The small size will discourage you from getting overly involved with details. In addition, this exercise works best if done with acrylic paint. Since acrylic dries quickly, it is easier to rework the shapes without muddying the edges.

Begin on a white gessoed panel or piece of paper. (If it helps, you can transfer the drawing done in Exercise 1 to the painting surface and use that as a starting point.) Block in the major shapes as you would at the start of any painting. As you assign values to different areas, think in terms of discrete flat shapes—*without any blending between values*, as if the shapes were paper cutouts. Working in this manner will force you to make choices: Which one of the few values available is the best choice for each value zone? Are the value differences within a single zone close enough to be grouped into a single value?

How can the landscape forms be described with as few shapes and planes as possible? For example, the trees in this scene are reduced to just two values: half-dark and full-dark. The slope is largely one value: half-light. And although the sky has some clouds and value gradations, it is converted to all full-light. Such choices may require deviating from the source photograph—shaping an edge for clarity or simplicity, leaving out an element that you see, or combining some elements. Be mindful of the patterns made by the flat shapes; the patterns they form direct the eye through the composition.

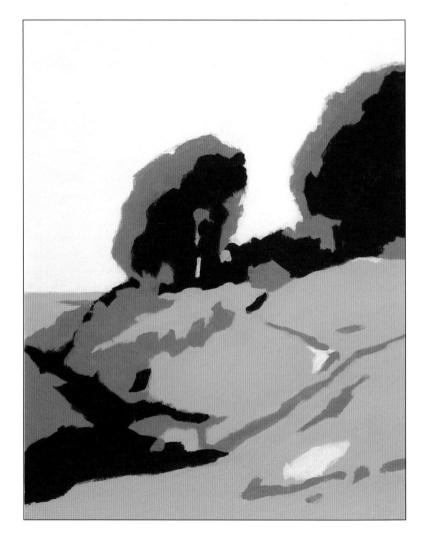

## EXERCISE 3:
## TWO-VALUE PAINTING
## OR DRAWING

As in the four-value painting, this exercise works with a limited set of values—but only two, black and white. Such strict value limitations require you to make even more choices about intermediate values than the previous exercise: Which values will fall into white, and which ones will fall into dark? This type of *high-contrast* rendering generates a strong graphic interpretation, making it an extremely effective way to explore the *value plan*, the light and dark patterns that form the underlying framework of a composition.

Begin by sketching in the darkest areas with the black value. Don't worry about getting the placement of the shapes perfect. This is an exploratory exercise. You will alternately add and subtract the black and white shapes to determine the placement of forms and, most important, the correct balance between light and dark areas. Generally, the values within the scene that correspond to the lightest areas will fall into white, and areas that correspond to shadows will fall into black. The challenge is determining what to assign intermediate values; many elements will either need to merge with the black or with the white. Be prepared to deviate

from the original in order to create an effective distribution of dark and light masses. In this example, the trees in actuality have a light side and a shadow side, but they are reduced to full-black. From a design standpoint, this creates a contiguous dark pattern that reinforces the diagonal movement along the ridge and then flows into the foreground along the right. The sky contains several value gradations in the photograph, but it must be reduced to all white. The sloping ground plane (which used four values in Exercise 2) has been reduced to all white, with just a few select darks to indicate the perspective of the slope.

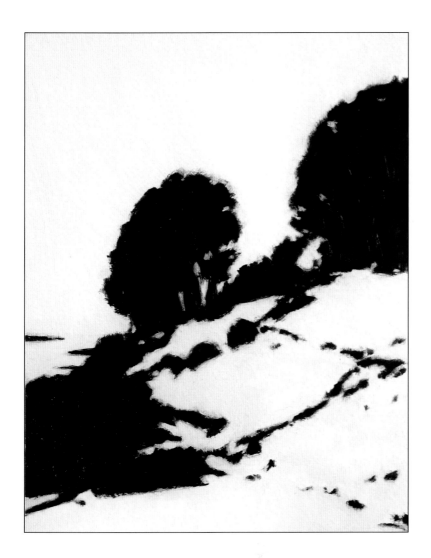

**Strategy.** This exercise is easier if done with acrylic paint, as it will allow you to rework the shapes and values with little blending of the edges. Work on a surface of approximately 8 x 10 inches. If you prefer, this exercise can be done as a drawing. Use a soft drawing tool, like a 2B pencil or charcoal, and definitely have an eraser ready!

# TREES

There are few things in the landscape that are as challenging to simplify as trees, and so they serve as an excellent demonstration of simplification and massing. They have so many leaves and so many branches growing in every direction, and they seem both solid and "unsolid" at the same time. Yet these troublesome forms can be simplified in the same way everything else is: by reducing the myriad details to basic shapes and value zones.

There is a wide range in how trees are painted, from the more realistic, in which the artist seems to capture every leaf, to the ultrasimplified, in which the painter reduces the tree to nothing more than a few smears of light and dark paint. As you study the various approaches, you will see the economy of information with which they are actually rendered. Each of the two examples here is painted in a different style, yet each reduces the complexity in the same way: by paying close attention to the outer contour of the tree and its edges and dividing the overall bough structure into two essential patterns of light and dark.

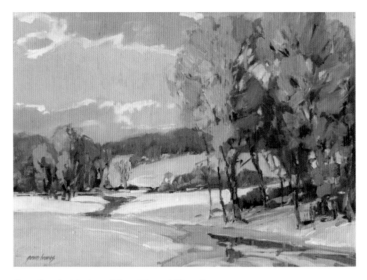

Gavin Brooks, *Mt. Carmel Farm Winter*, 2002, oil on canvas, 12 x 16 inches (30.48 x 40.64 cm)

Gavin Brooks's field study shows how trees can be rendered with an absolute economy of strokes. It is not how much detail is included but how well placed the few simple masses of light and dark are. Notice how in each of the two main trees on the right there are strokes in the middle of the form that distinguish themselves slightly from the surrounding tree. With color and edges, she is able to pull that part of the tree slightly forward and help imply the tree's roundness.

Craig Kosak, *Poplars*, 2006, oil on canvas, 14 x 22 inches (35.56 x 55.88 cm)

Kosak's tree portrait, executed in the studio, is "tighter" than the piece by Gavin Brooks, yet he creates a convincing tree structure using the same steps. The characteristic shape of the poplars is captured through the outer contour. The complex internal boughs are then reduced to two basic values. Last, the edges of the trees are perforated with "sky holes," giving the tree its "unsolid" and leafy quality that makes it look natural. Kosak also adds a delightful spin to the tree motif: As the trees recede into the distance, they get lighter and bluer. This exaggerated atmospheric perspective adds greater depth to an otherwise frontal view of the trees, and the bending adds an unexpected and haunting quality to the poplars.

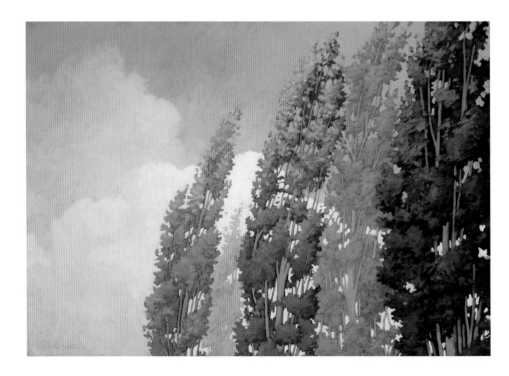

## TREE MASSING IN THREE STEPS

For this exercise, choose a tree with a good cross- or sidelight. When light strikes the tree from the side, the patterns of light and dark are much more distinct. Backlit and frontlit trees offer dramatic potential, but they lack the volume cues referenced in this demonstration. It is also easier to work from life, as opposed to a photograph; reality has many more dimensional cues than a photo, and these will be needed as you analyze the volume and shapes.

**Step 1 (right): Define the outer contour of the tree.** Each type of tree has a distinctive contour and posture that is essential in describing its character, much as capturing the overall shape of a person's head is in a portrait. Sketch in the outer contour, taking note of whether the overall tree is round, oval, shaped like an umbrella, irregular, or conical, like so many varieties of evergreen trees. Observe how the trunk inserts itself into the upper portion of the tree. If there are strong branches reaching into the interior, put them in.

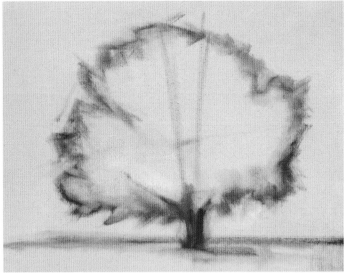

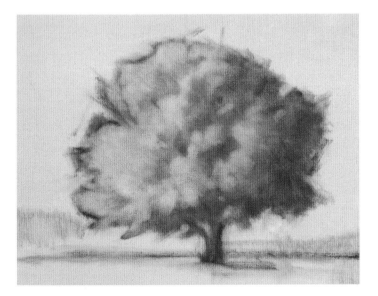

**Step 2 (left): Define the interior patterns of light and dark.** Within the overall contour you have defined, begin to sort out the light and dark patterns. At first, the interior mass of the tree may appear to be an irregular maze of patterns and values. Look carefully, squint, and try to distill the many varying shades into just two value zones. It is true that the tree is composed of many spots of light and dark, but like a pointillist painting, the many spots merge into larger patterns. There are some intermediate values between the overall dark and light patterns, but it is best to stick with two values as much as possible. This is the most difficult of the three steps and will take practice.

**Step 3 (right): Develop the edges and "sky holes."** The last step is to assert the tree's see-though appearance. The edges of trees are irregular, made up of many small points (leaves). In some areas, the sky can be seen through the branches. These areas are called "sky holes" and are extremely important in giving a tree its character. There are usually more sky holes toward the outer edges of the tree, but they can be present in the interior, as well, depending on the season and the density of the foliage. The sky holes should be slightly darker than the surrounding sky or background. If they are too light, they will pop forward instead of looking like a hole. Also, do not make the holes too sharp edged, as that will also make them pop forward. For a natural look, it is better to make a few choice sky holes than lots of tiny ones, which can look overworked.

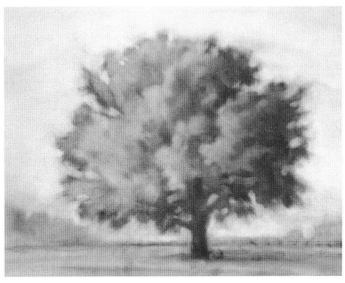

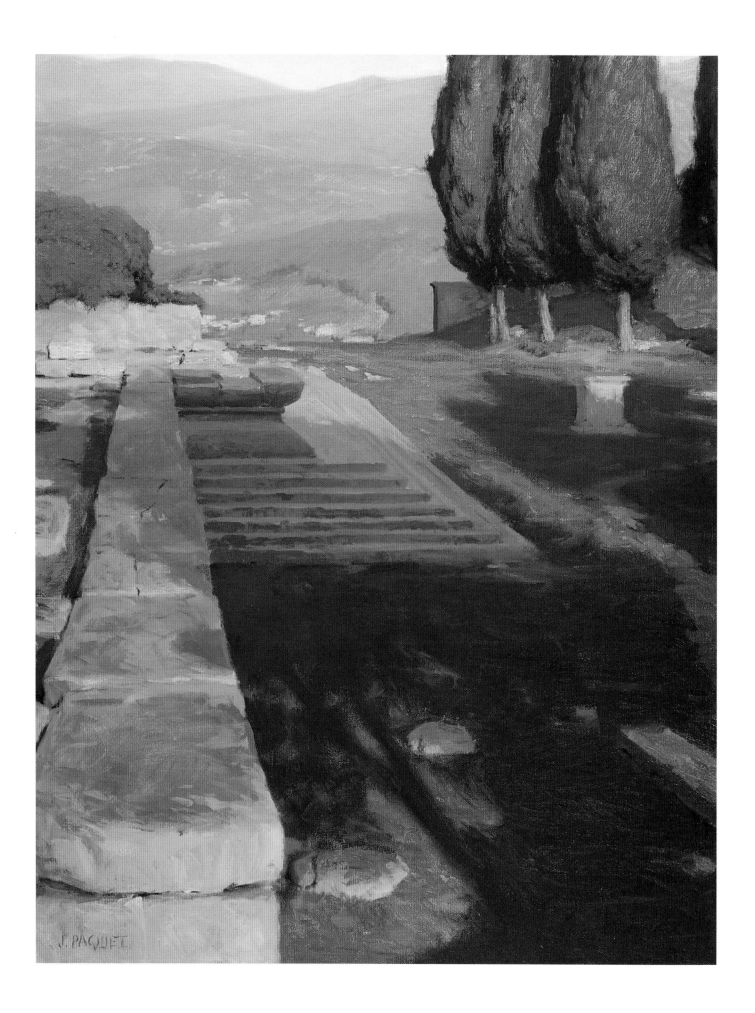

CHAPTER SIX

# SITE SELECTION

I devour nature ceaselessly. I exaggerate,
sometimes I make changes in the subject;
but still I don't invent the whole picture.
On the contrary, I find it already there.
It's a question of picking out what one wants
from nature.

—VINCENT VAN GOGH

The landscape painter considers many factors when choosing what to paint, not the least of which is subject matter and the level of inspiration it evokes. The landscape painter doesn't only evaluate the scene's beauty and narrative content but whether or not it incorporates the visual cues necessary to create an illusion of space within a two-dimensional painting. If it does, then the painter can move on to determining the best way to compose the subject. As you learn what to look for, you'll discover that few scenes present themselves in an ideal fashion. But as you cultivate an eye for *site selection* as you become familiar with the visual cues and how to identify them, then you will know which types of scenes to avoid and which types set you up for success.

Joseph Paquet, *Roman Temple Ruins*, 2008, oil on linen, 28 x 22 inches (71.12 x 55.88 cm)

A landscape painter's subject can be almost anything, but the choice is never arbitrary. A potential site must contain the types of visual cues painters rely on to differentiate forms and suggest depth. Strongest in the *Roman Temple Ruins* scene is the linear perspective, which pulls our eye *back*, deep into the space. Also essential is a defining crosslight (entering from the right), which creates clear patterns of light and shadow and suggests volume. Paquet also incorporates differences in scale, overlapping forms, and a clear middle ground, foreground, and background. Together, these cues organize the space and create a convincing illusion of depth in the image.

# SPATIAL CUES

When you look at a landscape, consider the following: Are there clear patterns of light and shade that create a sense of volume? Are there ample value differences to distinguish various shapes from one another, or do the forms merge into an ambiguous mass? A person's natural depth perception makes *everything* seen in the natural world appear dimensional. However, for a painting on a flat picture plane to convey a sense of depth, it must provide differentiation among the forms and include enough of the spatial cues painters depend on to create the illusion of distance in their work.

The first cue, patterns of light and shade, is arguably one of the most important ones. It generates the value contrasts that allow us to distinguish colors and shapes from one another. The other spatial cues are scale; overlap (interposition), a division of the composition or "landscape stage" into a foreground, middle ground, and background (which is a form of overlap); and linear perspective.

All painters look for these cues; however, finding and working with them in the landscape is particularly challenging. The light source in landscape, daylight, is completely inconsistent. As the sun arcs across the sky, the color of the light changes, and so do the shadow patterns. Nor can painters actually move elements around to catch the light better, as they can with a still life. What's more, the organic nature of landscape presents scenes that are quite disorganized and complex, making it that much harder to differentiate shapes and find their essential planes and masses. In other words, the very conditions landscape painters would love to impose on their subject—a consistent light source and a controlled arrangement of elements—are those over which they have little control.

**Building three-dimensional space with spatial cues.** In this sequence of drawings, the addition of spatial cues builds an increasingly three-dimensional composition. **(A) VOLUME.** A highly recognizable cue, volume gives solidity and dimension to forms through patterns of light and shadow. Yet the tree sits alone with no relation to the surrounding world, and so the scene lacks depth. **(B) VOLUME + SCALE.** A second tree is added. The change in scale suggests that the new tree is farther back than the first tree, which begins to imply depth. **(C) VOLUME + SCALE + OVERLAP.** Now the trees have a difference in scale *and* they overlap one another. A background is introduced, which both trees also overlap, heightening the sense of depth even further. **(D) VOLUME + SCALE + OVERLAP + PERSPECTIVE.** In the final image, the addition of subtle lines of perspective, in the form of fence posts and cast shadows in the foreground, leads the eye even deeper into the space. A clearer foreground, middle ground, and background are more obvious, as well. Not all these spatial cues will be present in every subject, but even a few can work together to build the illusion of a third dimension.

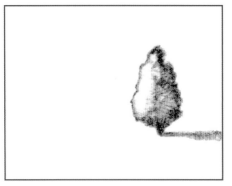

A. VOLUME

B. VOLUME + SCALE

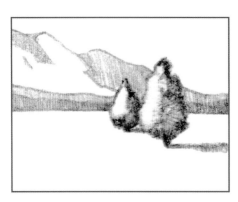

C. VOLUME + SCALE + OVERLAP

D. VOLUME + SCALE + OVERLAP + PERSPECTIVE

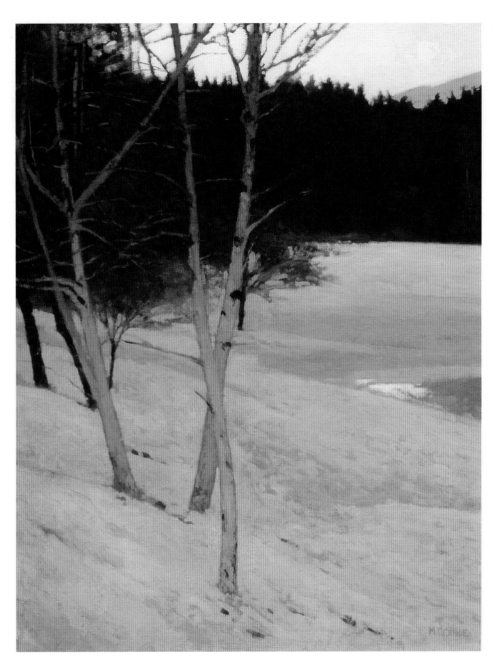

Marc Bohne, *Winter Evening*, 2002, oil on panel, 24 x 20 inches (60.96 x 50.8 cm)

## SELECTION THROUGH OBSERVATION

When we see a finished painting and marvel at the elegance of its composition, we don't hear the backstory of all the looking and searching that went into finding a site that had all the right cues. We don't see the many compositions that were considered before the final choice was made. Finding sites that translate well into painting takes practice. Good sites don't always jump out at you. When you arrive at a locale, spend some time really *looking* for the necessary visual cues. If what you see does not seem to offer enough cues, walk around the site to a different vantage point. Look through the viewfinder (see page 89), squint, and then look some more. Sometimes, the magic of a good subject can be unearthed by your keen skills of observation. At other times, your skills of observation determine that a subject is not viable and should not be attempted.

Spatial illusion in landscape painting is not an arbitrary occurrence. It is the result of carefully selected and well-orchestrated *spatial cues*. Bohne lays a strong foundation by reducing the composition to just a few major shapes—the sky, the dark trees in the background, the snow field, and the vertical trees in the foreground. Such a simply stated arrangement ultimately makes for a stronger visual impression than one comprised of many minor shapes. In this particular painting, the shapes themselves suggest little volume (an essential spatial cue); however, he is able to build a spatial illusion by relying on other cues: scale, overlap, and a well-defined foreground, middle ground, and background.

## PATTERNS OF LIGHT AND SHADE

Some of the most descriptive spatial cues are patterns of light and shadow. When sunlight strikes forms from the side, it creates a light side and a shadow side. This value difference models the form, creating an illusion of volume and solidity. Since the sun cannot be asked to hold still, and landscape elements cannot be repositioned to best catch the light, finding clear patterns of light and shade is largely a matter of painting at the *right time* and looking in the *right direction*.

**THE BEST TIME.** Because the sun is lower in the sky in the morning and in the late afternoon, more crosslighting occurs, and the light side and shadow side of forms are much more noticeable. This makes a *huge* difference in how well forms are differentiated. At midday, when the sun is overhead, the light stays consistent for longer periods of time, but volume-generating shadows are diminished. For example, forms such as trees are more top lit, and cast shadows are at a minimum. Compared to mornings or late afternoons, midday light is considered to be "flat." Colors may still appear bright, but there are fewer value contrasts, and there is an "even" quality to the light.

In the spring and summer, ideal times to paint are in the mornings, from sunrise until about 10:00 or 11:00 a.m., or in the late afternoons, beginning at 3:00 or 4:00 p.m. and until sunset. The sun is lower in the sky, and sidelit forms with defining shadows are more visible. Of course, these times vary depending on the season and latitude. Keep in mind, the closer you work to sunrise or sunset, the quicker the light changes. If the subject you're interested in is not receiving a good crosslight, try walking some distance to find a different vantage point. Sometimes just a few hundred feet puts you in a position to see a clearer crosslight.

Avoid positioning yourself with the sun directly behind or directly in front of you. This backlights or frontlights the scene, which hides form-revealing shadows and replaces them with flat, undifferentiated shapes. This is desirable with subjects such as dramatic sunrises and sunsets, but in most other situations, backlighting and frontlighting offer diminished cues for volume.

Depending on where you live, winter can be an ideal season to paint outdoors (if you can stand the cold and painting with your gloves on). Not only does winter offer a different palette of colors from spring and summer, but the sun is always lower in the sky, never directly overhead, so it casts desirable patterns of light and shadow for longer periods of time.

**WHERE TO LOOK: FACING THE RIGHT DIRECTION.** In the morning or late afternoon, you can find subjects with the best crosslight and shadow patterns in this way: Stand facing the sun and then extend your arms out, pointing in opposite directions. The directions you are pointing are the best directions to face when painting. They reveal the most crosslighting. If looking in those two directions does not show clear crosslighting on your subject, try changing your position. You can't move the sun, but you can walk around the subject to a position that reveals a better pattern of light and shadow.

**WHERE WILL THE SUN BE?** Pay attention to where the sun is headed. Say you have found a sunny spot filled with interesting shadows. Will the sun drop behind a tree in ten minutes, taking all your shadows with it? Similarly, determine if the sun is about to rise from behind a tree or building, which can change the light and shadow structure of the entire scene.

The real voyage of discovery consists not in seeking new landscapes, but in having new eyes.
—MARCEL PROUST

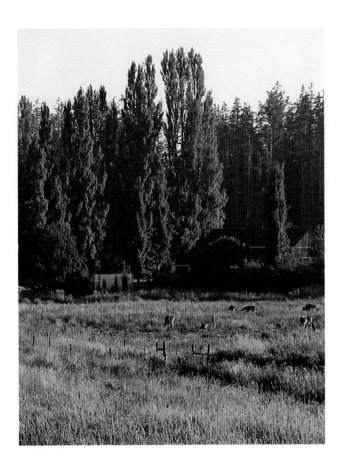

How I have walked . . . day after day,
and all alone, to see if there was
not something among the old things
which was new!

—THOMAS COLE

**Crosslight vs. flat light.** There is a remarkable difference between the way light falls on a scene in the morning or late afternoon and at midday. The image above shows well-defined cross- or sidelight. In the early morning, the light enters from the right. Because the sun is lower in the sky, it creates a much clearer light side and shadow side. The trees have more volume, and they stand out more. The crosslight also brings out more patterns in the foreground, which conveniently create perspective cues: The eye follows the dark furrow upward from the lower right to the left. The morning light also enhances color contrasts. A stronger cool-warm relationship is established between the overall mass of trees and the foreground. At midday (right), with the sun high overhead, the light is "flat." There isn't a clear crosslight, and volume-generating shadows are scarce. Patterns of light and shade are not well defined and don't inform the structure of the trees. As a result, the group of trees seems to sit on one plane. The field is uniformly lit, so additional patterns of light and shade, which might otherwise define its grooves and furrows, are lost. Although the colors are vivid, the entire scene has sameness. Could a successful painting be made out of this midday scene? Yes, but you would need to work harder to compensate for the weaker cues.

## OVERLAP (INTERPOSITION) AND SCALE

In terms of visual perception, elements overlapping one another (when part of their shape is obscured by one of the other elements) is one of the clearest ways to suggest space. Which element is in front and which one is in back is very clear. In real life, to the unaided eye, a solitary house alone in a field will appear quite dimensional. But in a flat picture, a solitary house *overlapping a tree* will suggest depth even better.

Scale, which is the relative size of elements, also communicates a great deal about an object's position in space. We readily perceive larger elements as closer and smaller elements as farther away. Whenever possible, try to find scenes that include overlaps and differences in scale. You don't necessarily need many to create a positive spatial effect.

## FOREGROUND, MIDDLE GROUND, AND BACKGROUND

Establishing a foreground, middle ground, and background is a tried-and-true method of organizing a composition into spatial layers; however, not every scene can be neatly organized into three divisions, nor are the divisions always clearly demarcated. Sometimes there are only two zones, sometimes more. If you train your eye to look for these divisions, you will begin to see potential subjects in a more structured way, even when they don't strictly conform to these standard divisions. Also, remember the sky! It isn't just a flat backdrop to the landscape stage. When treated properly—as a dimensional plane in its own right—it can serve as a strong background layer. (See page 76.)

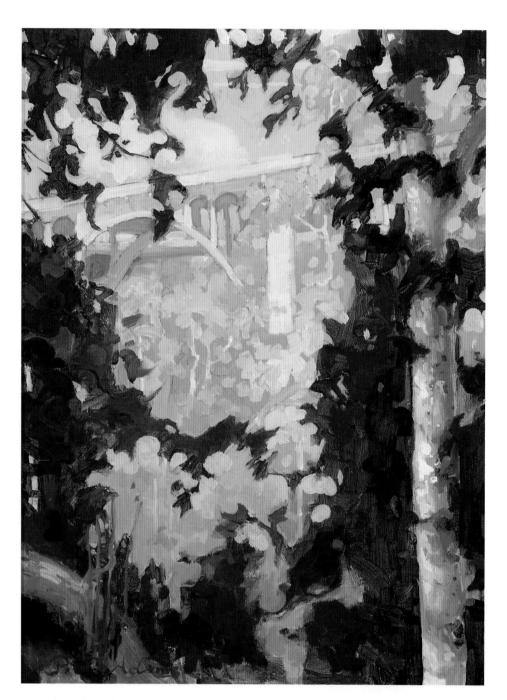

Peter Adams, *Foliage and Structure: Pasadena's Colorado Street Bridge*, 2008, oil on panel, 16 x 12 inches (40.64 x 30.48 cm). Courtesy of American Legacy Fine Arts, LLC

Peter Adams employs a classic compositional device to create a sense of entry and deep space. The dark ring of foliage around the edge of the picture window acts as a kind of portal that creates a heightened separation between the foreground and the background. What appears through the opening, in this case the Colorado Street Bridge, becomes the focal point of the composition. Edgar Payne (in his book *Composition of Outdoor Painting*) refers to this type of composition as the "O" or circle. The O may be circular, rectangular, or irregular.

## LINEAR PERSPECTIVE

Volume, scale, and overlap (including having a foreground, middle ground, and background) all support the suggestion of a third dimension, but none defy the flatness of the picture plane better than *linear perspective*. Linear perspective is the suggestion of depth as lines converge toward a vanishing point on the horizon.

Landscapes exert a strong horizontal energy with an enormous amount of content spreading across the painter's field of vision. This often leads the painter to not pay enough attention to the *forward* energy, to the movement that will carry the eye *into* the scene and not just across it from left to right. Linear perspective and diagonals, such as the classic railroad tracks vanishing into the distance, are very effective for this. The eye, following the linear cues, is drawn *into and through* the window that frames the composition.

You do not have to be an architect or know how to plot one-, two-, and three-point perspective to take advantage of linear perspective, nor does the perspective have to be as obvious as the railroad tracks. A road, a winding stream, a furrow in the ground, a fence, or even a few unconnected objects that align to form an eye path can often be all that's needed to carry your eye back at an angle. In terms of composition, diagonals are less stable than verticals and horizontals, and consequently, they suggest more movement and energy.

> Perspective is to painting what the bridle is to the horse, the rudder to a ship.
>
> —LEONARDO DA VINCI

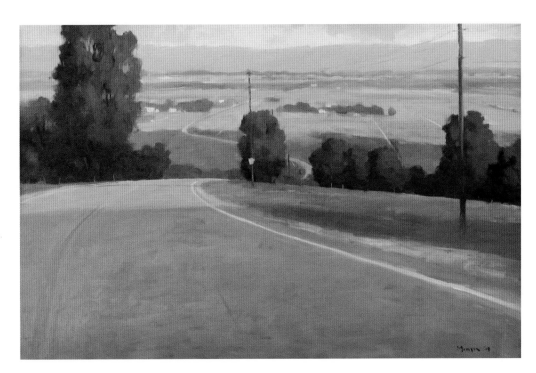

Terry Miura, *Into the Valley*, 2004, oil on linen, 24 x 36 inches (60.96 x 91.44 cm)

Of the various spatial cues painters may use to suggest depth in their landscapes, linear perspective is one of the most powerful. The wide, sweeping perspective of the road here in *Into the Valley* is like a magnet that strongly pulls the viewer *into* the picture window. The scale of the trees, the telephone poles, and the smaller shapes in the distance further support the sense of depth that is begun with the linear perspective.

## PERSPECTIVE AND DIMENSION IN THE SKY

The sky is one of the most influential components of the landscape—and one of the most underexamined. Students often treat the sky as nothing more than a flat screen of solid color that sits behind the land. In actuality, skies can be just as dimensional as the ground. The dimension of the sky can be implied in two ways: First, with cloud forms. They vary in size and show perspective. Distant clouds along the horizon are smaller and narrower, while nearer clouds are higher in the sky and larger. Second, and subtler, are the color and value gradations from horizon to the zenith, which can suggest curvature and space. Incorporating these effects into your skies will not only make them more interesting but contribute to a sense of spaciousness throughout the entire composition.

**Perspective and scale in clouds.** Scale and perspective apply to clouds just as they do to elements on the ground. Clouds along the horizon are farther away and therefore smaller, while clouds closer to us are higher in the sky and larger. Clouds naturally follow the imaginary contour and perspective suggested by the dome of the sky. The effects are not always as obvious as shown in this photograph, but they do exist. Notice how the scale and perspective in the clouds makes the land look more dimensional. If necessary, reposition the clouds in the painting, and change their scale to conform to the perspective implied by the dome of the sky. (They're going to move anyway!)

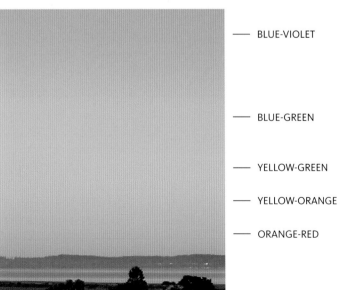

—— BLUE-VIOLET

—— BLUE-GREEN

—— YELLOW-GREEN

—— YELLOW-ORANGE

—— ORANGE-RED

**Color gradations in the sky.** To interpret the sky as a solid patch of color is to miss one of the best opportunities to explore the richness of color available to the landscape painter. The sky undergoes several color gradations from the horizon to the zenith. In this photo, starting at the horizon there is a subtle band of warmer color that appears reddish or orange. This gradually blends to a warm blue and then a cooler blue. *These shifts are subtle. They will not be seen as distinct bands of color but rather as blue tinged with these hues.* These color shifts follow the spectrum, and they will vary according to weather conditions and the time of day. They are more obvious in the early mornings and late afternoons (as shown in this photograph), and they are wildly exaggerated at sunrise and sunset. Colors chosen for a cloudless sky are especially important; color choice can make the sky feel like the luminous light source that it is or like a plain monochromatic backdrop.

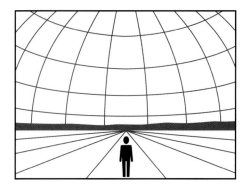

**The dome of the sky.** The sky is not a flat backdrop, like a giant curtain hanging behind the land. The sky can be likened to a huge dome that fully surrounds the landscape on every side. If you imagine a series of contour lines traced along the inside of the dome, like latitude and longitude lines, you get a fair representation of the shape of the sky. Clouds, diminishing in size as they recede, naturally follow these lines of perspective.

### SEEING THE LIGHT

Often, the color that will make the sky in a painting most convincing is not the perceived color, which is often blue, but the warm glare of sunlight. Try this experiment: On a sunny day, squint very hard at the horizon. Then quickly release your squint and open your eyes wide. You'll see an immediate burst of warm (yellow) replace the blue. The yellow corresponds to the warm sunlight.

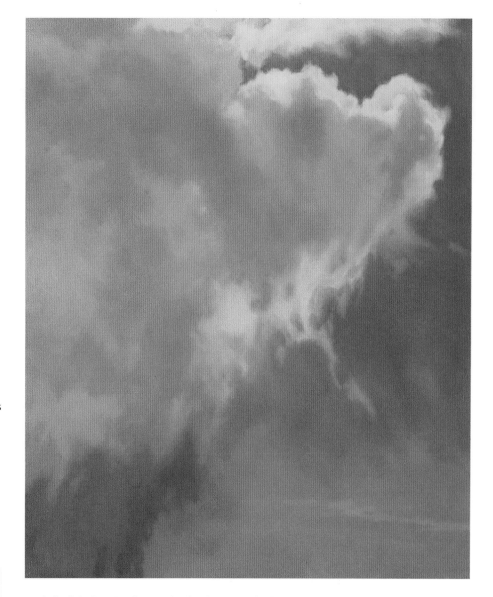

Mitchell Albala, *Orcas Squall*, 2006, oil on board, 20 x 16 inches (50.8 x 40.64 cm)

Because they are so amorphous and possess such soft and irregular edges, clouds are one of the most difficult landscape forms to resolve. However, the key to understanding clouds is the same as it is for other landscape forms: Shapes must be reduced to basic value zones and special attention given to differing planes. "Planes" may seem too strong a word to be applicable to clouds, but planes are indeed present. The painter must be willing to look closely and perhaps exaggerate some of the more ambiguous edges. In *Orcas Squall*, the cloud is described with a limited range or values that correspond to its front, side, and top planes, giving it an illusion of solidity. Differences in color temperature further reinforce the light and dark planes.

# SUBJECTS WITH DIMINISHED CUES

The sun is the arbiter of all that can be seen. Its presence or absence, and the strength with which it strikes the landscape, dramatically affects the perception of spatial cues and how flat or dimensional a scene appears. In any situation in which the sun is behind or in front of the painter, such as sunrises or sunsets, the essential cues for volume are compromised, and shapes lose some or all of their modeling. Shapes may appear flat or entirely silhouetted. The same holds true with

subjects that are all in shadow or all in light. When confronted with these types of situations, painters must compose largely with flat shapes, in collagelike fashion. They must carefully consider how each shape fits together and overlaps to create a layered space. The cues of overlap, scale, and perspective take on greater importance. Russell Chatham uses this approach very effectively in his painting *Bare Trees and Hayfields in November* that is seen on page 98.

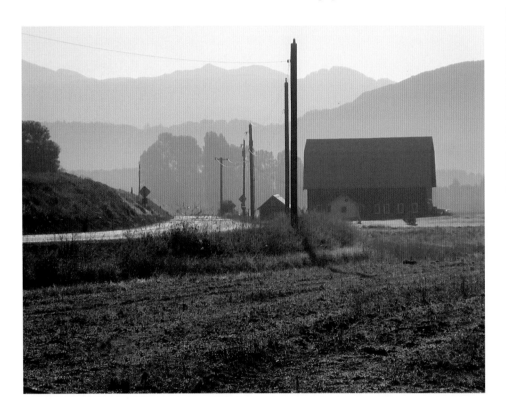

**Organizing space with flat shapes.** At sunrise, the elements in this scene were almost entirely back-lit. Without volume-generating crosslight, elements in the landscape appear flat—single-value and single-color shapes. The painter can compensate for this by playing up the other cues: differences in scale, overlaps, and perspective. The barn overlaps the trees and the hills, the hills overlap one another and ultimately overlap the sky, and the telephone poles overlap everything. The road and plow lines, though at a shallow angle, provide subtle perspective to help defy the horizontal layering of the composition.

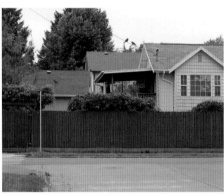

**Diminished value contrasts on cloudy days.** The most obvious difference between sunny and cloudy days is the color. Gray days lack the color-boosting effects of direct sunlight, but this gives the painter a chance to explore a palette of more neutral colors. The other significant difference is that the value contrasts that are so well defined on sunny days are harder to discern on overcast days. Notice that in the cloudy scene, the value contrasts in the house and the tree behind the house are still present, but are much less pronounced. You may need to look more closely to discern value differences on cloudy days and perhaps exaggerate them for effect. Also observe that contrast between the sky and the land, which is ordinarily the strongest value contrast in the landscape, tends to be even greater on cloudy days.

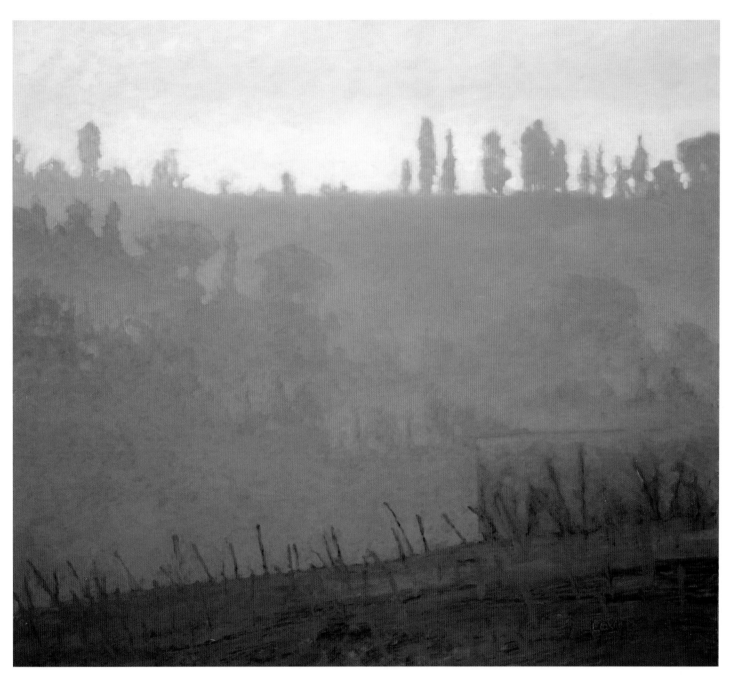

Kent Lovelace, *Giusto*, 2005, oil on copper,
18 x 20 inches (45.72 x 50.8 cm)

The backlit subject in *Giusto* did not have a traditional crosslight to suggest volume. The trees, hills, and ground were reduced to flat zones of color and value, yet the painting does not imply a flat space. Lovelace layers the shapes in such a way that each one overlaps the next to create a stepped recession into the landscape. He also uses diagonals to help move the eye through the layers. He imposes a reverse Z: Starting in the lower left, the eye follows the ground line upward at a slight diagonal. At the brown rooftop, it reverses direction and travels along the implied diagonal made by the treetops until it reaches the upper left. Once atop the hill, the eye resumes a rightward path along the ridge.

# PROBLEM SUBJECTS

There are a variety of landscape subjects that make for difficult translation. They may be scenes that have wonderful color or possess great depth but may, in fact, lack enough of the spatial cues needed to suggest space in a two-dimensional painting.

Complex scenes can make for very interesting subjects. Bridges, boat-filled harbors, and architecture, for instance, hold a lot of visual interest, but the novice should be cautious. Without good drawing skills and a seasoned ability to simplify, these subjects present enormous challenges. Because of the time needed to resolve their complex issues, they might be subjects best left for the studio.

Some of the most compelling views occur at unusual vantage points—looking down on a scene from a height or looking up a slope. Such compositions present a classic site selection problem: They *appear* very dimensional in reality but will require careful drawing and compositional manipulation to capture the effects in a two-dimensional picture. Compositions with multiple perspectives can also be problematic. If the scene includes elements that are well below your eye level (at your feet, for example) and objects that are far away in front of you, it is very difficult to reconcile such divergent perspectives.

**Opposite, top: Horizontal strips of landscape without any verticals or diagonals.** Scenes that rely heavily on horizontal bands stretching across our field of vision, without vertical elements or diagonals, provide limited cues to the third dimension. In this scene, the trees sit on one horizontal plane, without distinguishing near and far reference points. To make this scene more dynamic, the painter could introduce elements into the foreground, such as ripples in the water, or a boat, and the sky could be activated with cloud shapes that suggest recession and perspective.

**"Walls" of trees.** Complex clusters of foliage or close-ups of trees can become an indistinguishable mass of foliage and limbs, especially when there are no other landscape or architectural elements to reference. They appear to be dimensional in real life, but to create an illusion of space in a painting, they must have clear patterns of lights and darks to define structure. Relatively speaking, the tree in this example exists on one plane and will appear flat in a painting.

**Undifferentiated garden scenes.** Gardens offer a lot of color and visual appeal, but differentiating among the many interweaving layers of color and shape can be challenging. A garden's relatively shallow space can also be harder to organize spatially.

**Patterns of light and dark do not correspond to the actual forms.**
Although this scene had a lot of depth, with a path in perspective lead-
ing down into a wooded area, it poses problems similar to the wall of
trees. If you squint, the value patterns merge together because they do
not correspond to the structure of the forms. Painting such a scene is
possible, but you will have to work doubly hard to differentiate between
values and reinforce cues of scale, overlap, and linear perspective.

## SITE SELECTION CHECKLIST

- Are the various parts of the scene adequately differenti-ated? Do the values, colors, and shapes distinguish them-selves from one another or do they blend together?

- How is the scene lit? Is there a crosslight that produces a light side and shadow side to reveal the volume of the forms? Would a different van-tage point reveal more crosslight?

- If the scene does not have a clear crosslight (as in sunrises, sunsets, or overcast days), can the flat shapes be organ-ized in a way that steps the eye through the landscape? Are there enough overlaps, scale differences, and distinct value zones?

- Have you included overlap-ping elements and elements that vary in scale to help indi-cate a layered space?

- What time of day are you painting? Morning and late afternoon offer the best op-portunities for clear patterns of light and shadow. Midday light tends to flatten value contrasts.

- In what direction is the sun moving? Will it come up over the trees in five minutes and change the light structure of the entire scene? Will it drop down behind the house before too long?

- Is there a way to introduce elements of linear perspec-tive? If there is not a naturally occurring diagonal (such as a road, fence, or street), is there anything in the foreground that could be exaggerated, such as a stone or a furrow in the ground? Can something be invented?

- Have you picked a scene with ambiguous cues? Have you chosen a complex cluster of foliage that has little differen-tiation? Do the patterns of light and dark correspond to the shape of the forms? Have you chosen a subject that is largely a horizontal band? How can you introduce near and far reference points?

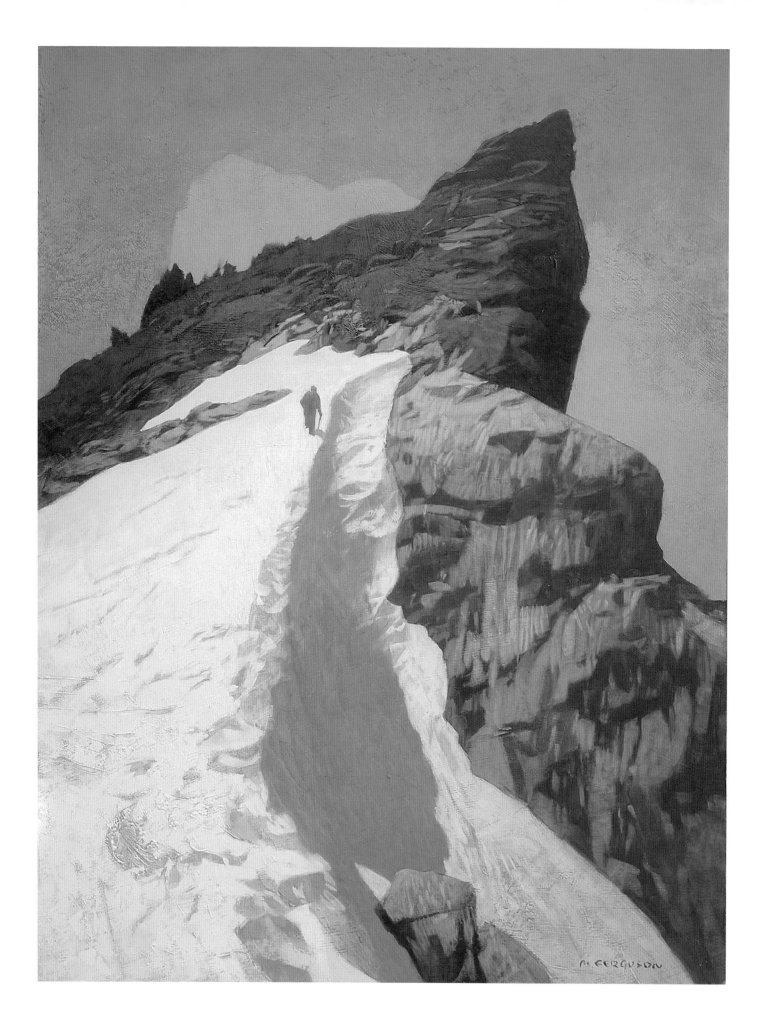

# COMPOSITION

The composition is the organized sum of the interior functions of every part of the work.

—WASSILY KANDINSKY

In the previous chapter, site selection was discussed as the first stage in the life of a painting. Through site selection, you determine whether or not the scene presents the spatial cues necessary to translate three-dimensional reality into a painting. Composition is the next step. How do the visual elements within the scene relate to one another, and to the surrounding picture window, to create a unified whole? A good composition arranges the compositional energies—shapes, colors, values, movements, and lines—in a way that supports the vision of the artist.

Michael Ferguson, *Stillaguamish*, 1998, acrylic on board, 33 x 25 inches (83.82 x 63.5 cm)

Like a conductor, painters orchestrate all the elements within a composition toward a desired outcome. First and foremost, they decide how the subject will be positioned within the *picture window* that is created by the four sides of the painting; then they determine how the shapes of the subject itself relate to one another. In *Stillaguamish*, sharp diagonals within a vertical format pull the viewer's eye inward and up the slope to create a sense of ascension. The energies of the composition are reinforced by converting the major shapes into bold, simplified masses.

# APPROACHING COMPOSITION

If you listened to a group of painters talk about composition, you might hear words like *balance*, *harmony*, and *rhythm*, but more likely, you would hear comments such as these: "That tree needs to move over a little bit. It's too close to the edge." "My eye goes right to that spot." "I follow that line and then it stops, but I want it to continue." "It feels like something else needs to be going on in the foreground."

Each of these observations suggests that composition is guided by an intuitive sense that tells us if something is out of balance or does not fit. Yet each observation could also be fully explained in terms of a compositional principle. While composition may be partly directed by innate sensibilities, it is the learned principles that give us control over the composition and let us direct it toward our own ends. The layperson may sense that a composition is out of balance, but the painter with a working knowledge of the energies and rules of composition will be able to tell you *why* it is out of balance. An artist who knows the reasons *why* can manipulate these energies and bring the work into balance.

A discussion of composition is challenging because the energies of composition are fundamentally abstract. In any given painting there are really two overlapping events. One is the surface story, or the narrative content of the painting—a river, a mountain, a bridge. The other is the underlying design. The design is not always apparent (at least not to the un-

trained eye) because our attention is drawn to objects and events we recognize. But the narrative content is actually directed by the underlying design, which comprises values, shapes, patterns, and lines. If the artist uses the principles of composition skillfully, the underlying design won't be obvious but will quietly do its job "beneath the surface."

The challenge of composition is further compounded by the fact that there are so many elements and principles of design, and each artist and each art book discusses them somewhat differently. What's more, no one principle can be discussed in isolation because the principles overlap and are applied differently in each situation. The approach taken in this chapter, therefore, focuses on what is *visible*, what can actually be seen in nature. It is only through thumbnail sketches, photos, and actual paintings that compositional "principles" or actions will be demonstrated.

A great deal of emphasis is placed on the first act of composition: composing through the picture window. What small portion of the boundless landscape will we select using the limited focus of our picture window? Rather than review the many principles of composition and design individually, we will combine them into a set of compositional considerations—visual circumstances we must learn to identify as desirable or to be avoided. Then we will look at how the principles are applied in several completed paintings.

## PICTURE PLANE VS. PICTURE WINDOW

This chapter refers to the picture plane and the picture window. It is important to understand the difference. The picture plane corresponds to the flat, two-dimensional surface of the painting or drawing. It can be thought of as an imaginary pane of glass, behind which the artist arranges the compositional elements. The picture window refers to the flexible frame or "window" imposed by the painter around the larger subject, which defines the edges of the composition.

A composition is an arrangement, built out of parts, that aims at seamlessness.

—ERIC MAISEL

# COMPOSITION THROUGH THE PICTURE WINDOW

Unlike reality, a painting is bounded by an imaginary frame or window. The edges of the window have a beginning and an end that correspond to the edges of the canvas and determine what will be included in the composition and what will get trimmed away. Without altering or deleting a single element, a *picture window* can be imposed upon the larger scene that will produce a completely self-contained composition. If a good composition can't be found by imposing a picture window around the scene, then the scene itself is probably not a viable starting point.

The picture window is dynamic. It expands horizontally and vertically, and as it does so, it exerts a pressure of containment around the scene that actually changes the way the interior shapes relate to one another. In this way, the top, bottom, and left and right edges of the picture window are the four most important compositional elements in any painting. They establish a number of variables: what the actual subject is; how near or far, or how far above or below, the viewer is relative to the subject matter in the scene; how the primary masses are distributed within the space; whether the space is contained vertically, horizontally, or in a square; and how all that changes the impression of the subject.

  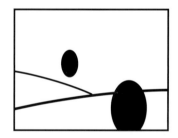

**Relating to the edges of the picture window.** A composition is not just a group of elements in relation to one another; it is a group of elements in relation to one another and *in relation to the picture window*. Each of the three compositions above is made up of the same elements in the same relationship to one another. In the first, the shapes are free-floating, having no relation to the edges of a picture window. But when a picture window is imposed around the subject, the elements become engaged with the edges to form a complete composition. Depending on the way the picture window frames the elements, a different sense of space is suggested. The window creates forces of compression (or expansion) between the elements and the edges. The spaces in between and around the elements also have weight, position, and energy and become compositional elements unto themselves.

## LIMITED FOCUS THROUGH SELECTION

In its raw, "uncomposed" state, nature presents everything from east to west, north to south, and ground to sky. No matter how grand the subject, no matter how distant the vista, we must ultimately select a smaller slice of life than is presented to us. Imposing a picture window on the scene directly lends itself to an essential practice of landscape painting: choosing a limited focus.

It may seem that an all-inclusive composition would suggest the depth and breadth of the landscape best. This may be our experience when we are standing in the midst of nature, fully surrounded on every side by limitless vistas, but a painting is not reality. For a painting to maintain focus, it must include fewer elements than the eye apprehends in nature. Moreover, your painting must organize selected elements in a way that guides the viewer's attention through the painting. Including too much within the composition can lead to a competition among the elements for the viewer's attention. Ask yourself the following: How does what I include or leave out of the composition contribute to the primary visual intention of the painting? What is the *least* amount of content that can be included without sacrificing the idea?

In painting, the suggestion of depth relies primarily on spatial cues, not massive amounts of scenery and details. A limited focus does eliminate some real estate, but it doesn't necessarily restrict the number of cues. In fact, it can heighten the spatial illusion by focusing attention on the particular cues in the landscape that most effectively indicate depth.

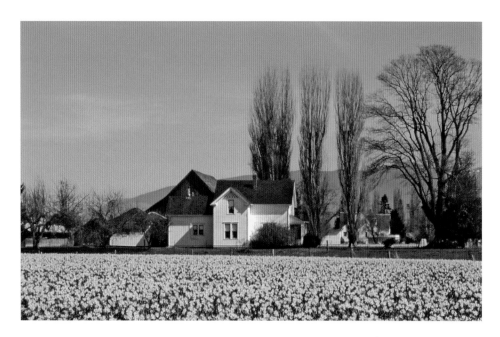 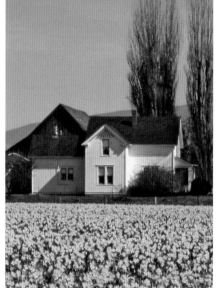

**Limited focus, example 1.** Eliminating nonessential elements through a limited focus sometimes produces the suggestion of greater space, the opposite of what might be expected. The full-frame composition depicts a farmhouse amidst a field of daffodils. It presents a strongly horizontal space, with most of the visual interest along the middle ground. With so many extra trees to the left and right, there are too many things vying for attention. Is the picture about the daffodil field, the farmhouse, or the trees? By applying a limited focus that excludes the extraneous material, and flipping the format to vertical, the composition becomes more focused. There is a much stronger movement *into* the picture window as well as clear upward energy. The eye traverses a greater distance across the field and lands at the house. The energy continues up the front of the house, into the tall trees, and then into the sky.

**Limited focus, example 2.** The full-frame scene has interesting positive and negative patterns created by the dark evergreen trees against the white snow; however, it has too much information and lacks focus. By imposing a limited focus—selecting a much smaller portion of the wider scene—the sprawling hillside is transformed into an intimate view, and the composition is strengthened. The diagonal movement from the lower left to upper right brings simplicity and focus to the idea.

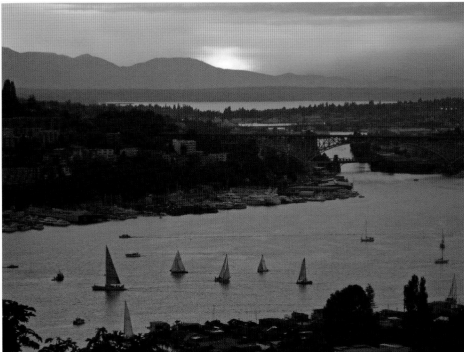

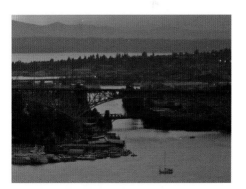

**Limited focus, example 3.** Multiple compositions can often be extracted from a single scene. The full-frame scene above certainly captures the drama of the sunset, but the large, dense masses of the middle ground and foreground are somewhat static and pull attention away from the main area of interest: the passage of water beneath the bridge with its interesting color, shape, and pattern. Both limited-focus choices bring greater attention to that area. The horizontal composition preserves more of the left-right breadth of the original scene but has greater focus on the main area of interest. In the vertical composition, there is a greater sense of being carried inward, along the canal, as opposed being carried across the scene from left to right.

Kathleen Dunphy, *Winter Light*, 2007,
oil on linen, 24 x 24 inches (60.96 x 60.96 cm)

A composition is determined in large part by
how much or how little of the scene the painter
chooses to include. In *Winter Light*, Dunphy uses
a *limited focus* that both simplifies the composi-
tion and suggests an intimate view within the
snowy woods. Consider the large amount of
trees and snow that are *not* shown (outside the
picture window); yet, there is still a strong sug-
gestion of space. In painting, the suggestion of
depth isn't necessarily created with expansive
subject matter but with the appropriate spatial
cues. Although the space suggested in *Winter
Light* is not very deep, it is divided into a distinct
foreground, middle ground, and background.
The vertical trees serve as a counterpoint to the
gentle diagonals that lead us through the space:
Our eye is led from the lower right to the left
and then back to the right along the base of the
background trees.

An effective design resonates with the viewer's sense of logic and proportion, and though this
thought process may be so rapid as to seem subconscious, the viewer nonetheless makes an
intellectual connection with good design. The mind is engaged, seeking harmony as the eye
darts from shape to shape to find similarities and variations. In a successful design, the viewer
senses a plan and responds to the arrangement of shapes and colors every bit as much as to
recognizable objects or to the picture's narrative content.

—RICHARD MCDANIEL

**The viewfinder.** The handiest tool for exploring possible compositions is the humble viewfinder. By holding it in front of your eye and moving it forward and back, up and down, and left and right you can explore a wide variety of potential compositions. The viewfinder is not just for beginners! Taking five minutes with a viewfinder at the start of your session can set you on the right track. Shown here is the ViewCatcher from the Color Wheel Company, with an adjustable window for standard proportions, such as 8 x 10 or 9 x 12 inches. You can also make your own viewfinder out of cardboard or use the viewfinder or screen in your digital camera.

BOARD    CANVAS TAPED TO BOARD    EXTRA CANVAS SPACE

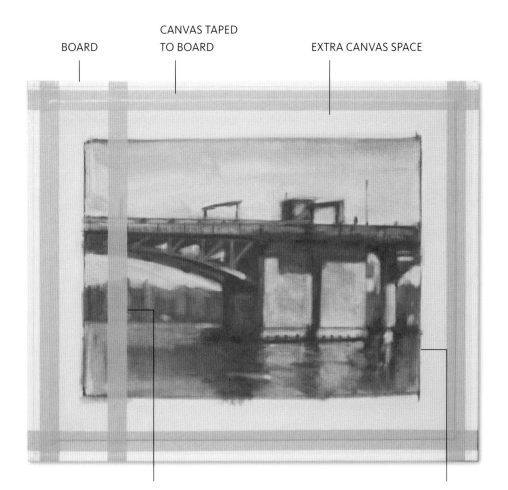

**The flexible picture window.** The flexible picture window can be practically applied *as you work*. Many artists paint on standard-size surfaces: 8 x 10, 11 x 14, 18 x 24 inches, and so on. This requires accurately placing the subject within the given proportion. But what if you discover that the standard proportion isn't the right choice for your composition? What if midway through the painting you realize you need more space at the top? Using a flexible picture window can help. To do this, work on an oversize piece of canvas taped to a lightweight board. Start with a smaller picture window a few inches from the edges. As you work, if you determine that the composition needs to expand or contract, you have the extra room on the canvas to do so. This is one of the best ways to learn composition because it lets you experience how changing the picture window affects the overall composition. If you decide that the painting is a keeper, you can always stretch it after it's dry or leave it unstretched and mat it. (You can use a similar approach in the studio, as well.)

ADJUSTED PICTURE WINDOW RESULTING IN IMPROVED COMPOSITION    INITIAL PICTURE WINDOW

# COMPOSITIONAL CONSIDERATIONS

Before analyzing compositions by contemporary masters, it will be helpful to study some of the basic factors of which landscape painters should be aware. There are many principles of design, which overlap and work together to produce the desired outcome. As explained earlier on page 84, rather than review the principles as isolated factors, they are synthesized into sets of compositional *considerations*—compositional events the landscape painter can identify as desirable or to be avoided.

## THE ENERGY OF FORMAT

Format is one of the first and most basic compositional considerations. How does the proportion of the picture window—horizontal, panoramic, vertical, or square—influence the composition? A pull is created in whatever direction has the greatest length, be it horizontal or vertical. The influence of format is inescapable; even before you begin filling the canvas, the format is already exerting directional energies.

Just because you are painting a landscape does not mean that a horizontal format is always the best option. Sometimes a vertical or square format suggests greater depth or focuses the directional energies

better. Do quick thumbnail studies or flip the viewfinder back and forth between the horizontal and vertical to see if one orientation makes the composition stronger. Also, don't feel bound by standard proportions (11 x 14, 16 x 20, 24 x 36 inches, and so on). As you consider various options, there is often a particular proportion that best serves the compositional intent, and that proportion may not necessarily conform to one of the standard formats.

**Horizontal.** The wide horizontal format is called *landscape* for a reason. It naturally suggests expansion from left to right. The wider the format, the stronger the horizontal energy becomes, and the more vertical elements will be needed to break up the strong horizontality.

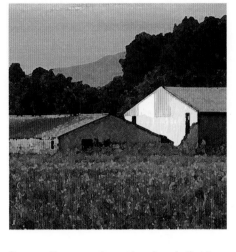

**Vertical.** The vertical, or *portrait*, format is less common in landscape painting, but it can be very effective with certain subjects. While it does not suggest the wide-open space of a horizontal format, it can create a sense of deep space by moving the energy *inward* and *upward*. The limited-focus example shown on page 87 and Christopher Martin Hoff's *Floating 3* (page 101) are both excellent examples of the inward and upward movement that can be achieved using the vertical format.

**Square.** The square format is unique in that it favors neither the vertical nor the horizontal and therefore lends a sense of balance and calmness to a composition. It is ideal when the artist wants to heighten abstraction or wants the internal compositional elements to dictate visual movement instead of the horizontal and vertical edges of the picture window.

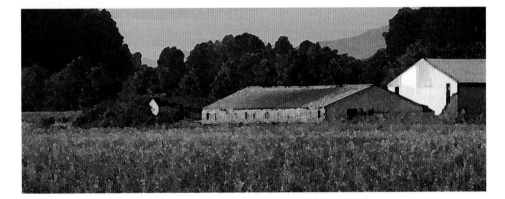

**Panoramic.** Maintaining a sense of integration within the composition is a challenge with the panoramic format. How can a connection be maintained between what is happening all the way to the left and all the way to the right? The wider the canvas becomes, the more important it is to use vertical subdivisions to move the eye across the space from side to side. The panorama can also be divided into halves or thirds. These are not physical divisions, as in an actual diptych or triptych, but implied divisions. If each subdivision is composed as if to stand alone, then the entire composition will integrate better.

## DIVISIONS OF THE PICTURE PLANE

As painters distribute values and shapes across the picture plane, they invariably create divisions within their composition. These divisions play a key role in laying the foundation of the composition. What follows are a number of considerations painters find helpful in organizing their subject within the picture plane.

**Composing with a grid.** Painters sometimes use a grid to organize a composition. The grid can be divided into thirds (3 x 3), fifths (5 x 5), or a combination of thirds and fifths (3 x 5). More than five divisions become too complex to be of practical use. The grid lines intersect along *power points* (the green circles), places where the eye likes to rest. By aligning elements along the grid lines or on the intersections of those lines, the grid serves as a kind of compositional template. Grids help the painter position elements in an orderly and balanced way and avoid placing elements in trouble spots, like along the edges or in the center. It should be noted that elements do not have to be precisely aligned along the grid to be effective. The grid is meant to be a general guide for composing, not a formula to be slavishly adhered to.

### APPORTION APPROPRIATE SPACE TO AREAS OF GREATEST INTEREST

I frequently ask students, "What is your painting about?" I want to know what made them choose that particular scene. Sometimes they aren't sure, or they point to a part of the scene to which they have assigned very little space in the painting. If the vastness of the cloud-filled sky is what inspires, then the sky should occupy the majority of space in the painting. Apportion an appropriate amount of weight to areas of greatest interest. This makes sense both in terms of the narrative content and the composition.

**Placement of the horizon line.** The placement of the horizon line determines whether the emphasis will be on the land or the sky—or neither. It also has an effect on how depth is perceived in the composition. When the horizon is high (near right), the composition is dominated by a large foreground, which can carry the viewer deeply into the space, especially if there are spatial cues that imply a recession, such as ripples in water or perspective lines in the ground. When the horizon line is low (opposite, left), the sky dominates. The sky appears expansive compared to the land, fostering the impression that the horizon is at a great distance. When the horizon line divides the picture plane in half (opposite, right), neither the ground nor the sky dominates. This emphasizes what lies at the horizon, and it can be hard to tell whether the sky or the land is dominant.

## MOVEMENT AND RHYTHM

Among the most important energies in a composition are visual movement and rhythm. Along what lines, over what shapes, and through what intersections will the eye move around the painting? Does our eye follow the ground line until it reaches the tree and then continue on, or does it move up the tree, connect to the mountain, and then move across the painting in the other direction? In this context, movement does not mean the factual description of, say, rushing water; rather, it is the journey of the eye as it makes connections among the elements in the composition.

These connections, or eye paths, are sometimes very obvious. For example, the eye easily travels up a telephone pole or follows the strong line of a mountaintop. Of greater subtlety, however, are implied eye paths. These are formed not by conspicuous lines, as in the telephone pole, but rather by connections made in our mind as the eye tries to connect things along a common path. As the stars of the constellations are connected in the mind of the beholder, so can the elements in a composition be connected by eye paths created by the painter. For example, the eye might not flow along the irregular contour of the treetops, but it can flow along an implied diagonal that aligns along the tops of the tallest trees. Christopher Martin Hoff's and John McCormick's paintings at the end of this chapter are particularly good examples of eye paths in action.

A fundamental rule of composition is that every painting should have a *focal point*—one spot that is the center of attention. However, all areas of a painting should be interesting. It is much more important to keep the eye moving in and around the space, never stopping or resting in one spot for too long. Rather than think in terms of a single focal point, think about areas of primary emphasis and secondary emphasis in the composition.

## UNITY AND INTEGRATION

A composition that has visual unity and integration will convey a sense that all the parts belong together, regardless of how complex or simple the composition may be; one part does not appear detached from any other. Unity and integration, what some call harmony, is not so much a specific formula imposed upon a composition: A + B = harmony. Rather, it is the cumulative effect of all our choices, a reflection of how well our compositional intent is working and whether there is agreement among all the energies within the composition.

These considerations are guidelines, not intractable rules. As you hone your composition sensibilities, you will find that your intuitive sense and learned knowledge work in tandem.

—HENRI MATISSE

## BALANCE

The artist strives to make every work achieve visual balance, a state in which all components of the composition contribute to a general sense of stability. Balance can be achieved through *symmetry*; evenly distributing the visual elements on either side of the center achieves a state of absolute equality. However, without some visual tension, symmetry can be static or boring. Balance can also be achieved through *asymmetry*; a variable and unequal distribution of elements offers more visual stimulation, supports movement and rhythm, and yet can still feel balanced overall.

Nature scarcely ever gives us the very best; for that we must have recourse to art.

—BALTASAR GRACIÁN

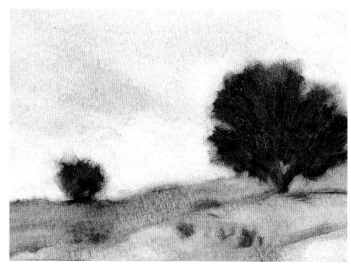

**Visual weight.** Balance in composition is governed by weight. Size, value, and position are the major determinants of visual weight, but other visual elements can also play a role. For example, a large dark mass dominating half the picture might have great visual weight, but it can easily be overpowered by a small, bright color on the other side. Similarly, a small form that has a unique shape or holds symbolic meaning, like a human figure, can have greater visual weight than something that is larger in size or darker in value. The visual weight assigned to an element helps determine the amount of attention it receives. The three compositions here show just a few of the many factors that influence balance and weight: above, left, a large object dominates the right side of the picture. With nothing to counterbalance its weight, the composition is heavy on the right. Above, a smaller element is added on the left. It isn't large enough to outweigh the large tree, but it activates the left side of the composition enough to create more balance. Left, the form on the right is still large, but because it is much lighter in value, the small, dark tree on the left has greater visual weight. Here, value density trumps size.

## VARIATION

Variation is one of the most essential considerations, because it is the *differences* within a composition—of size, value, color, shape, and angles—that keep the eye moving through the painting and maintain visual interest. A composition may be full of movement or static, active or passive. Variation is what regulates these energies.

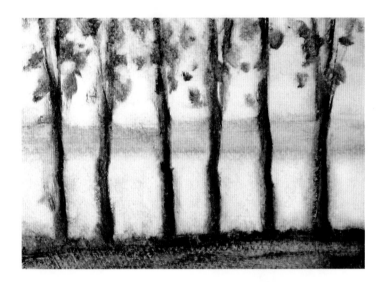

**Counteract extremely horizontal subjects with diagonals and perspective.** Both compositions are similar, with a foreground, middle ground, and background sky in nearly the same size and position. Yet each gives vastly different suggestions of space. Because there is nothing to interrupt the horizontal expansiveness of the top composition, it is static. The eye tends to remain on the strip of trees in the middle ground with no cues to draw it elsewhere. Above, perspective markers are added to create a greater sense of depth. Small vertical posts in the foreground lead the eye back along a line of perspective. The band of trees in the middle ground also tapers slightly from right to left, another perspective hint. Even the background sky has clouds that reinforce the diagonals created on the land.

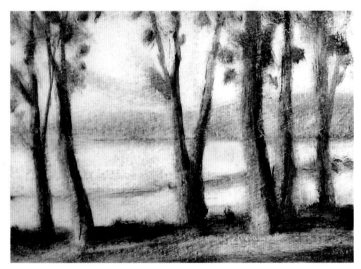

**The effect of variation.** Both these compositions have the same ingredients. But at top, the trees are the same thickness, all relatively vertical, and evenly spaced. They mirror the horizontality and verticality of the frame, yielding regularity and uniformity. Above, variation is added to the tree spacing, so the eye moves across the picture in a less predictable, more engaging way. Diagonals are introduced: The ground rises slightly, and the trees tilt at various angles. The thickness of the trunks also varies, and two trees sit forward of the ground line. The result is a more natural and dynamic composition.

No one is an artist unless he carries his picture in his head before painting it, and is sure of his method and composition.
—CLAUDE MONET

## RELATING TO THE EDGE

A composition involves not only how groups of elements relate to one another but how those elements relate to the edges of the picture window. The space between the elements and the edges can exert forces of connection or resistance that have a profound effect on the overall composition.

**Avoid placing elements too near the edge.** If an element is placed too close to the edge of the picture widow, it becomes "magnetized" to the edge. When the trees are pressed against the edges (top), a visual tension is created that draws too much attention there. When the trees are moved away from the edges (above), the visual tension is released. There is more balance between the foreground trees and the open space in the middle. With more breathing room, the tree on the right seems farther back.

**Center vs. off-center.** Centering naturally creates symmetry and balance, but it can also lack the variation that keeps a composition alive and interesting. The center of a painting is magnetically charged. Anything but the most minor element placed there will draw attention to itself. At top, the sailboat and the horizon are both centered, respectively, creating a pull toward the middle. Even the small boat on the right is not enough to offset it. Above, the larger boat is moved off-center to the left, and the horizon line is raised. The asymmetry feels more natural. There is a subtle movement from the lower left to upper right.

Here, on the river's verge, I could be busy for months without changing my place, simply leaning a little more to right or left.
—PAUL CÉZANNE

## THE FOREGROUND CHALLENGE

Foregrounds are among the most challenging components of the land-scape. There is often a large amount of space between the painter and the middle ground. Fields, bodies of water, or streets stretch away from our feet into the distance. These foreground planes always appear dimensional in reality, but if they are not activated with sufficient spatial cues, they can look more like vertical planes than horizontal ones. The following three techniques can help:

- Use perspective markers. There are often few indicators within a flat foreground that suggest perspective. However, if you look carefully, there are nearly always some subtle markers that can be used to guide the eye across the flat plane: a furrow in the ground, a patch of grass or dirt, a broken fence post, or a few stones that form an eye path. You don't need many such indicators; they can be effective even when used sparingly. Borrow from what is there and expand if needed. If you don't see such variations—and there will be times when you don't—invent them.

- Mind color and value differences. Value and color differences can be used to divide the foreground plane into sections or zones that create visual steps across the plane. For example, a brighter color in the near foreground can pull that part of the foreground closer, while a slightly duller color applied to the rear of the foreground can push that area back. Trees or other objects often cast shadows, which can be used to draw the eye across the foreground. The shadows can be reshaped for best effect.

- Include texture variation. Varying the texture of the foreground—greater texture in the forward part of the plane and less texture as the plane recedes—is a reliable way to add depth to an otherwise flat plane.

**Activating a foreground with perspective cues.** Both versions are identical except for the treatment of the foreground. In the first example, the foreground is undifferentiated. Although it is obvious that the field advances toward the hillside, it does not carry the eye across the plane nearly as effectively as does the second example. There, subtle lines of perspective created by the fence on the right, and the tonal variations within the grasses, fully activate the foreground and give it a greater sense of depth.

# COMPOSITIONAL ANALYSIS

The energies that direct a composition often work "beneath the surface"; yet, we feel their influence through the sense of balance, harmony, and integration that is conveyed. We must learn to see these invisible energies as readily as we see the pigment on our canvases. One of the best ways to do this is by "mapping" a successful composition. The following paintings are analyzed in depth, with reference to the compositional considerations discussed throughout the chapter.

Each work of art is a collection of signs invented during the picture's execution to suit the needs of their position. Taken out of the composition for which they were created, these signs have no further use.

—HENRI MATISSE

Russell Chatham, *Bare Trees and Hayfields in November*, 1991, oil on canvas, 40 x 72 inches (101.6 x 182.88 cm)

This painting is built upon strong horizontals asserted through the wide horizontal format and the horizontal bands of trees. Yet Chatham is able to draw the viewer *over* the horizontals and *into* the third dimension of depth. He does this not by modeling the forms with value (the trees are essentially flat strips with only slight modeling), but by the way he layers the shapes. Chatham relies heavily on overlapping elements. The wide bands of trees pull the eye back at regular intervals and are punctuated by snowfields that establish a common ground. The first field, in the foreground, serves as an entry into the painting. The second snowfield is in the middle and maintains a continuation of the ground by revealing another portion of it. Finally, the third snowfield at the top moves our eye even farther back. Had that distant field been only a solid tone, it might have appeared flat. But Chatham places tiny trees to provide a sense of scale and inserts field lines (at the right and left) that serve as lines of perspective to direct the eye back into the space.

## COMPOSITION THROUGH REDESIGN

If a potential scene offers the necessary spatial cues and presents its major shapes and values in a relatively organized way, then just making choices about how to position the picture window can lead to a good composition. However, with a subject as wild and disorganized as the landscape, there will be times when we need to make changes to what we see—recomposing, altering, adding, or deleting to improve upon the original. What are acceptable changes, and how far should we go in altering the original? If the major shapes and the arrangement of those shapes require little or no alteration, then other smaller changes are probably acceptable. But if we have to rearrange, add, or delete to the point that we are reinventing the entire scene, then that scene is not an acceptable starting point. Here are a few of the types of alterations I would consider reasonable. What makes them acceptable is the small degree of alteration.

- Moving an element over slightly to reveal more of what's behind it.

- Removing a minor element that obscures too much or interferes with the overall composition.

- Slightly increasing or reducing the size of an element.

- Reshaping clouds so that they suggest more perspective or integrate better with the directional energies present in the land.

- Adding small accents to the foreground plane to give it better perspective.

- Often, what is needed is not so much an actual change but an *emphasis* or *de-emphasis* of what is already there. We exaggerate something that is only hinted at or tone down something that is overstated. In other words, the scene has the right elements; the painter adjusts their relative strengths.

John McCormick, *Western Wind*, 2006, oil on canvas, 60 x 60 inches (152.4 x 152.4 cm)

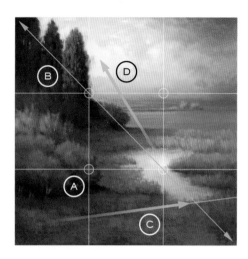

McCormick uses composition as a way to build an inner harmony within his paintings and impart a sense of reverie. His first compositional choice is format. The square helps reduce tension because it does not create a pull in either the horizontal or vertical direction. McCormick uses a grid to divide the composition into thirds. Aligning elements along the grid lines and on (or near) the power points (A) where the lines intersect helps lend balance and order to the composition. "I follow the grid very intuitively," McCormick says. "I use it as a way to get started or to fall back on if I get stuck, but it's not a system meant to be used in a heavy-handed, absolute way."

There are also several implied diagonals that help move the eye through the composition. The first diagonal divides the painting in half from the upper left to lower right and passes through two power points (B). It connects the path of the stream to the tall trees in the upper left to create a path from the foreground to the background. Another eye path is suggested by the furrow in the grasses of the lower third, which leads the eye across the near foreground to the start of the stream (C). From there, an important eye path is struck between the highlight on the stream (falling on a power point) and the brightest spot in the sky (D).

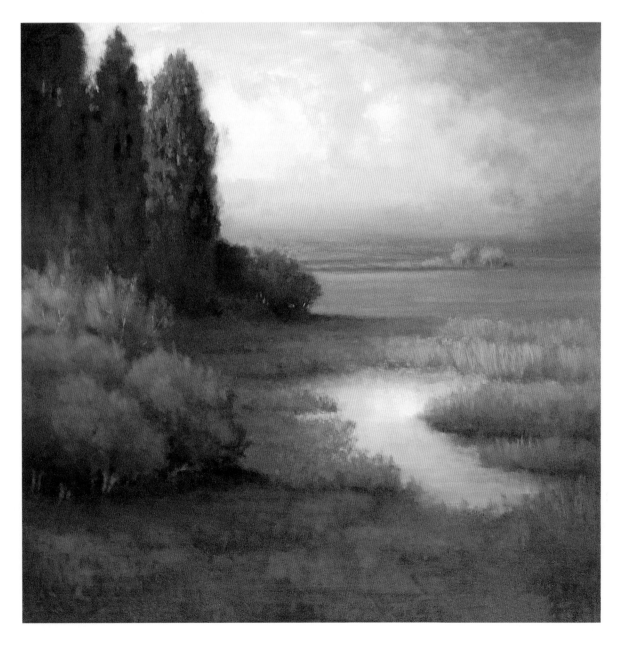

Christopher Martin Hoff, *Floating 3*, 2005, oil on canvas, 19 x 16 inches (48.26 x 40.64 cm)

*Floating 3* is a composition about movement. Its vertical format, combined with a series of clear eye paths, creates a directional energy that moves the eye *inward* and *upward*. The eye enters the composition along the lines of perspective at the bottom (A). Another eye path enters horizontally from the left side of the red tugboat (B) and joins the vertical eye path that rides up the bow of the boat (C). Although the dominant movement is upward, there are also cues that pull the eye to the upper right: The tugboat tilts slightly from its vertical axis, which "prevents it from getting locked into the edges of the canvas," says Hoff. This creates some tension and moves the eye slightly to the right. The line of movement that follows the right side of the boat (D) reinforces this. The long rope draped across the front of the boat is the biggest surprise in the composition. It provides a curvilinear contrast to the many straight lines and slows down all the upward energy.

There is that elementary principle of organization in any art that nothing gets in anything else's way, and everything is at its own limit of possibilities.

—FAIRFIELD PORTER

CHAPTER EIGHT

# LIGHT AND COLOR

I was very pleased with myself when I discovered that sunlight cannot be reproduced, but that it must be represented by something else—by color.

—PAUL CÉZANNE

It is an understatement to say that color is the driving force behind so many artists' passion for the landscape. Nowhere else is color presented with such diversity or brilliance, with as much atmosphere or such sublime lighting. For centuries, painters have been drawn to capture this beauty in their work, and when they succeed, it is pure magic.

Weaving this magic, however, requires a blending of spells. On one level, our response to color is a subjective experience, independent of specific theories or knowledge; we simply prefer certain colors, much as we prefer certain flavors. Yet our approach to color is also rational and measurable, governed by the laws of physics and the physiology of our eye. The artist must couple intuitive response with practical knowledge. A purely pragmatic approach to color, without any influence of intuition, would result in a technically proficient but soulless painting. A purely intuitive approach, uninformed by practical knowledge, would be undisciplined, and key color relationships might fail to work.

Ultimately, working with color is as much about ongoing experimentation as it is about the application of theory. Ideas and color strategies must be tested on both palette and canvas, and each attempt teaches you more. Understanding color is a lifelong endeavor, not something that can be fully grasped in a short amount of time. The most brilliant colorists confess that they are still trying to figure it out. With a solid understanding of basic color principles, coupled with observation and practice in color mixing, you can begin to make sense of it all and use color effectively to capture the magic of landscape light.

Rich Bowman, *Blue Bounty*, 2008, oil on canvas, 48 x 48 inches (121.92 x 121.92 cm). Courtesy Blue Gallery, Kansas City

The brilliance of real light cannot be imported into paintings directly, so artists apply various color strategies to create a convincing illusion. Here, Rich Bowman's color scheme incorporates the three primary colors: red, yellow, and blue, with blue being the dominant hue. He unifies the primaries by mixing each with a little bit of the others. The bright yellow-orange part of the cloud has a *tiny* bit of blue in it, while the violet underside has some warmer yellows and reds. The explosive brilliance at the top of the cloud is achieved through contrast: First, the yellow-orange appears more intense because it is surrounded by less-intense colors. Second, it is much lighter in value than what surrounds it. Third, there is a complementary relationship between the yellow-orange and blue-violet hues in the darker underside. And fourth, the colors shift in temperature as they make a transition from light to dark.

# REAL LIGHT VS. PAINTER'S LIGHT: THE LIMITATIONS OF PAINT

It is unlikely that you have ever looked at a scene in nature, crinkled your brow in bewilderment, and said, "Those colors just don't seem right!" Because the effects of actual landscape light are real, they never fail to be convincing. A painting, however, is a different kind of world. Artists may spend years learning color theory and how to mix colors, but they can *never* truly match the extreme range of colors and values found in nature. This is because natural light and painter's pigments on canvas are *not* the same thing. The sky illuminates brilliantly. It breathes light. The canvas only reflects light; it cannot actually glow. The brilliance of nature—the intensity of a field of sunstruck poppies or the radiance of the sun dancing on the water—is simply not possible with paint. Which pigment would you choose to make the viewer squint as if looking into the sun? Painters have only the darkest dark, the whitest white, and pure colors. That range may seem quite robust on the palette but is actually much narrower than the range of value and color brilliance found in nature.

These differences force artists to compensate by manipulating color and value in ways that are beyond what is seen in the actual subject. Artists borrow from the colors they see in the natural world and use them as a starting point, but getting the "right" color is never about copying nature or matching colors hue for hue, value for value. It is about finding a parallel relationship—a color *metaphor*—that substitutes for the real thing. This is the paradox color presents: Painters may strive to see the world as it is, to faithfully record the phenomenon of color nature presents to them, yet the limitations of pigment and canvas force them to alter

what they see in order to create a convincing illusion. In this way, effective color in painting is partly based on observation and partly invented.

Artists frequently say, "A painting is a lie that tells the truth." This is perhaps no truer than when dealing with color. The artist is always, first and foremost, a translator of color from one realm into another. Just as no two poets would use the same metaphor to describe the same emotion, no two painters would apply the same color strategy to describe the same light. The magic of capturing landscape light is that our paintings—constrained by the limitations of pigments on canvas—can evoke ideas and emotions equal to those experienced in reality.

In visual perception, a color is almost never seen as it really is, as it physically is. This fact makes color the most relative medium in art.

—JOSEF ALBERS

## A PAINTING ANSWERS ONLY TO ITSELF

As much as we pay respect to our initial inspiration, and try to capture a particular moment of light, the color within the painting ultimately answers only to itself, not the world that inspired it. Take your lessons and inspiration from nature, but judge success by how well the light works *within the painting*. The light in front of you lasts but a few moments, but the painting remains.

Russell Case, *Tower Shadows*, 2009, oil on linen, 12 x 9 inches (30.48 x 22.86 cm). Courtesy of Mitchell Brown Fine Art

To represent natural light, landscape painters do not copy nature's colors explicitly; they employ various color strategies that serve as a *metaphor* for light. The most striking thing here is how light and colorful the large rock shadow is. By controlling values to avoid extreme darks or lights, colors are better able to express their full chromatic identity and act *as* color—while also becoming the ultimate representation of light. Also note how the composition supports this shadow, with a central, strong diagonal placement.

## USE OF COLOR STRATEGIES

Painters may follow nature's lead, borrowing considerably from what they see, but an effective color solution also relies on a color *strategy*; an effective color solution is anything but random. How will the colors chosen and the way they are orchestrated support the painter's vision? What color groups dominate? Will the strength of the lights and darks be reinforced by temperature differences? Will complementary colors build contrasts that are vibrant or harmonizing or both? Will an analogous harmony help unify the colors? Is the color composition primarily a series of neutrals augmented by a few touches of bright color, or is it primarily intense color augmented by a few neutrals? Myriad colors can be assigned to the trees and to the fields, and to everything else under the sun, but it is a consistent color strategy that binds them all together.

**The relativity of color.** There is probably a time in all painters' lives when, in order to see if they have mixed the right color, they place a daub of color next to the surface of what they are trying to paint. If the two look the same, they have mixed the right color! This accomplishment seems logical but ignores a fundamental truth about color: *Color is entirely relative.* A color choice can never be evaluated in isolation, but only in the context of the surrounding colors. Every color choice affects the adjacent color and, in turn, the painting as a whole. In these two swatches, the inner squares are the exact same color, but when surrounded by two different hues, they appear to be different. The yellow square within the red appears a little brighter and lighter, while the square within the green appears a little darker.

Color is color only according to amount, placement, and application.

—CHARLES EMERSON

# LOOKING AT COLOR

Working with color is less about replicating the colors seen in nature than it is about establishing an effective relationship among the colors within a painting. There are no foolproof formulas that will solve every color problem every time; however, the more familiar you are with the ways colors interrelate, the more able you will be to make better choices. Fundamental color relationships never become passé; they form the core of the painter's working vocabulary.

## THE COLOR WHEEL

The color wheel is a map of the visible spectrum that makes it easier to see the different types of colors—primary, secondary, and tertiary—and the many color relationships, such as analogous and complementary. The wheel demonstrates that individual hues are really not separate but part of a unified, interrelated spectrum. Even complementary colors, those opposite each other on the wheel, have a relationship that is very useful to the painter.

It is the eye of ignorance that assigns a fixed and unchangeable color to every object.
—PAUL GAUGUIN

**Mapping color relationships with the color wheel.** *Primary* colors are the fundamental, essential pigment colors that cannot be produced by combining any other colors **(1)**. From red, yellow, and blue virtually every other color can be mixed, which is why a limited palette always contains at least the three primaries. Two primary colors mixed together produce *secondary* colors **(2)**: red + yellow = orange, blue + red = violet, and yellow + blue = green. These colors may be modified even further into *tertiary* colors **(3)** by mixing a primary with an adjacent secondary, such as red mixed with violet to yield red-violet, which then falls between the two. *Analogous* colors are those adjacent to each other on the color wheel. From a physical perspective, their wavelengths are very close, and so they are innately harmonious. *Complementary* colors are found at opposite sides of the color wheel: Red is opposite green, blue is opposite orange, yellow is opposite violet, and so on. Complements can be used to heighten color intensity or reduce color intensity, depending on how they are used.

**Describing color with hue, temperature, value, and intensity.** Many subjective labels can be applied to color—beautiful, happy, somber—but in terms of a common empirical language, artists describe color in terms of hue, temperature, value, and intensity. The most basic color description is *hue*, the general family to which the color belongs **(A)**. Two different hues are shown: violet (lavender) and green (chartreuse). *Color temperature* is an aspect of hue; it describes the relative coolness or warmth of a color **(B)**. Both swatches are green, but the one on the left is cooler; that is, it has more blue and less yellow. The swatch on the right is relatively warmer; it has much more yellow and less blue. *Value* is a measure of the relative lightness or darkness of a color **(C)**. Both swatches are the same hue, violet, but the one on the right is darker in value. Finally, *intensity* (also called *brightness, chroma,* or *saturation*) refers to the relative brilliance or dullness of a color **(D)**. These swatches are the same hue and value, but the one on the left is a purer color. It is said to have a high intensity, while the swatch on the right is duller and is said to have a lower intensity.

## LOCAL COLOR VS. PERCEIVED COLOR

Painters distinguish between *local* color and *perceived* color. Local color is the color of something uninfluenced by any light of a particular color. It corresponds to our preconceived notion of what color something is, based on our previous experience. Grass is green. Tree trunks are brown. Skies are blue. Perceived color, on the other hand, is the color of something as it actually appears to our eye under the influence of a particular color of light. In representational landscape painting, perceived color is always the color the painter is most interested in. We know that a tree is green, but that knowledge is misleading. It prejudices our perception of colors, inhibiting us from observing the color of the tree as it appears at that moment under the influence of a particular color of light. When instructors tell stu-

dents to "paint what you see," they are referring to perceived color.

In my first year of college, I bumped into some seniors painting outside. I was both impressed and confused. Their trees looked *wonderful*—painterly, colorful, and full of light. But they used blue in their trees. *Blue?* Trees are green! I questioned them, and they grinned at this lowly freshman. They told me they actually *saw* those colors, but I didn't believe them. It wasn't until I discovered, with my own brushes in hand, which color mixes actually produced the effects I was after that I understood what they were telling me. The color that got it "right" was not at all the color I expected, but the *perceived* color I actually saw. I now see blue in trees, violet in shadows, and even yellow in the sky. Using those colors produces better results than relying on my preconceived notions of what color I *think* things are.

**Identifying perceived color.** The color isolator is a simple tool that helps you see perceived color. You can make one by simply punching a hole in a stiff piece of cardboard. Close one eye and hold the isolator between 6 and 12 inches from your eye. Position the hole over the color that you are evaluating. This isolates the color, momentarily taking it out of its context, so that you can perceive it more objectively. Color isolators often have three holes, each one surrounded by a different value: dark (black), light (white), and middle gray. Look through the hole surrounded by the value that is closest in value to the color you are evaluating.

## COLOR TEMPERATURE

Color temperature—the relative "cool" or "warm" attribute of a color—is one of the most important and descriptive color relationships. Like all color relationships, it is entirely relative. Most people would agree that certain colors are cool, like blues, and others warm, like yellows and reds. But such permanent labels limit our sensitivity to temperature. From the painter's perspective, a cool color is only cool when set against a warmer (or less cool) color. A warm color is only warm when compared to a cooler (or less warm) color. In other words, colors are only cooler than or warmer than other colors.

Temperature differences provide a vital form of color contrast, occurring at all times and in all places. So prevalent are the shifts between cool and warm, particularly between passages of light and dark, that color temperature must always be considered. A painting with variations between cool and warm (as opposed to all warm or all cool) offers greater variation and interest to the color composition.

Of particular note, differences between light and shadow reflect a temperature shift. As a color makes a transition from light to shadow, it not only undergoes a change in value but a change in temperature. Colors in the light are (usually) warmer, and colors in shadow are (usually) cooler, although the opposite can be true. This transition is apparent in Claude Monet's *Antibes Seen from La Salis* (page 117). In the boughs of the tree, the yellow corresponds to lit areas, while the blues are appointed to the shadowed areas.

Temperature also affects the spatial position of colors. A well-known tenet in painting is that warm colors advance and cool colors recede. More precisely, warm colors will seem to advance or recede in space depending on context, and cool colors will do the same. For instance, there are circumstances in which cool colors advance when surrounded by warm colors. Rather than follow rules that are true only some of the time, train your eye to look for temperature differences, whatever they might be.

Color is my daylong obsession and torment.
—CLAUDE MONET

Jill Soukup, *Last Windows Alight*, 2007, oil on canvas, 20 x 16 inches (50.8 x 40.64 cm)

Soukup's urban landscape is built upon contrasts—of patterns, values, and colors. The striking relationship between the light and cast shadows on the wall are not simply the result of value differences; they achieve their richness through hue and temperature shifts, as well. All the lights have a warm yellow or red cast, while the darks have a cool blue-violet cast. Even the rich darks in the lower left corner have a cool component.

**Color temperature differences.** Differences in color temperature can be very obvious or quite subtle. The contrast between the yellow and violet of this complementary pair (**A**) shows a marked temperature difference. Even within a single hue (**B**), there can be temperature differences. The left swatch is relatively warmer than the right. (Pigment-wise, the left swatch is based on cadmium red and tilts toward the yellow, warmer side of the spectrum, while the right one is based on alizarin permanent and tilts toward the violet end of the spectrum.) Among neutral colors, temperature differences can be subtle (**C**). The left swatch is relatively warmer than the right. The left has tiny bit more yellow, while the right has less yellow and a tiny bit more blue.

## COMPLEMENTARY COLORS AND NEUTRALS

The use of complementary colors is one of the most important color strategies for painters. Complements are described as "opposites" because they fall opposite each other on the color wheel. Red and green, blue and orange, and yellow and violet are complements. Complementary colors are extremely versatile because they can create color emphasis or make colors more neutral, depending on how they are used. When placed side by side, they create a vibration that heightens the visual intensity of each other, especially if the values of the two complements are close. We have seen this many times in a painting when bright red flowers are surrounded by a field of green, making the flowers appear even more brilliant. However, when those same complementary pairs of colors are blended together, they have the opposite effect and become neutralized.

Complements' neutralizing ability can be used to great effect in painting. Adding its complement to a color reduces the intensity of that color. Neutrals affect how colors advance or recede, as well. High-intensity colors (when surrounded by more neutral colors) tend to come forward, while neutral or gray colors (when surrounded by bright colors) tend to recede. Neutrals can also make pure colors appear brighter. If pure colors are used everywhere, there is little relief from the intensity. But when coupled with neutrals, purer colors seem much brighter. Contrast of intensity—bright versus dull—lends greater interest and variation to a color composition. (See Naturalistic and Expressive Color on page 125.)

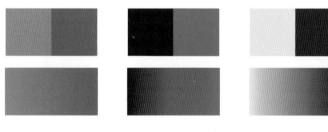

**Radiant and neutralizing complements.** When placed side by side, complementary pairs of colors create a vibration and heighten the visual intensity of the other (top row). I call these radiant complementary relationships. When complementary pairs of colors are mixed together (bottom row), they have the reverse effect: They cancel each other out and yield a neutral or duller color, seen in the middle of the mixture. I call these *neutralizing* complementary relationships.

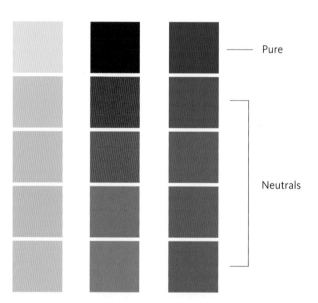

Pure

Neutrals

**Neutrals expand our color vocabulary.** Colors can range from the purest and most activated to the most "colorless" and gray. In the color swatches above, the top position is held by an absolutely pure hue. Each color below that is some degree of a neutral, getting progressively duller or grayer as its complement is added. When neutrals, or less-than-pure colors, are considered, there are infinitely more color possibilities.

Joseph Paquet, *Edge of Evening*, 2007, oil on mounted linen, 30 x 36 inches (76.2 x 91.44 cm)

There are no pigments that can radiate with the same intensity as an actual sunset; however, Paquet simulates the experience with a radiant complementary relationship. The yellow-orange light at the horizon feels much more intense when juxtaposed against its complement, the blue-violet snow. This is a more potent contrast than one created with noncomplementary colors. Paquet also demonstrates that complements do not have to be absolutely pure to be effective. Many areas within the violet snowbank are quite neutral, yet they still support the radiant relationship between the yellow-orange and blue-violet.

In nature, light creates the color. In the picture, color creates the light.

—HANS HOFMANN

## COLOR MIXES FOR LIGHT AND SHADE

As a color makes a transition from light into shadow, it doesn't simply undergo a change in value; it also undergoes a shift in hue, temperature, and intensity. For the light and shadow relationship to be convincing—to believe that both the light and shadow are occurring on a substance of the same color—there must be a common color present in both. A sunlit lawn might be a bright, intense yellow-green. A cast shadow on that lawn will naturally be a darker green, but it will also reflect a shift in hue and intensity. In terms of the color mix, the sunlit portion is made up of yellow and blue, but with *more* yellow. The shaded portion will be a darker, cooler green. It is also made up of yellow and blue, but it has much more *blue* than yellow. Thus, the mixtures for lights and shadows have similar ingredients, but the ratios vary. Since shadows are almost always duller than their corresponding light, the relationship can be made more convincing by reducing the intensity of the shadow. This can be done by adding a neutral color, such as burnt umber, or by adding the complement to the shadow's color.

Part of the trick to getting light and shadow to appear convincing in a painting is to not make the shadows too dark. Shadows in the landscape are often quite dark, particularly on sunny days, but if those darks are translated directly into the painting, much of the color within them will remain hidden. Shadows can be as rich and alive as light areas. Making the very dark values slightly lighter reveals more of the color buried within the shadow and makes the entire color composition appear more luminous. (See page 114 for more on how value affects color identity.)

Peter Malarkey, *Sunday*, 1999, oil on canvas, 16 x 20 inches (40.64 x 50.8 cm)

The many cast shadows here demonstrate the type of color mixes needed to create a convincing relationship between light and shadow. The sunstruck areas of the blue walls and doors are a light, warm blue. The cast shadows across the blue are, of course, darker, but they also undergo a shift in temperature and intensity. The shadow becomes slightly cooler and warm neutral spots of color reduce the shadow's intensity. Malarkey also cross-pollinates the mixtures. In the white areas of the wall, the lights are not entirely pure; they contain a little bit of the neutral color from the shadows. And the cooler shadows contain a little bit of the warmth from the light areas. The light and shadow share similar pigment mixes, but in varying proportions. Malarkey also avoids making the shadows too dark; if he had, the subtle hues that fill the shadows with color would be less discernable.

## THE CHALLENGE OF GREEN

To be sure, there is a lot of green in nature. This makes landscape painters susceptible to a common malady known as "greenitis," which induces them to overfill their paintings with green hues. An overabundance of green can give a painting an artificial or acidic look and destroy the coloristic variation that keeps a landscape painting alive and interesting. There are several remedies for greenitis, all of which stretch one's eye toward seeing other hues *within* the green and seeing the temperature differences between the lights and shadows.

### SUPPORT GREEN WITH OTHER COLORS.

One of the secrets to working with green is to use it in combination with other colors. In the landscape, green is rarely *only* green. It contains a variety of other colors, virtually every color of the spectrum—blue, purple, yellow, orange, and even its complement, red. Remember, green is a secondary color, made from a mixture of the primary colors yellow and blue. By thinking of green in terms of its component ingredients, we stretch our eye to see more of these other hues. Once we see more yellows and blues, then it is easier to see colors that are analogous to yellow and blue, like red and orange or violet. Mixing your own greens, instead of relying on tube greens, is a great way to expand your color vocabulary around greens.

### PAY ATTENTION TO COLOR TEMPERATURES WITHIN GREENS.

Yellow and blue, the component colors of green, have a natural cool/warm relationship, which often corresponds to light and shade in the landscape. Under a warm sun, sunlit passages are (usually) warmer and shadow passages are (usually) cooler. The more sensitive you are to temperature differences within green, the more varied those greens will become.

## THE SPATIAL PROPERTIES OF COLOR

Of the many powers color exerts in painting, no power requires a more sensitive eye than the one used to suggest space. Color has spatial powers that go far beyond the basic tenet that warm colors advance and cool colors recede. *All colors—according to their color, placement, and application—can either come forward or recede relative to the colors around them.*

Every color in a painting is attached to something depicted within the three-dimensional space. The row of hedges in the foreground is closest to us, the house sits in the middle ground, and the sky sits even farther back. We mix colors for each of those areas according to the colors we perceive, but if we also mix colors that express an appropriate amount of advancement or recession, we effectively reinforce that element's position in space. The reverse can also be true, which is what makes reading color in spatial terms so tricky. All the spatial cues in a painting can be correct—volume, drawing, overlapping forms, scale, and perspective—but a color can still be assigned to an element that contradicts its position in space. The position and drawing of the hedge can say, "I'm up front," but the *color* of the hedge can actually say, "I'm farther back than the sky!" In other words, colors can advance and recede independent of the objects to which they are attached. What's more, it is not only the color itself that implies spatial properties, but how *much* of that color is used (areawise), *where* it is used, and *how* it is applied. Even the hardness and softness of the edge of the stroke comes into play.

Color temperature and intensity also influence the spatial properties of color. Warm colors (when surrounded by cooler colors) tend to advance, while cool colors (when surrounded by warm colors) tend to recede. Brighter, purer colors usually advance more than neutral or grayed-out colors. You can help something in the distance "hold its place" by graying it out slightly, and you can make something in the foreground come forward by applying a more intense color to it.

They'll sell you thousands of greens. Veronese green and emerald green and cadmium green and any sort of green you like; but that particular green, never.

—PABLO PICASSO

## CORRECT VALUES, CORRECT COLOR

Value and color are inextricably woven together. As we build color relationships within our paintings, it is very important to maintain the proper value relationships and continue to refine them as needed. When a color does not work, the fault is not always the hue but often an incorrect value. Correct value relationships are essential for getting colors to work.

# HOW VALUE AFFECTS COLOR IDENTITY

Creating a convincing illusion of light requires a delicate balance between value and color. They work interdependently. Of special importance to the landscape painter is the way value affects color identity. When colors become extremely dark or extremely light, their color identity becomes much less potent. A shadow, if made very dark, will read primarily as a dark value and very little as color. Similarly, an extremely light or nearly white passage also has much less color identity. A color's full personality is expressed when its value is neither too dark nor too light but when it is in the middle-value range. An understanding of this is essential for landscape painters who, in an effort to capture the luminosity found in nature, must be able to let colors achieve maximum expression.

## VALUE-PRIORITY AND COLOR-PRIORITY SYSTEMS

The effect of value on color identity can be demonstrated by comparing two schools of painting: the Dutch landscapists of the seventeenth century and the Impressionists of the nineteenth century. Both successfully depict natural light, but each does it through very different means: The former tradition uses a value-priority system, the latter a color-priority system.

An extreme contrast between light and dark, a value-priority system, was used by the old masters of *chiaroscuro* (from the Italian "light-dark"). In the first half of the seventeenth century, painters like Caravaggio and Rembrandt used exaggerated contrasts to create the illusion of volume and evoke a sense of drama in their work. In the landscape tradition, the Dutch landscapists of the seventeenth century used a similar metaphor for light. They relied on heightened value contrasts to convey the drama of landscape light. Color is not absent in Dutch landscapes, but when value contrasts take priority, color relationships take a secondary role.

On the opposite end of the spectrum, the Impressionists used a color-priority system. Their goal was also to depict landscape light, but they believed that pure color was a better metaphor for the intensity and emotional impact of light than strong value contrasts. So they sought a strategy that relied less on value contrasts and more on color contrasts. This strategy employs, in part, a reduced value range. By keeping most of the colors in the middle range—neither too dark nor too

**How value affects color identity.** Extremes of value profoundly affect a color's ability to be read as color. In this 9-step value scale, colors on the left are very light in value, nearly white, with only the smallest amount of hue visible. On the right, colors are very dark in value, nearly black, and almost none of their intrinsic hue is left. If you squint at the chart, the colors in the middle zone (around steps 4 to 6) appear brightest and seem to come forward. There seems to be more "color" in this region. This demonstrates a fundamental truth about color: *A color's chromatic identity is most visible when its value is neither too dark nor too light but is in the middle-value range.*

light—colors retain more of their coloristic identity. Value relationships are still present, lending structure and volume to the subject, but in a more subordinate way. While a Dutch landscape painting relies predominately on value contrasts, an Impressionist painting relies much more on color contrasts.

Although the Impressionist approach to color is perhaps more in tune with contemporary color sensibilities, it is important to note that it is not a "truer" or more accurate depiction of natural light than the value-priority, Dutch landscapist approach. Both systems rely on artistic metaphors; both are "lies that tell a

truth." We don't see the world in the chocolaty, golden browns of the Dutch landscapists, nor do we see it in the high-key, exaggerated colors of the Impressionists. What we actually see is a combination of the two—a lot of neutrals punctuated by occasional pure or nearly pure colors. Contemporary artists can draw from the collective wisdom of many traditions. There are painters who use a value-priority system, those who use a color-priority system, and those who use a combination of both.

Meindert Hobbema, *Entrance to a Village*, c. 1665, oil on wood, 29½ x 43⅜ inches (74.93 x 110.17 cm). The Metropolitan Museum of Art, Bequest of Benjamin Altman, 1913 (14.40.614). Image © The Metropolitan Museum of Art

Hobbema's painting *Entrance to a Village* is shown here in both color and black and white. If you squint, it is easy to see that there's not nearly as much difference between them as compared to the color and black-and-white versions of the Impressionist painting on the following two pages. Although color is present, it is clearly subordinate to strong value contrasts. Hobbema's metaphor for light is extreme value contrast. Since very light or very dark colors hold less of their intrinsic color identity, they read primarily as values, as opposed to areas that also carry a lot of color information.

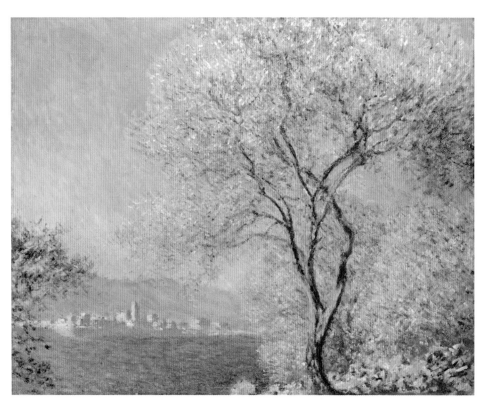

Claude Monet, *Antibes Seen from La Salis*, 1888, oil on canvas, 27⅞ x 36¼ inches
(70.8 x 92.07 cm). Toledo Museum of Art

The difference between the color and black-and-white versions of Monet's painting is much greater
than in Hobbema's painting. The Monet loses much in the translation to black and white. It looks
flat and washed out because many of the contrasts that make the painting work are based on color,
not just value. Hobbema's painting is based perhaps 85 percent on value and 15 percent on color,
while the Monet is based about 40 percent on value and 60 percent on color. *Antibes* still possesses a
value structure, but it has much less contrast. Nearly all the colors used are closer to the middle-value
range, allowing them to keep more of their coloristic identity and react with one another in more
chromatic ways. The overall effect is greater luminosity. *What value can achieve through contrast, color
achieves through chromatic identity.*

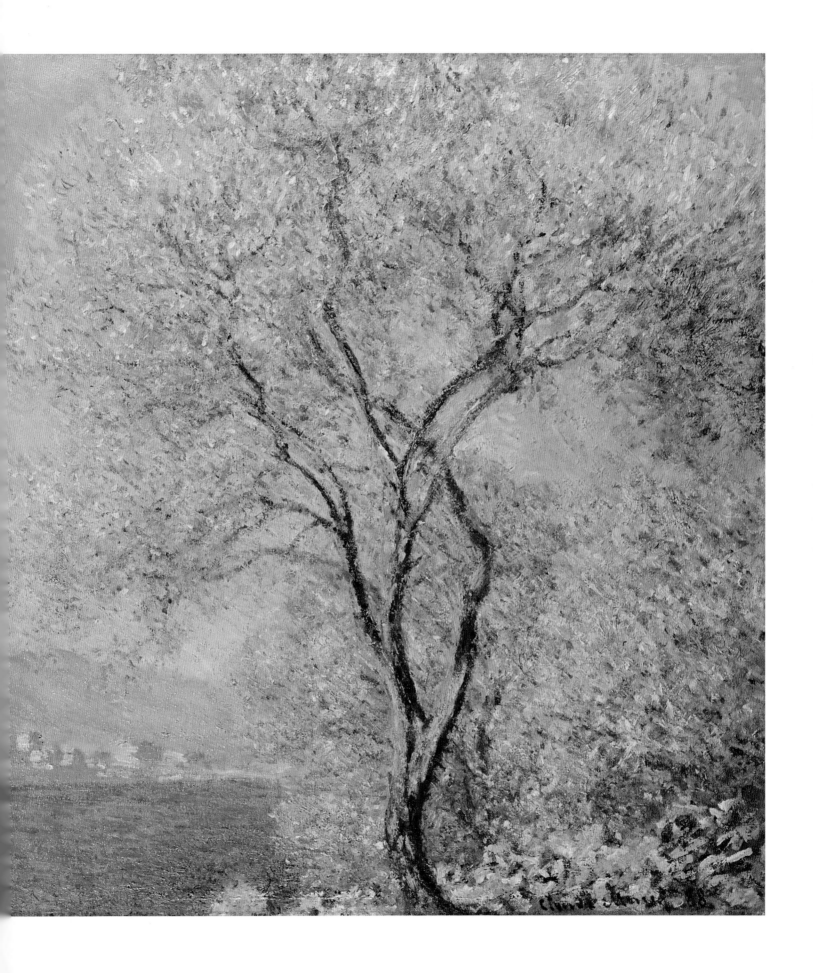

Color is only beautiful when
it means something.

—ROBERT HENRI

Kurt Solmssen, *Yellow Boat, Reading*, 2002, oil on canvas, 50 x 70 inches (127 x 177.8 cm)

Kurt Solmssen uses a color strategy that blends a value-priority and a color-priority system. He finds large patterns of light and shadow that fit together in interesting ways and then exaggerates the value contrasts for dramatic effect. He uses rich, dark colors for his shadows but keeps the lighter colors bright and intense. He is able to do this by carefully modulating values. If the sunlit areas were too light in value, they could not hold as much of their intrinsic color identity, which is what gives them richness and vibrancy. Instead, he selects values for the yellow lawn, green hedges, and blue water that are closer to the middle range, so they can retain more of their intrinsic color identity. The rich darks accentuate those colors further and form a strong diagonal pattern that helps organize the painting. Solmssen, in a commitment to working from direct observation, completes such 70-inch canvases entirely outdoors.

Edgar Payne, *Anchored at Concarneau*, c. 1921, 29 x 29 inches (73.66 x 73.66 cm). Courtesy of George Stern Fine Arts

Edgar Payne was among the best known of the California Impressionists of the early twentieth century. Many landscape painters often cite his book *Composition of Outdoor Painting* as a formative part of their training. There is an undeniable luminosity in *Anchored at Concarneau*. Payne achieves this by applying one of the most important lessons of Impressionist color: To keep colors luminous, avoid overly dark or overly light values. Colors in the middle-value range are better able to express their full chromatic identity. He also employs a radiant complementary relationship: Against the blue of the water and sky, the orange sails appear to glow in the sunlight. Though complements are "opposite" colors, he maintains a unified light by commingling the hues; in both the sky and the water, there are strokes of blue and orange laid side by side. Even in the shadowed sail in the middle, there are touches of duller orange and blue.

# HARMONY, UNIFICATION, AND THE "ENVELOPE OF LIGHT"

The landscape painter takes special interest in the "envelope of light"—the unified color and atmosphere that is so apparent in the landscape. The Impressionists first used the phrase not to describe *local* color (the color of *things*) but the color of the atmosphere that *surrounds* those things. Monet said, "For me, a landscape does not exist in its own right, since its appearance changes at every moment; but the surrounding atmosphere brings it to life—the air and the light, which vary continually. For me, it is only the surrounding atmosphere that gives subjects their true value."

A painting, of course, is not illuminated from within or enveloped by atmosphere, as is the actual landscape. It exists on a two-dimensional surface and can only reflect light. But the harmony and unifying effects of atmosphere can be imported into our paintings by using strategies that emphasize the similarities among colors, showing that there is a shared essence of every color in every other color.

## ANALOGOUS HARMONY

Analogous harmony describes the compatibility of colors adjacent to each other on the color wheel (referred to as analogous colors). Red and orange, for example, have similar wavelengths; they are as familial as any two colors can be and are therefore innately harmonious. The more closely related the analogous harmony, the more unified the light appears. When applied to landscape painting, analogous harmony is an extremely effective way to unify colors and suggest the "envelope of light."

However, a strictly analogous color scheme could lack color variation. In a painting comprising all blue hues, for instance, the color will be extremely unified, but there will be no other contrasting colors to lend variation to the composition. *Ballard Bridge* (page 122) and Jim Lamb's *Tuscan Hill Farm* (opposite) both use analogous color schemes yet integrate many other hues into the painting. Each painting has a ruling hue that influences all the other colors. The result is a harmony that unifies through analogy, while also achieving coloristic variation.

**Harmony and integration.** The ancient Chinese yin-yang symbol expresses the natural but opposing forces in nature: dark and light, masculine and feminine, hot and cold. Though contrasting, these forces are also interdependent. There is always a little of one energy present within the other. This idea can be expressed in color, as well. The colorist does not see each color in the spectrum as separate but as different aspects of an all-encompassing harmony. Both metaphorically and literally, every color within the spectrum relates to every other color.

## CONSIDER THE OVERALL COLOR OF THE LIGHT

If you are is interested in conveying an "envelope of light," you cannot use the same sets of colors that have worked well in the past over and over. As the light changes, each moment presents a unique color-light. While there may be many colors in any given subject, there is usually one *ruling* hue that dominates. That hue is not the local color of the subject but the *average color of the light* surrounding the subject. Before starting a painting, ask, "What is the essential color harmony of the scene?" Is there an overall color of light out of which all the other colors emerge?

Jim Lamb, *Tuscan Hill Farm*, 2007, oil on board, 15 x 15 inches (38.1 x 38.1 cm)

Jim Lamb uses analogous harmony to foster the illusion of a dense, colored light that bathes the entire scene just before sunset. There are a variety of different hues in here: blues, purples, oranges, ochres, greens, and lavenders in the sky, yet each is tinged by the ruling hue, orange, that controls the color of the light. The orange is obvious in certain areas, as in the foreground and the striped tracks in the road. In other areas, as in the trees and sky, other hues dominate, but they are still influenced by the ruling hue. *Tuscan Hill Farm* demonstrates a universal principle of painting landscape light: The color of the light informs the color of everything it touches.

**Analogous harmony.** Analogous colors are inherently compatible because they are related chromatically. This sampling of colors from *Ballard Bridge* (right) expresses an analogous harmony based on yellow and green. Note that the analogy does not have to be absolutely strict to be effective. Colors in this sampling include cool hues and some neutrals, but each is tinged by the dominant golden hue. Here, analogous harmony is combined with colors that have a reduced value range, which supports the illusion of density within the atmosphere.

## THE EFFECT OF REDUCED TONAL RANGE ON ATMOSPHERE

While analogous harmony works to unify the light, controlling the value contrasts has a profound effect on how clear or dense the atmosphere in a painting appears. As the contrast between light and dark is reduced, the illusion of atmosphere or "envelope of light" is increased. In nature, this is seen in an exaggerated way in foggy conditions. The reverse is also true: As value contrasts increase, the density of atmosphere diminishes. The harmony may remain, but the light suggested is clearer. When combined with analogous harmony, reduced value contrasts give the artist a powerful recipe for creating a rich, atmospheric, and unified light within a painting.

Mitchell Albala, *Ballard Bridge*, 2000, oil on canvas, 29 x 22 inches (73.66 x 55.88 cm)

*Ballard Bridge* uses several strategies to suggest the envelope of light. The painting uses an analogous harmony, which has a strong unifying effect on the colors. There are many hues within the painting (green, violet, blue, yellow, and orange); yet, they are all influenced by the ruling hue, the golden-yellow color of the light. Reducing value contrasts heightens the illusion of a dense, foggy atmosphere. To suggest a sense of space within this frontal and symmetrical composition, I expanded and enlarged the reflection in the water as it advances toward the viewer. It also changes color. A subtle yellow-orange/blue-violet complementary relationship creates a contrast that seems to lift the surface of the water. Edges are also modulated. Softer edges hold the bridge back at the top of the painting, while sharper edges in the reflection help bring that plane forward.

Jim Lamb, *Tuscan Hill Farm*, 2007, oil on board, 15 x 15 inches (38.1 x 38.1 cm)

Jim Lamb uses analogous harmony to foster the illusion of a dense, colored light that bathes the entire scene just before sunset. There are a variety of different hues in here: blues, purples, oranges, ochres, greens, and lavenders in the sky, yet each is tinged by the ruling hue, orange, that controls the color of the light. The orange is obvious in certain areas, as in the foreground and the striped tracks in the road. In other areas, as in the trees and sky, other hues dominate, but they are still influenced by the ruling hue. *Tuscan Hill Farm* demonstrates a universal principle of painting landscape light: The color of the light informs the color of everything it touches.

**Analogous harmony.** Analogous colors are inherently compatible because they are related chromatically. This sampling of colors from *Ballard Bridge* (right) expresses an analogous harmony based on yellow and green. Note that the analogy does not have to be absolutely strict to be effective. Colors in this sampling include cool hues and some neutrals, but each is tinged by the dominant golden hue. Here, analogous harmony is combined with colors that have a reduced value range, which supports the illusion of density within the atmosphere.

Mitchell Albala, *Ballard Bridge*, 2000, oil on canvas, 29 x 22 inches (73.66 x 55.88 cm)

*Ballard Bridge* uses several strategies to suggest the envelope of light. The painting uses an analogous harmony, which has a strong unifying effect on the colors. There are many hues within the painting (green, violet, blue, yellow, and orange); yet, they are all influenced by the ruling hue, the golden-yellow color of the light. Reducing value contrasts heightens the illusion of a dense, foggy atmosphere. To suggest a sense of space within this frontal and symmetrical composition, I expanded and enlarged the reflection in the water as it advances toward the viewer. It also changes color. A subtle yellow-orange/blue-violet complementary relationship creates a contrast that seems to lift the surface of the water. Edges are also modulated. Softer edges hold the bridge back at the top of the painting, while sharper edges in the reflection help bring that plane forward.

## THE EFFECT OF REDUCED TONAL RANGE ON ATMOSPHERE

While analogous harmony works to unify the light, controlling the value contrasts has a profound effect on how clear or dense the atmosphere in a painting appears. As the contrast between light and dark is reduced, the illusion of atmosphere or "envelope of light" is increased. In nature, this is seen in an exaggerated way in foggy conditions. The reverse is also true: As value contrasts increase, the density of atmosphere diminishes. The harmony may remain, but the light suggested is clearer. When combined with analogous harmony, reduced value contrasts give the artist a powerful recipe for creating a rich, atmospheric, and unified light within a painting.

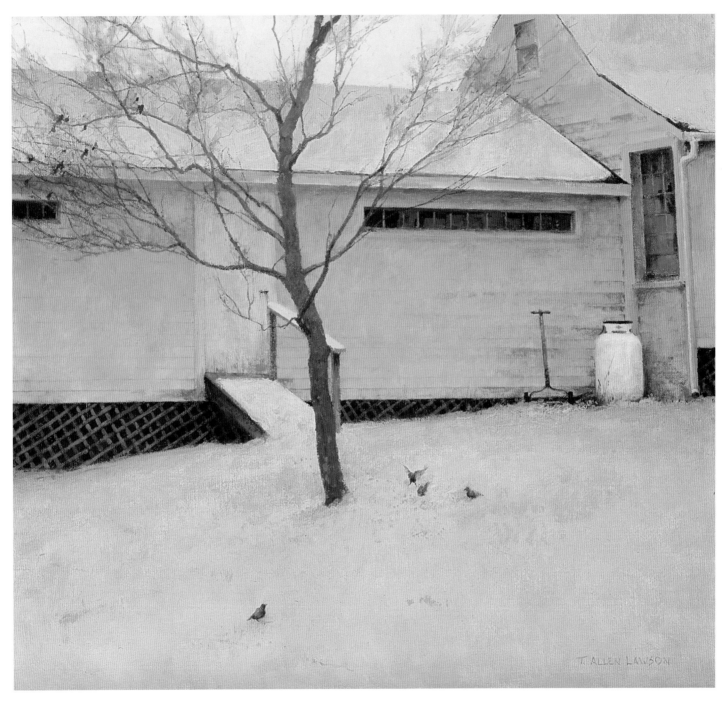

T. Allen Lawson, *Dooryard*, 2007, oil on linen, 24 x 26 inches (60.96 x 66.04 cm)

Analogous harmony is not the only way to bring colors into agreement. The strong sense of unified light in T. Allen Lawson's paint-ing is achieved through a *harmony of neutrals*. A "perfect" neutral would have no color bias at all; it would be an absolute gray; thus, as colors become increasingly gray, they begin to harmonize through a common association to neutral or to the "absence of color." Though more subdued, Lawson's color relationships are vital to the color strategy. There is a clear temperature shift between the cool snow and the warmer sides of the house. The strip of pale yellow sky is a gentle surprise amidst the neutral tones. It, too, is somewhat neutral, so it doesn't jump off the canvas. Lawson achieves a palpable sense of stillness and harmony through a skillful orchestration of neutral hues.

## ATMOSPHERIC PERSPECTIVE

Atmospheric perspective (also known as aerial perspective) is one of nature's most visible demonstrations of the envelope of light. The farther away something is, the more atmosphere it is seen through. That atmosphere, and the color it reflects, affects the appearance of both values and colors. Value contrasts are reduced, details are softened, and colors become lighter, cooler, and less saturated. On a typical blue-sky day, atmospheric perspective is seen as an increasing shift toward blue and/or violet in forms as they recede farther into the distance. Across extreme distances, the bluing effect can be so strong that the colors of the landscape merge with the sky. Because atmospheric perspective is such a recognizable effect, both in reality and in painting, it is an extremely reliable cue for indicating distance and space.

Air is a physical substance that has density. It contains small particles of moisture, dust, and pollution that reflect whatever color passes through it. Generally, it is an increasing amount of blue or violet that is seen across greater distances. At sunrise and sunset, however, different colors are reflected in the atmosphere, so we may see much warmer colors. In terms of actual pigment mixes, atmospheric perspective usually translates into less yellow, which in turn brings out more blues and violets.

While atmospheric perspective is always present, it varies according to distance, humidity, dust, and pollution. In New York, where I learned to paint, I could see atmospheric perspective in as little as a few hundred feet on a humid day. In other areas of the country, where there is less humidity, atmospheric perspective may become obvious only at much greater distances.

I was never one to paint space; I paint air.

—FAIRFIELD PORTER

**Atmospheric perspective in action.** Air is a physical substance that reflects the color of light passing through it. As we look through more layers of atmosphere, value contrasts are diminished and colors become lighter, bluer, and less saturated. These effects are predictable and recognizable, so they are a reliable way to suggest depth within a painting. In the photo, the *local* color of all the hills is surely green, but seen through the layers of colored atmosphere, the distant hills appear very blue. On the left, the hills become lighter, paler, and bluer as they recede into the distance, until they nearly merge into the sky.

# NATURALISTIC AND EXPRESSIVE COLOR

Throughout the chapter, we have explored the idea of color "metaphors"—strategies artists use to capture the effects of natural light in their paintings. These metaphors may be visualized along a continuum, with *naturalistic* or realistic color on one end and *expressive* color on the other.

With naturalistic color, painters endeavor to choose colors that capture a real likeness of nature, as they might perceive them in the real world. They pay a great deal of attention to *perceived* color—how something appears under the influence of a particular color of light—and to the many neutral colors observed in nature. On the other end of the continuum, artists who use *expressive* color explore color in more subjective and expressive ways, often raising the color intensity to what might be considered outside the bounds of "reality" or selecting colors

that are intentionally different from the object's local color. Even within such a departure, an expressive strategy can still capture a truth about the artist's experience of the color and the nature of light. Every interpretation of color, every translation of natural light, can be seen as falling somewhere along this continuum.

**"CONVINCING" COLOR.** One type of color approach is not better than another; however, the success of any approach is measured in the same way: Is the color strategy convincing? In this context, *convincing* does not necessarily mean realistic but whether it allows the viewer to suspend judgment and accept the visual metaphor being set up by the painter. The colors can be wildly exaggerated or greatly subdued, but the painter must get the viewer to agree with the interpretation.

All color is no color.

—KENNETH CLARK

Jay Moore, *Elk Creek*, 2007, oil on canvas, 20 x 40 inches (50.8 x 101.6 cm)

Jay Moore captures a likeness of nature's colors by using a naturalistic color scheme. He is sensitive to the many neutral or gray colors found in nature, which in this scene are found in the many shadow areas. Yet, he is able to achieve maximum color impact by reserving the most intense color for a single area: the yellow grasses of the middle ground. The darker values and neutrals surrounding the yellow make it stand out that much more. Less is more when bright color is used judiciously within a field of less-bright or neutral colors.

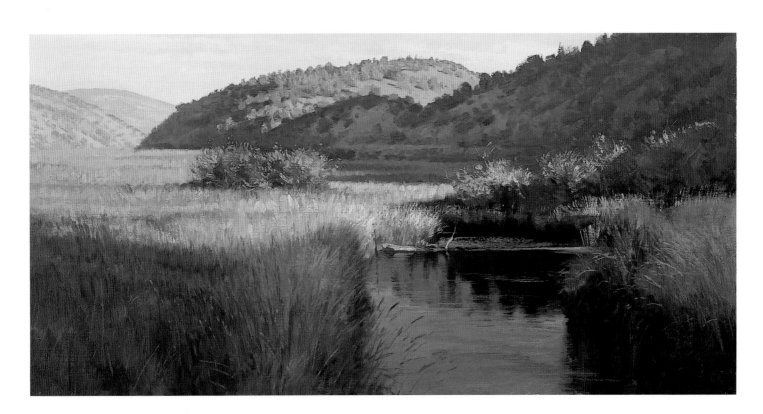

Expressive color gives the artist greater opportunity to revel in color for the pure love of it. And with so many moments of brilliant color in the landscape, there are more than a few opportunities to do this. However, if saturated colors are overused, the overall color arrangement may be too loud. For bright, pure colors to work within the context of the painting, they must be used in such a way that the viewer can accept the high-key metaphor on its own terms.

A musical analogy can express how this happens. On the piano, I can play "Chopsticks" in a very low register, with deep, resonant notes, or I can play it in an upper register, on the other end of the keyboard. The progression of the notes, what establishes the basic melody, is the same in both registers. It is not the different octaves that determine the melody but the relationship among the notes. In the same way, colors can be mapped in different octaves, so to speak—in a low, neutral key or a high, intense key—as long as the relationship among the colors remains convincing within the context of the painting. The Impressionists frequently used colors that were "impossible," that were certainly not seen in reality, but in the context of the entire painting, the colors were entirely believable and achieved a remarkable illusion of light.

> A thimbleful of red is redder
> than a bucketful.
> —HENRI MATISSE

**WITH GREAT POTENTIAL COMES GREAT RESPONSIBILITY.** Artists and viewers alike respond *very* well to bright, saturated color and always have. Being able to evoke an immediate, strong, and positive reaction is no small achievement. But color can be so captivating that it can cause the painter (and viewer) to overlook the other important ways colors must work together. Color, as powerful as it is, is just one dimension of a painting. There are other essential dimensions, such as subject, value, composition, and technique. Because color is regarded as interpretive and expressive, artists may feel they have license to disregard color principles; however, just because a color may evoke an emotional response in the artist does not mean it works on an aesthetic level in the context of the entire painting. Expressive color is ultimately a commitment to *meaningful* color.

**COMBINING PURE COLOR WITH NEUTRALS.** If only pure color is used, and used everywhere, then nothing will stand

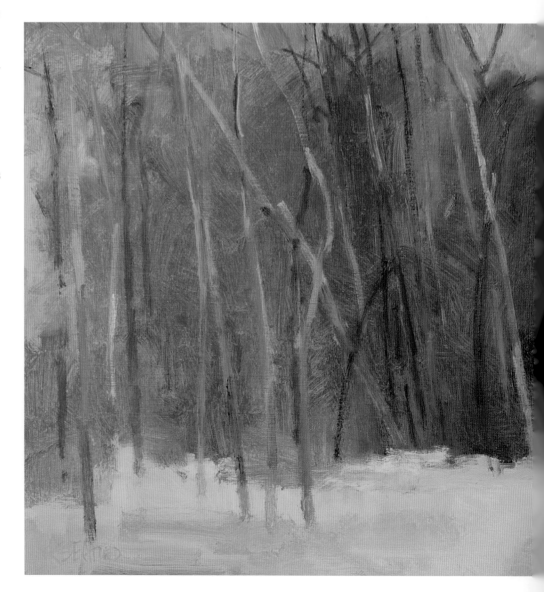

out. Put another way, everything stands out, but there is no variation, no relief from the intensity. An all-saturated set of colors tends to sit on the surface, keeping everything in the painting on one plane. The natural differences between bright and dull that help suggest near and far are lost. Referring again to a musical analogy, all pure color is like a chorus of sopranos. They will sound very harmonious, but if a single baritone is added to the chorus, then suddenly the sopranos are heard differently, and the baritone takes on special meaning. Similarly, if pure color is contrasted with some "less pure" neutrals,

then the colors will seem that much brighter, and the presence of neutrals will add variation to the color arrangement. Contrast of color—bright versus dull—is much more interesting than a field of "all bright."

The world has many more neutrals than the aspiring colorist might expect. We do not see the world all in grays, nor do we see it in all high-key colors. What we actually see is a combination of the two—a lot of neutrals punctuated by occasional pure or nearly pure colors. The painter's task is to combine them in a way that best expresses their coloristic vision.

## REDEFINING "COLORFUL"

The word *colorful* typically suggests bright, saturated colors. But neutral or gray colors are *also* color. They may be more subdued than intense colors, but they do just as much work. In a very real sense, T. Allen Lawson's neutral-colored *Dooryard* (page 123) is just as "colorful" as Rodger Bechtold's *Tree Rhythm 1 and 2* (below). In Bechtold's painting brighter colors are more apparent, their voice a little stronger. In Lawson's piece, the neutral colors speak more softly but communicate just as clearly. A colorful painting is not measured by the amount of saturated colors it has but by how effectively the colors are used to create a desired effect.

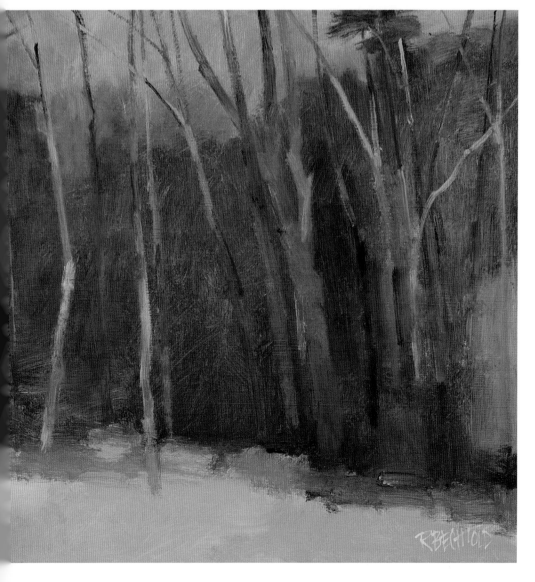

Rodger Bechtold, *Tree Rhythm 1 and 2*, 2008, oil on canvas, 20 x 40 inches (50.8 x 101.6 cm)

Rodger Bechtold uses an expressive color model here. His colors are more exaggerated than those used in a naturalistic color scheme, yet they pass the expressive-color test: They are convincing within the context of the painting. They do not overpower or become saccharine because they are supported with less intense colors. As compared to Jay Moore's *Elk Creek* (page 125), *Tree Rhythm 1 and 2* is predominantly higher-key color, bracketed with some neutrals. Jay Moore's painting is predominantly built with neutrals and bracketed with select areas of pure color.

CHAPTER NINE

# THE LIFE OF A PAINTING: FROM START TO FINISH

Great things are done by a series of small things brought together.

—VINCENT VAN GOGH

Now that foundational principles such as value, massing, composition, and color have been explored, we can consider the actual process of painting from start to finish. How does one start a painting? How is color mixed and applied? Are the concerns at the start of the painting different than those at the end?

Throughout the life of a painting, artists must make so many aesthetic and technical choices that they find it helpful to divide the overall process into three stages: In stage 1, *preparatory work*, an idea or vision is first explored with sketches or small studies—anything that helps the painter get to know the subject and test its visual integrity. In stage 2, *underpainting*, a value-based, monochromatic version of the painting is established that lays a foundation of placement, composition, and value. Stage 3, *development*, involves everything from the initial lay-in of color to completion. Ongoing revisions continue to support the idea that was envisioned in stage 1 and mapped out in stage 2.

Considering each part of the process as a separate stage helps you stay mindful of the necessary steps and increases the likelihood of making the best choices. In practice, the borders between the stages are not as precisely defined as they are in this chapter; however, they apply just as readily to one-session plein air painting as they do to longer studio painting, albeit in a far more abbreviated way in outdoor work.

Larry Gray, *2:00 at Saco Pass*, 2008, oil on canvas, 50 x 39 inches (127 x 99.06 cm). Courtesy of The Haen Gallery

Whether executed in an hour or over the course of many days or weeks, the life of a successful painting involves a series of creative and technical choices. Although Gray's process is very much an intuitive exploration and one based on visual memory, he works in stages that give him greater control over each phase and support him in achieving his vision. *2:00 at Saco Pass* was begun with an underpainting in which the large directional energies, shapes, and values were fleshed out. Then, development involved an ongoing series of layered color. Gray points out that he is willing to respond to the evolving vision at any stage by making necessary changes.

# STAGE 1: PREPARATORY WORK

The explorations made before beginning a painting are an essential stage in bringing a vision to life. Painting students often spend a lot of time wondering how to finish a painting, but it is at the start that many of the most critical decisions are made. A simple thumbnail sketch, a color study, or a compositional study is an effective way to test the visual integrity of an idea or composition. A study can expose potential problems, reveal new directions, or help you determine that the visual idea will not work as it was initially envisioned.

Unfortunately, this first stage is often not given enough attention, especially in plein air painting. Sometimes, it is completely ignored. As a first effort at expressing an idea on paper or canvas, a preparatory study holds great importance. It is the stage in which potential problems are resolved and the direction of the painting is laid out. For example, if you can't resolve a compositional problem in a thumbnail, it will not magically resolve itself in the actual painting. In the studio, you may spend hours or days with preparatory work, choosing subject matter, exploring color options, and experimenting with different compositions. Outdoors, when the entire process is compressed into a few hours, preparatory work is just as important but must be done more quickly. A few minutes taken with the viewfinder and spending five minutes doing a thumbnail can be all that is required to get on course and avoid the need to backtrack later on.

Opposite, top: Tim Horn, *Study for New Day*, 2008, pencil on paper, 4 x 5 inches (10.16 x 12.7 cm)

Even the simplest thumbnail can serve as a plan. What does this sketch for the painting *New Day* (page 59) reveal? Everything except color. It shows the arrangement of the major shapes, gives a suggestion of values, and imposes a picture window that frames the composition.

Opposite, bottom: Mitchell Albala, *Discovery Lighthouse*, 2008, pencil on paper, 3½ x 5 inches (8.89 x 12.7 cm)

The distribution of light and dark values helps define the structure of a composition. This thumbnail sketch "pushes" the values to extremes, making them nearly all dark or all light. The pattern created, which acts as the underlying framework of the composition, is called the *value plan*.

Mitchell Albala, *Union Tree*, 2008, oil on paper, 4½ x 5 inches (11.43 x 12.7 cm)

Studies or thumbnail sketches—the humble notations that are the painter's first attempt at working out a visual idea—are often the most reductive form of drawing or painting. Though small in form, they can be big in spirit. A small color study such as *Union Tree* is a wonderful way to test a color direction of a painting and attune the eye and hand to simplified shapes and masses.

STONE FISH — PORT CLYDE

## FROM THE GENERAL TO THE SPECIFIC

The three stages of the painting process conform to an approach artists refer to as "working from the general to the specific." It is a practical approach that suggests that broad decisions make more sense in the earlier stages, while progressively smaller and more specific decisions are more consistent with the later stages. The start of a painting is when you will make the most changes—exploring compositional variations, correcting drawing, adjusting values, and testing color. Keeping your decision-making as broad and flexible as possible in this first stage is critical. That won't happen if you are resistant to changing the first marks you put down. Getting overcommitted too soon is a sure way to restrict your creative options. As the painting progresses into the later stages, the general moves gradually give way to more specific decisions, such as color refinement, paint application, texture, and manipulation of edges. Working from the general to the specific is a practical way to support the formation of a vision, both conceptually and technically.

# STAGE 2: UNDERPAINTING

The start of every painting deserves a solid foundation. There's no better way to establish that—to lay the foundation, so to speak—than with an *underpainting,* a monochromatic version of the painting done on the canvas with paint. As the foundation stage, it works out the all-important issues of composition, drawing, and value relationships *before* getting too involved with color.

Underpainting is a traditional approach that has been used for centuries. And for good reason—it works. As practiced by the classical masters, it was an elaborate and lengthy process (called a *grisaille*), yielding highly realistic and detailed underpaintings. However, the approach demonstrated here, and the one used by many contemporary painters, is a simpler, modified version. It is even easy enough to be used with paintings done in short outdoor sessions.

An underpainting is begun by toning (staining) the entire surface of the painting with a middle-value color. Lighter values are then created by wiping away the toned surface to reveal the white of the canvas, and darker values are created by adding more of the same color used to tone the surface. Underpainting is an additive and subtractive process. A full range of values is achieved from a single pigment color. Paint is never laid on thickly in the underpainting; it remains thin and transparent so that it can be receptive to future layers of color. By alternately adding and subtracting, the painter is able to develop a full range of values in an entirely fluid manner. This helps the painter find the large shapes and value patterns that underlie the composition and make changes when they are needed most—at the start.

Some painters begin by sketching with a brush, pencil, or charcoal directly onto the white canvas. But white is the lightest value that can possibly be achieved in a painting—and not an effective tone against which to judge other values. A surface toned with a middle value, on the other hand, is a closer approximation of the *average* values found in the painting. Making a value choice against a middle-value tone requires judgment across only half of the complete range of possible values and thus makes comparisons easier.

Surprisingly, many painters don't bother with an underpainting. They might begin with a rough sketch for placement, often on a white surface, and then begin placing color as an immediate response to the subject. The problem with this approach is that it is very difficult for all but the most experienced painters to consider composition, drawing, and value *at the same time* that they are thinking about color. Separating the monochromatic underpainting from its multicolored development breaks the process down into more manageable steps. In my experience, I have yet to find a way of beginning that does as much for the novice (or more experienced painter) than an underpainting. It is the ideal means by which to make a measured, thoughtful start.

## COMPLEXITY, DRYING TIME, AND PAINT CONSISTENCY

Does an underpainting need to be complex? No, it can be as simple as a block-in of a few shapes and values zones or as complex as a rendering showing every nuance of light and shade. The criterion for a successful underpainting is not how "tight" it is but whether it allows you to establish composition, placement, and value relationships in a fluid, easily changeable way.

How fast does an underpainting dry? Those done in oil are usually completed in one session, and because an underpainting is very thin and partially cut with solvent, it dries much faster than fully loaded oil paint. An underpainting done in this manner will dry overnight, and the ability to wipe out and "erase" will be lost. In a long session, this thin paint might begin to dry in as little as three or four hours.

Can you apply fresh paint over a still-wet underpainting? Absolutely. Painters do it all the time, especially in one-session paintings. That is why the consistency of paint in the underpainting stage is so important. It is thinned just enough to be spreadable but not so much that it becomes wet like a wash. New paint will not stick well to a wet, slippery surface. If the underpainting is thin and is partially absorbed into the gesso ground, and never builds to texture, then it remains receptive to strokes of thicker paint. When applying paint over the underpainting, don't scrub too hard, as that can loosen the underlying tone. By applying light touches of color (always a good idea) your colors will adhere and stay fresh.

**Simple underpainting (left).** An underpainting does not need to be complex and detailed to be effective. In fact, the more it synthesizes shapes into simplified values and planes, the better. This 10 x 8–inch underpainting has enough structure to lay a foundation of placement and values, but not so much detail that discoveries cannot be made later on. Many of the light patterns on the trees are broad and round, shaped by my fingertip as I wiped out the lights. An underpainting of this complexity might take a person with drawing experience twenty to thirty minutes. When working on small pieces outside, a simpler underpainting is usually best. The underpainting tone used here is ultramarine blue, a pigment that offers a good value range and corresponds well to the many cool tones found within landscape shadows.

**Assert the underlying value structure with the underpainting (below).** The underpainting for the studio piece *August Falls* (page 45) simplifies the values to nearly two zones, reinforcing the value patterns that are the underlying foundation for the composition. The color for the underpainting, a neutral blue, was chosen to serve as a compatible undertone for the neutral colors that would come later. Naturally, I will spend more time working out subtle value gradations in an underpainting done in the studio than I would in a short plein air painting.

## SELECTING A COLOR FOR THE UNDERPAINTING

Although the underpainting is monochromatic, it *is* a color and will therefore profoundly influence the development of the painting's color direction. Even if the underpainting is completely covered up by the time the painting is finished, the presence of that under-color will have influenced the painter's choices. In fact, it is not uncommon to see the underpainting color show through the final layers of paint. (See the image opposite.)

Some painters use the same color for every underpainting, even pretoning their surfaces and letting them dry beforehand. Yet, if each painting is a unique response to the color of the light, then the initial color laid down should reflect that. For instance, if my overwhelming impression of the color-light is warm and golden, I might pick an analogous golden color like raw sienna. In other situations, I might use a contrasting or *complementary* color. If there is an overwhelming amount of green (no surprise in landscapes), I might choose a color in the red or violet family. Since that color will show through successive layers of paint, the green will be supported by the subtle complementary color relationships from the underpainting, which will add nuance and a richer variety of color in the shadows. Generally, I want some part of the color I witness to be part of the underpainting.

*The color used for the underpainting must be dark enough to provide an effective value range.* For that reason, light colors such as yellow or yellow ochre will not work well. Earth colors burnt umber and burnt sienna were classic underpainting tones in the sixteenth, seventeenth, and eighteenth centuries. To contemporary color sensibilities, burnt umber may seem too colorless, but it can be an effective starting point when a neutral under- painting is desired. Burnt sienna has a rich orange tone that can glow through successive layers, especially when there is a lot of green, but its richness can be overpowering.

The underpainting colors I prefer for plein air painting are raw sienna or ultramarine blue. Raw sienna makes for a delicious golden, warm tone. Used alone, raw sienna cannot create the darkest darks you will need, so add a bit of burnt umber to the mix at the latest stages of the underpainting. Ultramarine blue is also an effective underpainting tone. At first it appears to be a bit intense; however, it actually serves as a unifying color because it corresponds to the many cool colors in nature, especially in the shadows. It is a fairly dark pigment, so it can create a wide range of values. A custom underpainting color can also be mixed from two pigments, but be sure that the mixed color can provide an adequate range of values.

As stated, the color chosen for the underpainting has a direct influence on the color direction of the painting. Any pigment can be used as long as it is dark enough to provide an effective value range. From left to right, raw sienna and other "golden" pigments are favorites of landscapists because their warm undertone is reminiscent of the warmth generated by sunlight. Ultramarine blue corresponds to the many cool hues in the landscape, particularly in the shadows. Warm, reddish underpainting tones such as alizarin permanent, red oxide, and burnt sienna can show through successive layers of paint. And finally, some artists prefer a more "classic" underpainting tone such as burnt umber, which offers a warm, neutral tone on which to begin.

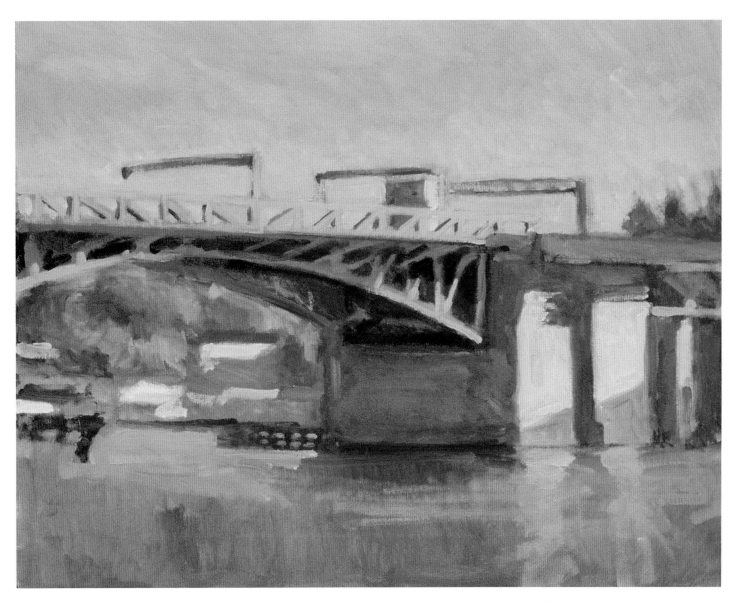

Mitchell Albala, *University Bridge*,
1998, alkyd on canvas,
16 x 20 inches (40.64 x 50.8 cm)

In *University Bridge*, my dominant color impression was the amount of blue—in the sky, in the water, and in the shadows on the bridge. I chose ultramarine blue as the underpainting color because I knew it would correspond to the blue areas as well as the cooler shadows. By letting it show through successive layers of paint—as seen in the shadow portion of the bridge pedestal, the girders, and the green trees in the distance—it helps unify the blues that touch nearly every area of the painting.

## DEMONSTRATION: UNDERPAINTING IN OIL

This following demonstration creates an underpainting for a simple plein air composition. Although the technique is not difficult after a little practice, it is essential that it be done correctly for the method to be successful. Thus, the rationale behind each step is explained, as well as the specific dos and don'ts of the technique.

### DEMONSTRATION NOTES

- Size: 8 x 10 inches

- Surface: Always select canvas on which a high-quality grade of gesso has been applied. A gessoed surface that is not absorbent enough (too slick) or is too absorbent can make the underpainting method more difficult. In this demonstration, I used a flat piece of Fredrix preprimed canvas taped to a lightweight board.

- Brushes: Large size 12 or size 14 bright for toning the surface; size 8 filbert for drawing in the basic shapes and most other areas; size 6 filbert as needed for smaller passages.

- Underpainting color: Raw sienna. This pigment is not quite dark enough to achieve the darkest darks, so a small amount of burnt umber is added in the later stages.

- Medium: The additive and subtractive approach used in this demonstration is ideally suited for oils. Because acrylics dry fast, they do not permit the subtractive wiping needed to reveal the white of the canvas. However, a modified approach can still be used with acrylics: Different values can be created by mixing white paint and one pigment color, and working wet-over-dry. Work in thin layers, not building too much texture, which would interfere with the later paint application.

**Step 1: Tone the surface.** Begin by covering the entire surface with the middle-value tone. (Be sure to use a pigment color that provides a wide value range.) Use a large, relatively short-bristled brush, such as a 12 or 14 bright. Use this size even on small 8 x 10–inch paintings. (A long brush, like a flat, or a soft synthetic brush, is too flexible.) **NOTE:** The darker the value of the underpainting tone, the more wiping you will need to do to pull out the lights. The effect of pulling out lights from a dark background can be dramatic; however, a basic middle-value backdrop (or slightly lighter than middle value) is easier to use, especially if you are new to the method.

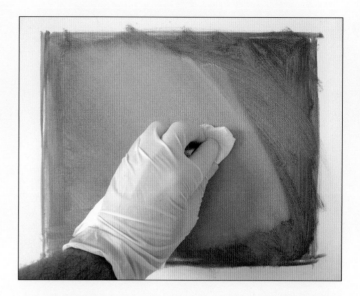

**Step 1a: Paint consistency is key!** A successful underpainting hinges on the consistency of the paint. Paint straight from the tube is too thick; it needs to be thinned with solvent to spread more easily. However, novices almost always add too much solvent, which creates a runny mixture that can be seen glistening on the surface (as shown); this is too wet to be workable! Any touch with a brush or rag lifts the pigment off completely, and additional strokes will not stick at all. The correct mixture can be described as pigment mixed with a *very* small amount of solvent. It should be fairly easy to spread around with a broad brush, perhaps requiring some scrubbing with the brush. The right consistency is wet enough to wipe out but dry enough to be receptive to successive layers of paint. In this context, "dry" does not mean dry to the touch; rather, it is thin paint that firmly adheres to the ground. **NOTE:** The amount of solvent needed will vary depending on the absorbency of the canvas. If the canvas is more absorbent, the pigment will bite into the surface, and it will take more solvent to remove the paint. If the surface is less absorbent, less solvent will be needed. **TIP:** Dipping the brush into a solvent cup will pick up too much solvent. Instead, sprinkle a few drops onto your palette, and thin the paint from there. This barely wets the brush.

**Step 1b: Wipe back.** Gently wipe the surface with a rag or paper towel to lift excess pigment. If the consistency of the initial tone was correct, about half the pigment will lift off, leaving a light stain of color. This stain should stick to the canvas and not wipe off too easily. This initial midtone does not have to be perfectly even; it just has to cover the entire surface.

**Step 1c: Test the consistency.** After wiping the surface, wrap a rag around the tip of your finger, and wipe a test spot. A *little* bit of pigment should come up. If wiping lightly pulls off too much tone, you have used too much solvent in your mixture. It should take some pressure and possibly a little solvent on the rag to lift off enough of the pigment to expose the white surface. If you cannot remove any of the tone, you may be working on an overly absorbent gessoed surface.

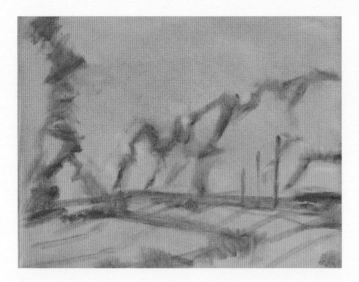

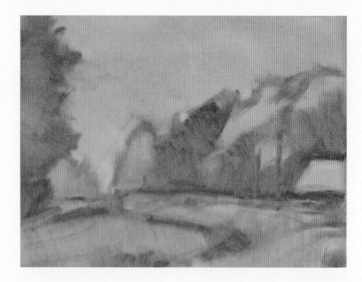

**Step 2: Sketch in the major shapes.** Use a brush for this step, not a pencil or charcoal. This is, after all, a *painting*, so why not flex your painterly muscles from the start? Think in terms of gesture, large shapes, and planes as much as possible. Don't be afraid to wipe out and make changes if necessary. Always use the biggest brush possible to avoid getting involved with detail. I used a size 8 filbert for the sketch and most of the painting and a 6 filbert for smaller passages.

**Step 3: Begin building value by establishing the darks.** Start by blocking in the darkest areas of value. This begins to define the structure of light and dark areas. From this stage forward, value relationships are developed by alternately subtracting lights (by wiping out) and adding darks (by brushing on more pigment). The consistency of the paint is the same: pigment cut with only the smallest amount of solvent.

**Step 4: Establish lights by wiping out the midtone with the rag.**
Lighter values are not made with white paint; rather, they are achieved by wiping out the midtone value to the white of the canvas. Wiping with a rag may seem awkward at first, but once you get the hang of it, you will be surprised at how much control you have. Wrap a portion of the rag around your fingertip rather than bunching up the rag and rubbing. Depending on the absorbency of the gesso, you may need to moisten the tip of the rag with solvent to remove the desired amount of pigment. To keep the lights fresh and clean, always use a clean portion of the rag. Wear protective gloves.

**Step 4a: Build darks by adding more pigment.** For darker shades of pigment to "stick" to the surface, you may need to use even less solvent. Remember, for the surface to remain workable, it has to stay thin and relatively dry—not dry to the touch, but thin and adhering to the ground. In underpainting, pigment should stay thin and never build to observable texture, as it might in later stages.

**Step 5: Continue value modulation.** Continue adjusting values by wiping out the lights and adding in darks. Note that the shapes are kept relatively flat and planar, which helps define the basic structure of the volumes. Use the largest brush possible; it will encourage you to simplify the patterns of light and dark.

**Step 6: Refinement and detail.** You can achieve fine effects if you wrap the rag around your fingertip and then wipe with your fingernail. You can also wrap the rag around the back end of the brush handle and "draw" with it. Both methods will work better if the rag is slightly moistened with solvent.

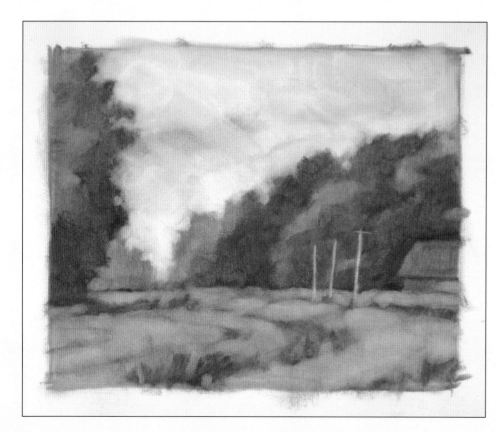

**Step 7: Complete underpainting.** Through an additive and subtractive process, a tonal version of the painting is eventually created. When you are satisfied with the composition and value structure, you can proceed to the application of color.

# STAGE 3: DEVELOPMENT

With an underpainting established—and a foundation of composition, drawing, and value worked out—you are ready to begin applying color. You will probably spend more time in this stage than any other, as there are many things to consider. Remember that the entire process is still guided by the principle of working from the general to the specific.

## FIRST STROKES: A HOLISTIC APPROACH TO PAINT APPLICATION

You can only make one stroke at a time, but in spirit and attitude, the application of paint should be approached in a holistic sense. In practice, this means continually circulating varying-size spots of color around the surface, rather than completely filling in whole areas. Work on one spot for a while, then another, and another, constantly moving around the canvas. Each area of the painting develops at the same pace, and no one area is completely "finished" before going on to the next.

Your efforts at getting correct values in the underpainting pay off now. When you apply a stroke of color, try to make the value of that color be as close as possible to the value in the underpainting. The underpainting serves as your guide to value-matching your color mixtures. Try not to deviate from the established values, except to correct. If you keep applying colors that do not match the value in the underpainting, you will lose the value structure you have already established.

Your first strokes of color on the monochromatic underpainting may look out of place. They stand out as the only opaque colors on a transparent underpainting. Yet, the goal is not to rush to cover up the underpainting. As you place spots of color around the canvas, you gradually build greater and greater coverage. The underpainting continues to work for you until a color model replaces the monochromatic value structure. These first strokes should not be too thick, so subsequent layers of paint can more easily be applied over them.

Which color first? Start with a color that will establish an anchor—the lightest light, the darkest dark, or the highest-key (brightest) color. These color-value decisions are so informative that the sooner they are established, the easier it will be to evaluate other colors in relation to them.

Suddenly I realized that each brushstroke is a decision… that has to do with one's gut: It's getting too heavy, too light…. The surface is getting too coarse or not fine enough…. Is it airy enough or is it laden?… In the end I realize that whatever meaning that picture has is the accumulated meaning of ten thousand brushstrokes, each one being decided as it was painted.
—ROBERT MOTHERWELL

## COLOR PASSES AND THE GRADUAL APPROACH TO "CORRECT" COLOR

Students often have the expectation of mixing the right color on the first try. See the color, mix the color, place it down. Perfect. However, if Monet did not ask this of himself, then I don't believe I should, either. If color is entirely relative, then how can I judge whether a color is "correct" unless I see it against its surrounding colors? I must first put all the colors down—a "first pass"—to see how they relate in context. I might go through several "color passes" in a painting, each one gradually bringing me closer to the desired color relationships. The first color pass might be 75 percent accurate, the second pass might bring me 10 percent closer, and the next pass closer still. A plein air painting may take only one or two passes, while a studio painting may take many more.

Use the ongoing "corrections" to your advantage. As you go over a color with a second pass, you don't have to entirely cover up the first color. What is already there is partly correct. Leaving some of it to show through gives more complexity and nuance to each passage. In other words, the "incorrect" color notes from your first pass may still be relevant and can work in your favor. It's like making soup. If the flavor isn't right at first, you don't throw out the whole batch and start over; you continue adding ingredients to what is already there to bring it around.

To start, always begin with the largest brushes possible. This will help you think in terms of big shapes and prevent you from getting overly involved in details. Throughout the painting process, both in the underpainting and later stages, it is important to use brush sizes that correspond to the shapes in the painting and to the size of the painting itself. As the painting evolves from larger, general shapes to smaller, more specific shapes, shift to smaller brushes. In small outdoor paintings, I primarily use brush sizes between 4 and 10. (I use the 4 or smaller only for the shapes that I cannot render with a larger brush.) These sizes might seem large to the novice, but remember, your tools influence your thinking. Larger brushes support your efforts at simplification and massing. On larger studio paintings, brush size is scaled up proportionally, using sizes 8, 10, 14, 16, and larger. This can be a difficult shift to make, as it requires a commitment to using larger volumes of paint. It is very easy to get into the bad habit of using a single size of brush. Varying your brush size also lends greater variation and interest to the surface of the painting.

You could paint with one brush if you had to, but it is much more efficient to assign different brushes to different color/value groups. For example, you can use one brush for the light greens; another for the darker, cooler shadows; and yet another for the sky. This avoids muddying your mixtures with tainted brushes and saves you the time of having to clean brushes every time you switch colors.

And finally, keep in mind that even with the best planning, midcourse corrections are often a necessary part of the painting process. As you get more deeply involved with a painting, it is only natural that you will discover things you did not notice before. An idea that seemed achievable at the outset may not come off as you expected. Yet, a successful painting is not the result of a thousand correct choices but of a thousand corrections. One of the ironies of the creative process is that a whole string of mistakes (if corrected) can lead to a successful painting.

I have always tried to hide my efforts and wished my works to have the light and joyousness of springtime which never lets anyone suspect the labors it has cost.

—HENRI MATISSE

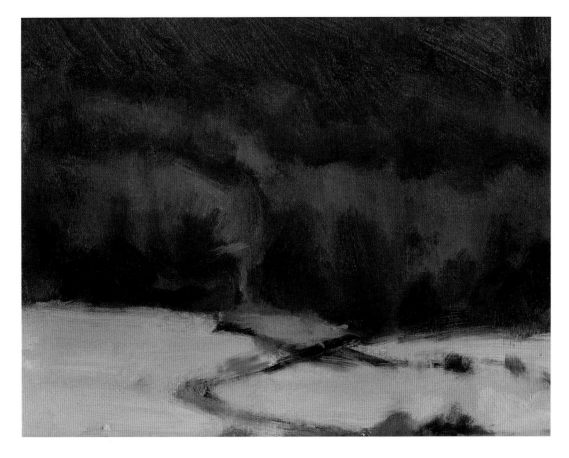

Mitchell Albala, *Hill Across from Cemetery*, 2004, oil on paper, 5 x 7 inches (12.7 x 17.78 cm)

Big brushes make for big thoughts. In this painted sketch, a large #12 bright was more effective at describing the broad patterns of light and dark on the hillside than a small brush. Using the largest brush possible for a given area encourages a "less is more" attitude within the landscape painter.

## WORKING WET-INTO-WET

The greatest technical challenge with oils is working *wet-into-wet*. Because oil paint dries slowly, the painter must often apply fresh paint over areas that have not yet dried—wet-into-wet. The effects can be painterly and highly desirable, but it is also an area where the novice can lose control. *It is necessary to work in a way that allows the paint surface to remain open and receptive to successive layers of paint yet permits a fresh stroke to sit on top of the stroke underneath, without a lot of blending.* Too much blending overworks the colors on the surface and creates the proverbial "mud." The goal: to apply one stroke over another without getting too much co-mixing. Two things will help you do this:

**1: START WITH THINNER LAYERS OF PAINT AND GRADUALLY WORK TO THICKER LAYERS.** A thinly layered stroke will be more receptive to a thicker, full-bodied stroke applied over it. In this context, "thin" does not mean thinned with solvent or medium; it refers to the physical thickness of the paint. If the underlying paint is thinned too much with solvent or medium, it can become slippery, and it will be harder to get a fresh stroke to stick to it. Always apply thicker strokes over thinner strokes.

**2: DON'T OVERWORK THE BRUSHSTROKES.** When applying a stroke over wet paint, the more stroking one does, the more the two colors will mix. Of course, sometimes that is what you want, such as when you are trying to create a gradual transition or softening edges. But if you do not want the two colors to blend, and if you want the top stroke to retain its individuality, *apply the stroke and just leave it.* Only a single stroke or two is permitted before the new color will start to blend with the wet color beneath. Go back to the palette and pick up more color. When working wet-into-wet, it also helps to use a softer brush with a lighter touch; stiffer brushes tend to press through soft layers of paint.

## COLOR MIXING

In chapter 8, we learned that color is described in terms of four characteristics: hue, temperature, value, and intensity. Color mixing is essentially a balancing act, an effort to mix two or more pigments together in such a way as to modulate these four attributes toward the desired color. What makes color mixing so challenging is that when we adjust for any one attribute, we invariably affect the other three. If you change the value, you affect the intensity. If you change the hue, you might affect the value. The attributes are talked about separately, but they are, in fact, inextricably tied together. The steps outlined here and on the following pages are by no means a complete treatise on color mixing, but they lay out my process as I develop a particular mixture.

**1: IDENTIFY THE HUE.** Every mixture starts with the hue because it establishes the core color from which the mixture will develop. If the color I want to mix is in the red family, I naturally start with a red pigment. Color temperature is a factor of hue, so I consider whether to choose a cool red (alizarin) or a warm red (cadmium). I pick the one that seems closest or mix them together if necessary. I can also add other colors to modify the core hue. For example, I may add some yellow to the red to shift it toward an orange hue.

### FAT OVER LEAN

In oil painting, there is a practice called "fat over lean," meaning more flexible (more oily) layers are applied over less flexible (less oily) layers. The more oil content there is in the paint, the more flexible and permeable the paint film will be. The less oil content there is, the less flexible and more brittle the paint film will be. By placing oily, or "fat," layers on top of faster drying, less oily, or "lean," layers, the lower layers can continue to breathe and dry. Oil painters often worry about fat over lean, fearing that the slightest deviation in consistency will lead to cracking. However, much of these concerns can be put to rest by being conscious of the order in which solvent and/or mediums are introduced into the painting process—and being consistent about it. Oil colors straight from the tube are considered lean, while all painting mediums, whether traditional oil-based mediums or modern alkyd-based mediums (Galkyd, Liquin, and so on), are considered fat. Thus, at the start of a painting, some solvent may be used, but in successive layers, solvent is abandoned and gradually replaced with medium. Thus, top layers are always fatter than lower layers. (It is worth noting that you do not have to add extra oil or mediums to your paints at all if you already like the consistency of paint straight from the tube.)

**2: IDENTIFY THE VALUE AND LIGHTEN AND DARKEN AS NECESSARY.** The most important thing to understand about modulating value is that it is not simply a matter of adding white to lighten and black to darken. Color is much more nuanced than that.

**2A: LIGHTENING.** Some pigments, like alizarin permanent, phthalo blue, and ultramarine blue, come out of the tube very dark. Adding a little bit of white is necessary to lighten them; it also brings out more of their intrinsic hue and intensity.

In certain mixtures, however, white has a cooling effect that can make the mixture pale and "chalky." This is desirable in some situations, as when painting atmospheric perspective, but in many other situations, it is not. Too much white can dilute a color's potency. *Although white is the only way to lighten certain mixtures, do not think of it as a universal lightening agent.* Instead of white, I sometimes try lightening with yellow. This, of course, also shifts the hue and temperature, but in the outdoors, where there are many areas illuminated by the warm sun and so many

greens (which are partly made up of yellow), yellows can serve nicely as a lightening agent.

---

TIP: To offset the cooling and paling quality of white, add a very small amount of yellow to the white pigment. How much? Use little enough to barely tinge the white but not enough to make the white look like a yellow mix.

---

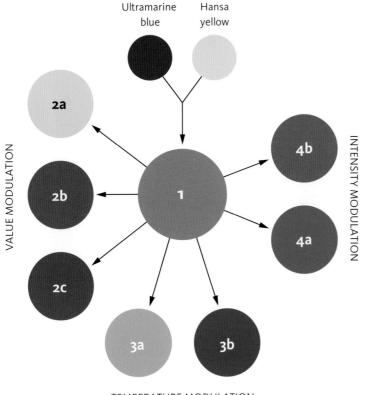

Ultramarine blue

Hansa yellow

VALUE MODULATION

INTENSITY MODULATION

TEMPERATURE MODULATION

**Modulating for hue, value, temperature, and intensity.** Adjusting any one of these four attributes affects the other three. The starting hue in this example is green, created with a mixture of hansa yellow and ultramarine blue (1). Because ultramarine blue is cool with a hint of violet, the green it generates is less of a bright green and more of an apple green. Lightening the starting hue with white cools it and slightly reduces intensity (2A). When darkened with burnt umber, umber's slightly reddish hint also dulls the mixture, shifting it toward a dark olive hue (2B). When darkened with a rich black made from ultramarine blue and burnt umber, the ultramarine component of this rich dark makes it cooler than the dark made with burnt umber (2C). The green is made warmer with the addition of more hansa yellow, which also lightens the mixture (3A). It is made relatively cooler by adding more ultramarine blue (3B). Intensity is heightened by adding phthalo blue, a much more intense and warmer blue than ultramarine (4A). Adding the complement to green, cadmium red, reduces intensity (4B).

**2B: DARKENING.** To darken a mixture, a darker pigment must be added. It is not advisable to use black as an all-purpose darkening agent. Many artists consider black an essential pigment; however, it is not a color in the way other pigments are. If overused, it has a tendency to render dark passages with a common dirty, colorless gray. Instead, use darker pigment colors or create "rich blacks" from other colors. These yield inherently more colorful darks because they are made *from* colors. If you do wish to use a pigment black from the tube, use it sparingly.

A color used to darken may also have the effect of *dulling* the color. For example, darkening yellow with burnt umber or raw sienna makes the yellow more neutral. At other times, adding a darker pigment doesn't dull the color but shifts the hue. Adding a darker pigment like ultramarine blue to that same yellow will shift it toward green.

> "Dark" and "blackish"
> are not the same concept.
> —LUDWIG WITTGENSTEIN

**3: MODULATE FOR INTENSITY.** This is the last factor. Here, the lessons about complementary colors and neutrals can be put to practical use. When placed side by side, complementary colors heighten the visual intensity of each other, but when mixed together, they have the opposite effect— they neutralize each other. Thus, complements are a tried-and-true method of modulating color intensity in mixtures. For instance, adding violet to yellow will reduce its intensity (as well as darken it). As more and more violet is added, the mixture becomes progressively duller, until it eventually becomes more violet than yellow. Adding a neutral color, such as a rich dark or burnt umber, can also neutralize color. Different rich darks have different color biases. For instance, burnt umber is the equivalent of a very dark neutral red-orange, so it also has a warming effect.

**4: MIX, TEST, REPEAT.** Once the color is mixed, apply it to the canvas. Chances are, it will look different on the canvas. Here is where the colorist lives or dies: *If the color is not right, adjust the mixture!* You may have to adjust the mixture two, three, or more times until you get the color you are aiming for. Remember, the color of the palette that surrounds the mixture is not the same color that surrounds the stroke on the painting, which accounts for perceptual differences. Also, if your canvas and palette are not receiving relatively equal levels of light, further disparity will be created.

**Rich darks.** Instead of using black, a wide range of rich darks can be mixed from other colors. Equal parts of burnt umber and ultramarine blue yield a dark, blacklike mix (left). Weighting the mixture toward one pigment or the other will create a warmer or cooler dark. Lightening with white will reveal the color bias of the mix. A mixture of at least twice as much viridian green as alizarin permanent (right) yields a rich dark based on the red-green complementary pair. Weighting the mixture toward one pigment or the other will create a dark that leans toward the green or leans toward the red.

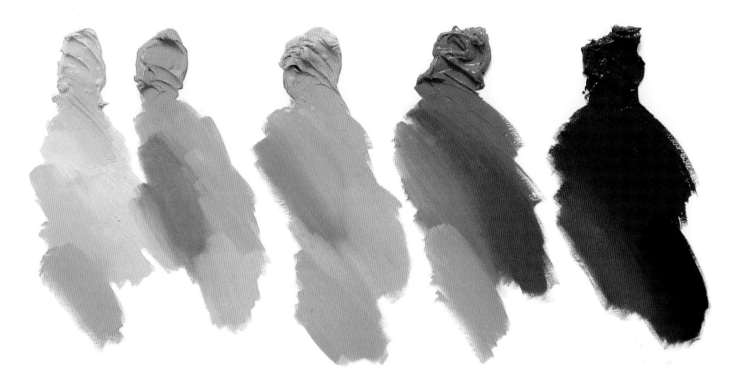

**Color pooling.** In any painting there will be several predominant color groups: for instance, blue for the sky, yellow ochre for the field, and dark green for the shadows. Every time you want to mix a color from one of those families, you have to mix it—over and over. It is much more efficient to premix large portions for each color group—a *color pool*—that you can use as the starting point for any color mixture related to that area. Granted, the starting color will not be the *exact* color you need in each instance, but it is *closer*. A little modulation is all that is needed. The color pools shown above were used for the painting *Fifty* on page 160. Color pooling also helps maintain color consistency throughout the painting. After a session, the colors can be saved on a mini glass plate, wrapped in plastic, and stored in the freezer.

### MIXING: THE BRUSH OR THE KNIFE?

In my initial color mixes, when I am thinking fast and testing, I prefer to use a brush. It gives me a more responsive relationship to my mixes. Once I find the color I am looking for, *then* I mix up a larger batch of that color with my palette knife. This becomes the color pool from which I begin subsequent mixes for that color family. It is also common practice to initially mix colors with a palette knife; however, I have often observed that when students mix with a palette knife, they are less likely to test the mixture as they go. They take time to mix the color but then apply it to the painting without making any additional modulations for a particular area. Batches of color mixed with the palette knife still need to be modulated for a particular area.

**A little bit is all you need!** Sometimes, only the tiniest bit of paint is needed to modulate a mixture. If the brush is dipped into a mound of paint, too much is invariably picked up. Instead, smear a thin swipe of the desired color onto the palette with the knife. Then draw from that smear with the brush. This picks up only a small amount of paint. The same applies to solvent. Rather than dip the brush into the cup, which certainly picks up too much solvent, sprinkle a few drops onto the palette and draw from there. This barely wets the brush.

## PAINT HANDLING: THE POETRY OF SUBSTANCE

Painting is, after all, about *paint*. It is a tactile art that gives the artist an opportunity to luxuriate in the sensuousness of the paint itself. Artists push their brushes or drag them sideways, lay the paint on with a palette knife, or caress the canvas with a sable brush. Their strokes fly across the surface with passion or gently glide over the painting like a passing cloud. Your brushwork—the unique mark that bears your painterly handwriting—is the outward expression of your artistic personality. It is an embodiment of the energy and emotion you bring to the painting, a record of your creative process preserved in paint.

Beyond the emotional energy it carries, the way you apply paint can support your visual mission in other ways. For instance, differences between transparent and opaque paint help imply different levels of depth within the painting. Thin and transparent paint will recede, so it can be used in areas of the painting that are meant to recede, like a sky. More fully loaded paint tends to advance, so it can be applied to areas of the painting that

correspond to elements closer to the viewer in the landscape stage. Paint can also serve as a metaphor for the types of substances found in nature: the fluffiness of clouds, the fluidity of water, or the hardness of craggy rocks. Paint application also affects how light reflects off the surface of the painting and is perceived by the eye. Paint itself becomes a key player in creating an illusion of light.

The many ways of applying paint are classified under two broad categories: *direct* and *indirect* painting. In direct painting, the painter endeavors to mix a color of the correct hue, value, and intensity and apply it *directly* to the canvas. A single opaque stroke of color is as close to the final color as possible. (This, of course, does not preclude painters from changing or correcting the color as many times as they wish.) The *alla prima* paintings by contemporary plein air artists are examples of direct painting. With indirect painting, the color seen by the viewer is not held within a single stroke but is built up through a series of transparent layers. The final effect is a combination of the colors within each layer. Both methods can achieve luminosity, but they do so in

very different ways. Of course, direct and indirect methods can be combined within the same painting. This is the advantage of contemporary painting. One can borrow from past and present traditions, combine them in creative ways, and choose whatever approach best facilitates the visual goal.

### BROKEN COLOR AND OPTICAL MIXTURE

One form of direct painting is broken color. In this method, small individual strokes of color—for example, small spots of yellow and blue—are laid side by side and at a distance are mixed by the eye to form green. The Impressionists were the first to employ this method extensively. The surfaces of their paintings are a tapestry of dots, dashes, and crisscrossing strokes. (See the image at right and also the Monet detail on page 149.) When colors are combined optically within the eye, a different kind of color perception is achieved. The overall surface of the painting appears to vibrate more. And when broken color is combined with textured paint, the effects are further enhanced. Light is reflected off the ridges and valleys of the paint to produce a scintillating effect.

Jerry Fresia, *Winter Glow*, 2007, oil on canvas, 41 x 68 inches
(104.14 x 172.72 cm)

Broken color and optical mixture are at work on a grand scale in *Winter Glow*.
Alternating strokes of different colors side by side results in an entire surface
that vibrates. Breaking up the color into smaller applications enables Fresia
to distribute common colors throughout the color field. There are warm orange
touches of color in virtually every area of the painting, even in the blue fore-
ground. And there are touches of blue in the warmer sky and mountaintop.
Ironically, a division of strokes enhances uniformity and cohesion of color.

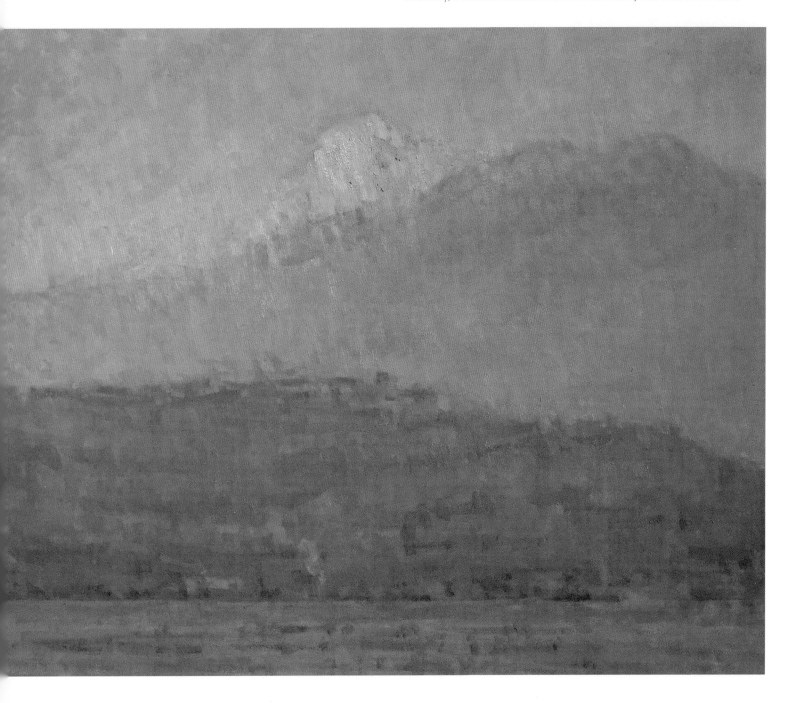

**Transparency, opacity, and texture.** Paint on the surface of a painting is relatively thin; yet small differences, ranging from the transparent to the textural, can imply different levels of depth within the image, a type of "spatial topography." The example to the left is painted with one color, ultra-marine blue, in nearly the same value; yet the top, middle, and bottom zones imply different levels of depth. The upper third, or "sky," is painted thinly and transparently. Light passes through this layer and bounces off the underlying white surface, giving it a see-through quality. This allows the sky to recede, which is exactly what a sky should do. The middle zone is more opaque. The eye rests on the surface of the paint and doesn't move through it, so that section sits in front of the sky. The bottom third, or "foreground," has the most texture and advances well in front of the other two zones. Nearly any passage made physically transparent will recede, and nearly any passage activated with enough texture will come forward.

Barbara Fugate, *View of Shi Shi, Washington Coast,* 2007, oil on panel, 5 x 7 inches (12.7 x 17.78 cm)

Fugate celebrates the tactility of paint itself in this small painting done on location. Her use of impasto is expressive but disciplined. She applies thicker daubs of paint in the areas closest to the viewer and less texture to the background and sky. The cresting waves in the foreground are formed with bold strokes, angled in the direction of the waves. As the waves recede, the strokes become smaller. The same type of transition occurs in the sky, though at a lower pitch, so as not to pull the sky closer to the viewer than the water. Note the touch of neutral colors in the rock formations, which serve as a contrast against the other, more intense colors.

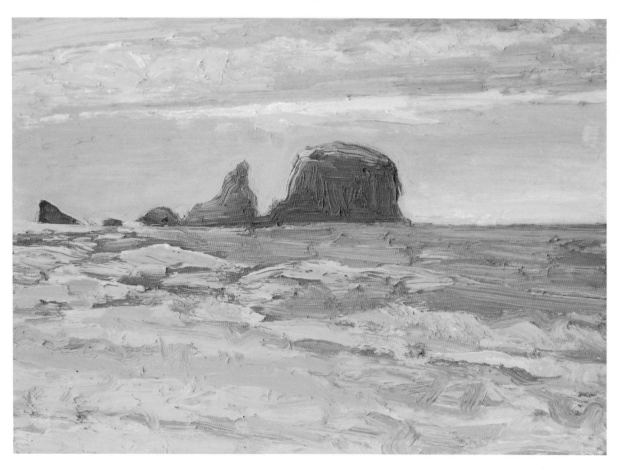

## MANY ARTISTS, MANY STROKES

There are as many ways of applying paint as there are artists. Whether applied directly or indirectly, or using some combination of the two, the brushwork has as much to do with the identity of the painting as does the subject or the color strategy. A sampling of details from selected paintings featured in this book demonstrates diverse styles of mark-making.

**Broken color.** This detail from the upper right quadrant of Claude Monet's *Antibes Seen from La Salis* (page 117) shows a classic application of broken color. When viewed at a distance, the small touches of color merge to form the impression of warm-colored light on the bough of a tree. The Impressionists were the first to totally abandon the indirect, glazing methods that were the tradition up until their time in favor of a direct method of applying small strokes of color side by side.

**Alla prima.** This detail of a 3-inch portion from the lower right corner of *Tuscan Hill Farm* on page 121 is typical of the alla prima, direct painting style used by many contemporary plein air painters. Jim Lamb lays his color on in juicy dollops, lending a tactile excitement to the surface of the painting. Light is reflected off the resulting valleys and ridges, adding to the textural variation of the surface. Also note that the fence posts at the left are achieved by scraping back the paint to reveal the magenta-like underpainting tone.

**Glazing.** Seen here in a detail of John McCormick's *Western Wind* (page 100), the indirect method of building layers of transparent glazes achieves a distinctive form of luminosity. The color that reaches the eye is a composite of the thin transparent colors held within each layer.

**Opaque and transparent.** In direct painting, thick, full-bodied strokes can be juxtaposed alongside semitransparent ones. This lends a textural variation to the picture surface and helps assert the physical difference between the substances being rendered—here, flowing water and rock. Texture can also be generated by the surface itself; in this case, cold press Arches watercolor paper, which has a very coarse tooth. (Detail from *Del Ascending*, page 18.)

## EDGES

Controlling edges is an essential means by which the painter can support the spatial illusion and help guide the eye through the painting. Edges occur at the boundaries between elements, where one spot of color ends and another begins, where one shape differentiates itself from another. When painters speak about edges, they are referring to the relative hardness or softness of the edge. Is the edge sharp, like a cut piece of paper, or soft and diffuse?

The control of edges becomes a useful tool in effective spatial mapping, achieving desired focus, describing the physical nature of picture elements, and creating visual variation. A sharp, hard edge heightens focus and makes the form to which it is attached come forward. A softer, fuzzy edge has the opposite effect,

making the object to which it is attached recede. Assigning varying degrees of hardness or softness to near and far elements creates a *spatial mapping* that supports the spatial illusion in the painting.

Because sharp edges bring greater focus to the elements they define, they can be used to bring attention to a particular area within a painting. The eye will not attach itself as easily to softer edges. Some edges completely dissolve and become "lost edges."

Edges also help describe the innumerable types of substances found in nature, from cottony clouds to glasslike shards of reflections on the water. What makes fog appear as it does? The extreme blur of the edges. What allows trees to simultaneously suggest a solid and "unsolid" appearance? Broken edges along their outer

contour. Edges add variation to the paint surface, as well. A painting is more interesting when all brush marks are not made in the same way.

So how do we know which edges to make soft and which to make sharp? A general rule of thumb is that the edges of things farther away will tend to be softer, while those closer will have crisper edges and more detail. A grassy field in the foreground reveals many edges with lots of individual blades of grass. That same field viewed at a greater distance appears more like a solid patch of color. Elements farther away show less detail, and so have softer edges. Squinting is a great way to interpret edges. Things that appear soft-focused when we squint are often the same edges that need to be softened in the painting.

### THINK FAST, EDGE SLOWLY

Edges require a great deal of sensitivity. When working slowly and methodically in the studio, it is easier to consider edges as we work. It is much harder to control edges outdoors, when we are working quickly and thinking about so many other things. If our attention to edges wanes, we should take a few minutes at the end of each session to evaluate. If the painting is still wet, it is fairly easy to crisp up some edges and soften others with a brush. If you are working wet-over-dry, softening or sharpening edges is more involved. You must use a painting medium to blend the wet color into the dry, or apply fresh paint to both edges and blend.

Edges have more to do with the interior of the painting rather than the exterior, more to do with the soul of a painting.

—DAVID A. LEFFEL

## SIGN WITH HUMILITY

We take great pride in a completed painting, and our signature is the outward statement that we approve of our efforts. It says, "I did this!" The signature is part of the painting, though, and it must be handled with sensitivity. If it is the first thing you notice, it's too big! If it is too far from the edge, it can interact with the painting in obvious ways. Also, be sensitive to the color of the signature; its value and hue help it rest softly or make it shout at the viewer. Don't shout.

Mitchell Albala, *Yakutat Bay 8*, 2003, oil on panel, 16 x 16 inches (40.64 x 40.64 cm)

Edges occur at the boundaries between shapes and colors. In a densely atmospheric subject such as *Yakutat Bay 8*, in which traditional spatial cues like volume and overlaps are absent, edges play a special role in suggesting differences between near and far. Relatively sharper edges (and stronger value contrasts) on the snow patches in the lower half create more contrast and pull the hillside forward. In the top half, edges are softer, helping that portion of the hill recede. At the very top, the edges are so soft and the contrast so low that a "lost edge" is created, which helps push back the top ridge of the hill.

# PLEIN AIR DEMONSTRATION:

## SKAGIT RIVER DIKE, NORTH

Working directly from nature is a very different type of painting experience than working from photos or sketches in the studio. Only through a direct one-to-one relationship with nature do we learn how to translate nature's forms, values, and colors into paint. When painting outdoors, I go through the same stages as I do in a studio painting—preparatory work, underpainting, and development—but in an abbreviated format; I am more interested in capturing a momentary impression than getting perfect color and detail. The question I ask myself is, How can I capture the essential qualities of the scene with the least amount of information?

## DEMONSTRATION NOTES

- Size: 8 x 10 inches

- Surface: Gessoed panel

- Medium: Oil and alkyd

- Brushes: A range of hog bristle brushes: large 14 bright for toning the surface, 4–8 filberts for later stages, and a small 2 synthetic filbert for details (for example, the telephone poles).

- Underpainting: This demonstration uses a *two-color* underpainting, a variation of the regular monochromatic underpainting. Rather than use a single color for the entire underpainting, an overall warm tone is laid in that corresponds to the lights, and then a darker and cooler color is used to block in the shadow masses. Thus, in the first minutes of painting, color and temperature differences can be suggested clearly. The two-color underpainting is harder to control and should be tried only after you have attained proficiency with regular monochromatic underpainting.

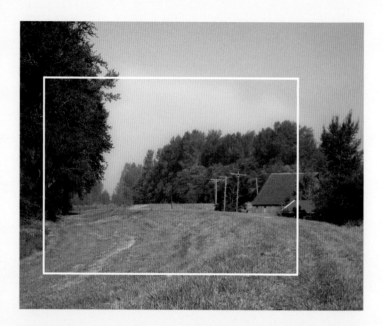

**Source photo.** The photo shows many of the elements that drew me to this scene, including the small slice of atmospheric perspective in the "notch" between the trees at the end of the dike and the dynamic curves of the foreground as it sweeps back toward the horizon line. To bring attention to these areas, I impose a limited focus (indicated by the white frame) that eliminates extraneous portions of the subject.

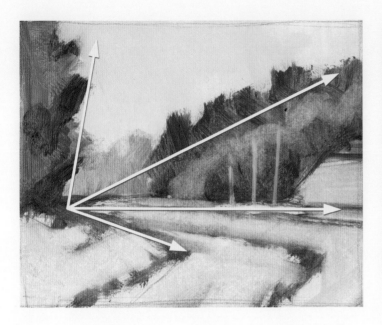

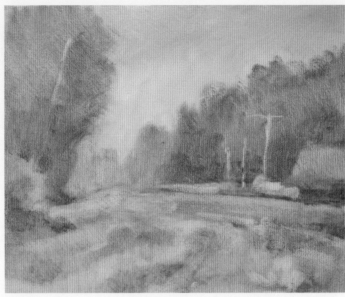

**Step 1: Thumbnail sketch.** Even a short plein air painting requires some kind of preliminary study to test the composition. This thumbnail was done with paint, which I often prefer over pencil because it helps me think in terms of big shapes and values. This simple 4 x 5–inch sketch defines the parameters of the composition with a picture window and emphasizes the directional energies I see in the subject: a series of diagonals expanding outward from the base of the large tree on the left.

**Step 2: First start under foggy conditions.** When I arrived on site at 7:30 a.m., the scene was swathed in fog. I love the magical and abstracting effects of fog, so I dove in with great enthusiasm. Of course, in less than an hour, the fog began to clear. This two-color underpainting uses a pair of complementary colors: a light pink based on cadmium red light and a pale green based on chrome oxide green. The overall dull appearance of the underpainting is the result of the two complements commingling in the painting process.

**Step 3: Second start under sunny conditions.** I could have tried to finish a "foggy" painting in the sunshine, but instead, I begin a second underpainting. Each hour of the day expresses a unique color-light that I consider when choosing the color(s) for the underpainting. With the sun out, the colors I choose for the new two-color underpainting are very different from those in the foggy underpainting: I tone the overall canvas with a warm yellow that is a combination of hansa yellow and Naples yellow. The darker lines blocking in the shapes are established with ultramarine blue. Together, they partially mix to create green, laying the groundwork for an analogous color scheme. Referring to the composition worked out in the thumbnail, I sketch in the major shapes and try to indicate the essential directional energies.

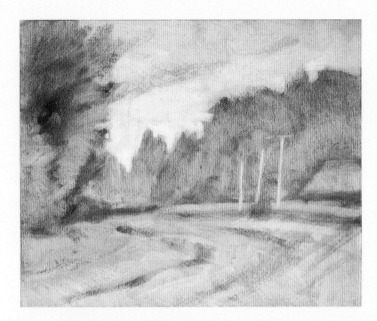

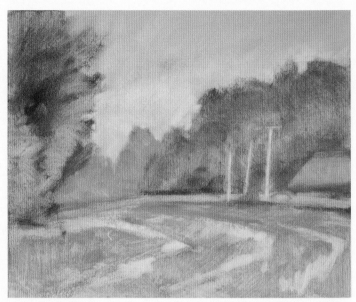

**Step 4: Final stage of underpainting.** In the later stage of the underpainting, the paint is still thin and transparent. I block in the areas that correspond to the shadows with the ultramarine blue used in the previous step. The lighter values in the sky are created by wiping out the yellow underpainting tone, while the thin lines of the telephone poles are rubbed out with a rag wrapped around the back end of the brush.

**Step 5: Initial color pass.** In the same fluid and open manner in which I began the painting, I begin to circulate color throughout the painting, never completely filling in whole sections. I need to see all the colors roughly indicated, side by side, to know what my next move will be. Note how closely related my color choices are to the initial colors used in the underpainting. The underpainting *supports* my color development. I begin developing the lighter greens with Naples yellow and sap green. (I intentionally lighten with yellow, as opposed to white, in order to avoid the chalky effect white sometimes produces.) My palette also includes some alkyd pigments, which reduce the drying time of the overall painting, allowing me to work wet-over-semi-dry in a short session.

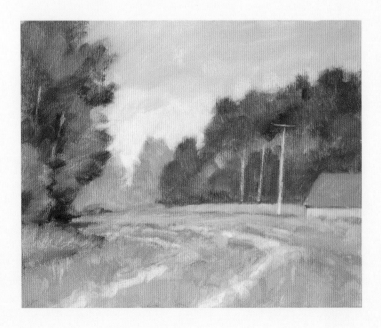

**Step 6: Color and shape refinement.** Capturing the rolling contours and perspective of the foreground is a challenge. The actual foreground (see photo) provides few value and color contrasts to suggest the structure I want, but it gives me a big hint: the sandy tracks that curve toward the viewer. So, I exaggerate these, which gives the ground plane more structure. I also begin to inject deeper yellows into the foreground with a combination of cadmium orange and Naples yellow. Color is added to the notch at the horizon with a mix of white and cadmium orange. The trees become darker and more opaque, but I stay with the limited colors I began with—Naples and hansa yellow, ultramarine, and sap green—which helps keep the colors analogous and unified. I make a small drawing adjustment to the house, moving it down slightly and making it a bit smaller. The roof of the house is very neutral: a mix of burnt umber, white, and dioxazine purple. After about an hour, the color of the light and the shadow patterns are beginning to change, so I stop for the day.

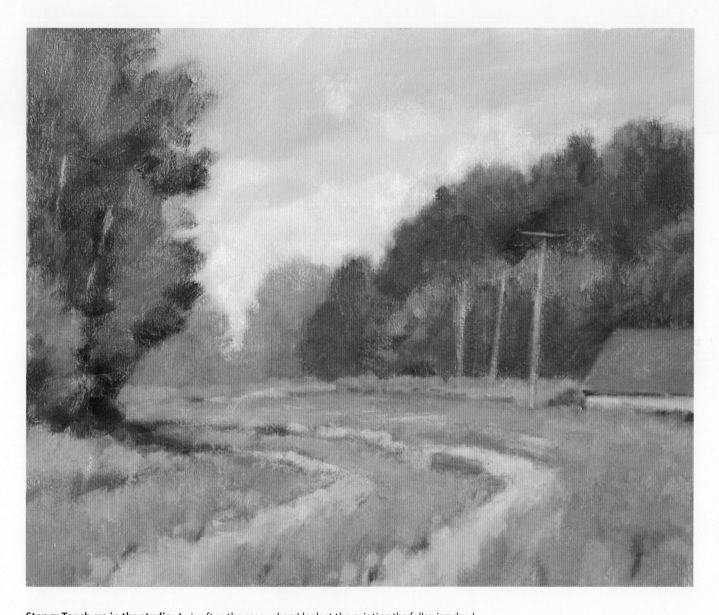

**Step 7: Touch-up in the studio.** As is often the case, when I look at the painting the following day, I notice a few areas I think could use improvement. I decide to risk losing some of the spontaneity of the outdoor session and apply a few fixes. The foreground does not have enough color variation, so I introduce even more warm touches into the mix with yellow ochre and cadmium orange. These strokes are applied more thickly, which also helps "lift" the foreground and make it appear closer. A few well-placed dark strokes at the very bottom also give the foreground some definition. I reshape the shadow at the base of the large tree so that it flows more naturally into the foreground. The house doesn't seem to recede enough, so I rework the edges, overlapping the grasses at the base of the house and inserting a tiny shadow on its left. Darkening the values of the house also helps it recede. And last, I apply a thin color to the telephone poles (Naples yellow and yellow ochre), which up to this point were just transparent wipeouts from the underpainting stage.

# STUDIO DEMONSTRATION:

## TWO PAWS

A larger studio painting makes a different type of visual statement than a small work done outdoors. In the studio, there is extra time to fully incubate ideas, explore various color and compositional strategies, and pay greater attention to paint handling. Even with thorough planning, however, painting is not always a linear process. It is a balance between holding to the original vision and not clinging to it so tightly that new discoveries or changes cannot be made. As will be seen, *Two Paws* required some compositional adjustments.

## DEMONSTRATION NOTES

• Size: 24 x 34 inches

• Surface: Fredrix preprimed canvas

• Medium: Oil

• Brushes: A range of hog bristle brushes: large 16 bright for toning the canvas and blocking in shapes in the underpainting, 8–12 filberts and brights for the later stages.

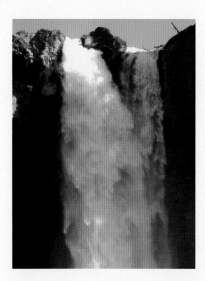

**Original source photo.** For a series I did on waterfalls, I observed Snoqualmie Falls in Washington State at different times of day and photographed it from every conceivable angle. What intrigued me about this particular vantage point was the way the sunlit portion of the waterfall touched the sky. Could the painting be about that relationship? What would happen, for example, if I made the water and the sky very close in value and color?

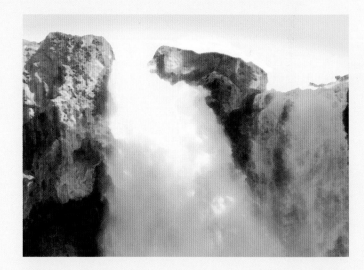

**Digitally enhanced photo study.** If my source photo is digital, I usually begin my explorations by manipulating the image with image-editing software. It lets me quickly and easily try several different compositions. By cropping out all but the top portion of the waterfall, I stay focused on the main event: the interchange between the sky and water. I also merge the colors of water and the sky to get my first taste of that ambiguous passage. Last, I apply a what I call a "shape" filter in Photoshop (see page 167) that helps suggest the basic shapes that will be the foundation of the composition.

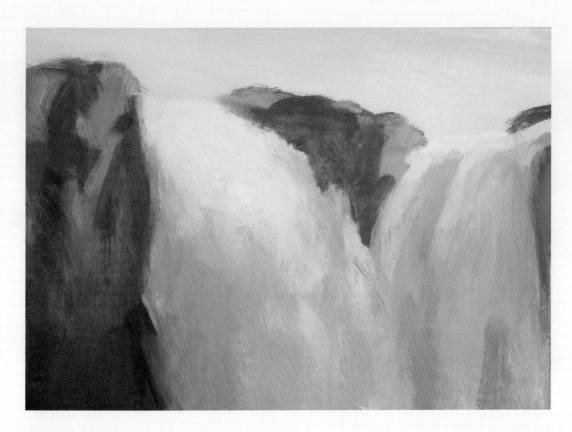

**Step 1: Traditional study.** Even when I problem-solve with digitally enhanced studies, I still like to do traditional studies by hand. It is a way of warming up and putting me on "speaking terms" with the aesthetics of that particular composition. My primary goals in the study were to suggest a general direction for color and express the ambiguous merging of the sky and the water.

**Step 2: Underpainting.** The first stage of the actual painting is, as with the plein air process, the underpainting. Here I establish the basic composition, drawing, and value relationships. I work fluidly and as openly as possible so that I can make changes to the design and composition if I need to. My underpainting tone is warm, a combination of burnt sienna and raw sienna. This will serve as a compatible warm undertone for the sky but also as a contrasting temperature for the cool shadows of the rock wall. **PROCEDURAL NOTE:** Sometimes when a small compositional study is scaled up to full size, the weight and density of the shapes can appear very different. I suspected this would be the case with *Two Paws*, so instead of starting on a stretched canvas of fixed proportions, I began on an oversize piece of preprimed canvas tacked to my wallboard. This would give me the freedom to change the proportions of the picture window if needed and still have enough canvas around the edges to stretch the painting later. The light bands of pigment along the bottom and right edges show where my picture window was first positioned. Once the underpainting is complete (and dry), *then* I stretch it onto appropriate-sized stretcher bars.

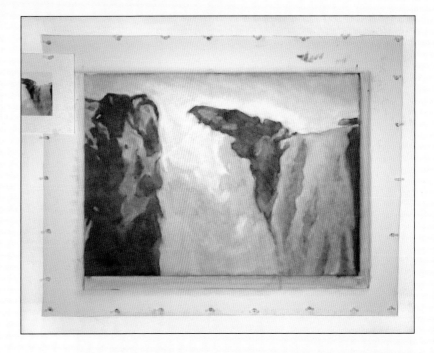

**Step 3: First color pass.** Although I use photographic references, I never copy photographic color. Observe how different my color direction is compared to the initial photo. When I devise my own color plan, the results are always more creative and interesting. My first strokes establish the cool and warm differences between the light and shadows. For the sky and sunlit portion of the waterfall, I use various yellows (nickel titanate and Naples). A light hint of warm (phthalo) blue is added to the uppermost portion of the sky to prevent it from being a flat color mass. The shadow portions of the waterfall are made with light mixes of ultramarine blue and dioxazine purple I then neutralize with nickel titanate and Naples yellow. The rock wall is a reddish base of dioxazine purple modified with yellow ochre, Naples yellow, and white. At this point, I am not overly concerned about getting the color "perfect" because I know that I won't be able to evaluate any single color until I see it in the context of all the others. From the outset, my primary concerns are the ambiguous merging of the sky and the water, a unified color of light, and the use of variable textures of paint to suggest the differences among air, water, and rock.

**Step 4: Color development.** In a painting such as *Two Paws*, in which the color balance and the temperature differences are so important, the final color is arrived at in small steps over the course of several sessions. I choose yellow (based on nickel titanate) for the sky. A cool yellow is less likely to advance than a warm yellow or orange, so it will help the sky to recede behind the rocks and water. Since the sky and the water will ultimately be the same color, I plan to differentiate them by applying greater texture to the water. This textural difference is also a metaphor for the physical differences between air and water. Notice that I have expanded the width of the waterfall and narrowed the left rock face.

**Step 5: Midcourse correction.** At every stage I must be willing to give a painting what it asks for, even if it is a time-consuming correction. At this point, I realize that a change to the composition is necessary. The rocks in the middle that separate the two "paws" of water are too high and bring too much attention to themselves. I lower the top edge of the rocks and add a small rivulet of water to help break up that mass. The rock shape now feels more natural, and the eye flows more gracefully along the top edge of the waterfall.

**Step 6: Building texture and staining.** One of the most enjoyable parts of the painting process for me is exploring the various effects I can produce with thick, textured paint. My style uses thick paint very deliberately, as opposed to being the result of a vigorous and expressive hand. I lay on thick strokes of paint to the sunlit areas of water (above, left). Thus, the most activated paint corresponds to light, movement, and the area of the subject closest to the viewer. After the paint is thoroughly dry, I "stain" the area by rubbing in a thinner color (above, middle). This color choice is intentional; it is meant to be cooler than, but about the same value as, the yellow. It's primarily a light neutral blue made with white, ultramarine, and nickel titanate yellow. With a dry, lint-free cloth, I wipe away the excess paint from the "hills" of the dried brush marks, leaving the paint in the ridges and "valleys" (above, right). This exaggerates the relief of the paint, allowing the color to vibrate more.

**Step 7: Final painting.** The later stages are devoted almost exclusively to fine-tuning the color and refining edges. I continue to shape the patterns of light and shadow on the rock faces and the subtle temperature differences within the plumes. The last change in color is to the rock wall, shifting it to a bluish hue, which brings it more into harmony with the overall waterfall.

CHAPTER TEN

# WORKING WITH PHOTOGRAPHS

A photograph is a secret about
a secret. The more it tells you
the less you know.

—DIANE ARBUS

Nothing replaces painting the landscape from life and nothing should. There are too many essential lessons to be drawn from a direct observation of nature to rely solely on photographs. However, a camera does offer landscape painters special benefits: It gives extended access to subjects from which they would not be able to work directly, either due to safety concerns or extreme weather conditions, and it lets them capture fleeting moments, be they figures in the landscape, trees bending in the wind, or short-lived atmospheric effects. Moreover, digital photography has made taking photographs easier and less expensive—and with the aid of a computer, photos are easy to manipulate in ways that directly support artists in their creative explorations. So essential is the camera to the landscape painter's tool kit that it is worth it to devote a chapter to working well with photographs, both as reference and as a means to analyze your subject and suggest creative approaches.

Mitchell Albala, *Fifty*, 2006, oil on panel,
20 x 20 inches (50.8 x 50.8 cm)

Although *Fifty* relied on photographic reference, it bears little resemblance to the original photo (on page 162), or to a photo at all. An artist who references photos correctly doesn't simply select a good photo and copy it but uses it only as starting point and an aid to memory. What makes a painting a painting is the artist's unique interpretation of color, composition, value, and the handling of the paint itself.

# USING PHOTOGRAPHS LIKE AN ARTIST

I have done several series of paintings based on subjects that were physically difficult to access. One was based on the cascading water at the base of waterfalls (*Del Ascending,* page 18) and another was based on fog-enshrouded, snow-capped hills in Alaska (*Yakutat Bay 8,* page 151; *Yakutat, Mid-Morning,* page 17). Because of the Alaskan cold, I was only able to work on location for a very brief time. At the base of the falls, rocky terrain and spray from the water prohibited live painting. The strong visual impression I experienced at the first moment I saw these subjects provided the inspiration to do the series, but I also needed a permanent photographic record of the sites. From that record, I could explore multiple compositions and interpret the imagery for years to come in the comfort of my studio. Of course, none of the paintings in those series looks anything like original reference photographs. My personal style, color, and abstract sensibilities directed my interpretations.

The desire to rely on the photo can be strong; the photo is clear, realistic, well detailed, and can make an effective visual statement in its own right. But when we rely too heavily on photographs or use them in the wrong way, they can actually create problems in our painting, or worse, stifle our creativity. Photos have a number of decidedly *unpainterly* qualities that, if transferred into the painting, make the work look less painterly. As a painter, you are an interpreter, bringing something to the act of painting that is uniquely yours. If all you are going to do is copy the photo, then why do the painting at all?

## POOR PHOTOGRAPHS MAKE POOR REFERENCE

Just as differentiation and spatial cues are essential ingredients for achieving maximum readability in a painting, so are they the ingredients needed in a photograph if it is to be an effective reference. Even though a photograph is highly realistic, it relies on the same visual cues painters use when translating reality into a convincing two-dimensional depiction. If these elements are not present, you will find that when you start to work with your photos back in the studio, they will not translate well into painting.

## SHOOT YOUR OWN PHOTOGRAPHS

Make it a rule to work from your own source material. Aside from issues of copyright infringement, using images from magazines or borrowing another person's photographs is artistically dishonest. If your vision is to be as original as possible, you must reference what you actually experienced with your own eyes, either from a study you made on location or from a photograph you took yourself. Interpretation and discovery occur when you experience for yourself the leap of translation from three dimensions to two dimensions.

That said, there are several situations in which referencing another's photograph is acceptable: First, as a study for your own educational purposes. You may want to diagram a well-composed photograph to understand how the shapes fit together, or you might trace the shapes as an exercise in simplification. Second, for referencing subject-specific detail. How do the branches of the sycamore tree bend? What kinds of patterns does the melting snow make on the Alaskan hillside?

A snapshot is a correct rendition of physical fact; sharply focused it will show the numberless grasses upon the ground.... The actual form of the mass upon which these grasses occur, it does not suggest; nor does it convey nature's subtle color changes or color-flow. But, most of all, the camera does not have an idea about the objects reflected upon its lens. It does not "feel" anything, and will render one thing as well as another.

—JOHN F. CARLSON

The composition for *Fifty* (left) was extracted from just a small portion of the much larger cloudscape seen in the photograph on the opposite page. The photograph's color was not used at all; the color in the final painting was entirely invented.

## PHOTOGRAPHIC REFERENCE DON'TS

**DON'T COPY, INTERPRET.** The worst mistake painters can make is to directly copy a photograph. In fact, the degree to which they copy is the degree to which they stop thinking like painters. A photograph, in part, is an already-resolved visual problem. Its colors are set. It has already been converted into two dimensions, and the picture window and composition are defined. If painters rely too heavily on those fixed parameters, there is no room left for their own creativity and interpretation.

**DON'T TRUST PHOTOGRAPHIC VALUES.** The most misleading type of information provided by the photograph is its value relationships. All too often, the camera creates too much contrast between the lights and shadows, especially in bright daylight. It underexposes the darks (turning them to black) and overexposes the lights (turning them overly light or white). This may look fine in a photo, but black and white are poor substitutes for the color solutions available to the landscape painter. If you copy the photographic values, you will translate all the shadows to ultradark green or black. Lightening the values you see in the photo with image-editing software will help ensure that color is maintained in the shadows. (See Exploring Options through Digital Effects on page 166.)

**DON'T RELY ON PHOTOGRAPHS FOR COLOR, JUST FOR COMPOSITION AND DRAWING.** If the painter's subjective interpretations of color didn't offer something more than what a photograph can convey, then photography would have replaced painting a long time ago. A photograph is good for suggesting *generalized* color direction, but it should not be used for matching colors value for value, hue for hue. A photograph invariably pulls the painter toward its own color direction, which often is far less interesting than the color solution the painter invents. You are a more responsive and intentional colorist than the camera will ever be. Instead, try working from a black-and-white photo. It will encourage you to be more experimental with your color choices. Effective color solutions come from only two places: a direct observation of nature and your imagination (or some combination of the two).

**DON'T TRANSLATE PHOTOGRAPHIC EFFECTS INTO YOUR PAINTING.** A painting that *looks* like it has been done from a photo has an undesirable aesthetic quality. The camera often produces shallow depth of field (a blurry background behind the subject). That is a uniquely photographic effect, not a painterly one. If you copy that, it will be an obvious indication that you are copying photographs. Photographic shadows also have a certain quality, perfectly formed and overly dark. If you map these too closely, the painting will take on a photographic quality instead of being a reflection of your interpretation and style.

**DON'T LET THE PHOTO BECOME A CRUTCH.** At a certain stage of the painting, the photograph needs to be put aside. As a painting develops, it takes on a life of its own. It calls for changes and new directions, and you need to be able to respond. Staying too focused on the photo will prevent that from happening. Ultimately, the painting needs to become independent of its source photo.

### SHOOTING TECHNIQUE

The camera has difficulty finding a compromise exposure between extreme darks and extreme lights. When the camera exposes for a bright sky, the photo will have lots of saturation and color in the sky, but the ground becomes underexposed and turns overly dark. The opposite happens when the camera exposes for the ground. The ground is well exposed and richly saturated, but the sky "blows out" to white and loses most of its color and value. The solution: Take two photos, one exposed for the lights and one exposed for the darks. If you want to take one photo, always expose for the lights and let the land appear dark. If the sky is overexposed to white, it is not recoverable; that is, the information simply doesn't exist in the digital image. However, there is lots of information buried in the darks that can be recovered in image-editing software.

Rodger Bechtold, *East Gable of the Sorensen Barn*, 2009, oil on linen,
60 x 60 inches (152.4 x 152.4 cm)

Although Rodger Bechtold is a painter who references photography, he creates paintings that in no
way resemble photos. Indeed, everything that appears in the photograph also appears in the painting
but is significantly altered. "A photograph will never make a painting," Bechtold says. "The more you
try to copy the photograph, the more you trivialize it. The danger is in becoming too easily influenced
by the photo and not by what inspired you in the first place." The most startling difference between
the reference and the painting is the color. Bechtold reinvents virtually every color relationship in
the painting: the contrast between the sky and the roof, the sunlight and cast shadow on the face of
the barn, the red in the trees, and the foreground that explodes in warmer colors. Nor does he accept
the horizontal composition imposed by the photograph; he composes within a square format to place
greater emphasis on the barn. He also alters the drawing, heightening the perspective to emphasize
the rising face of the gable. Through a willingness to depart from the reality imposed by the photo, he
reveals to the viewer a vision that is greater than what he started with.

Photographs capture moments,
but they're only raw material.
I draw from my pictures but I am
always trying to expand the space
inside them.

—JEAN-FRANCIS LE SAINT

# EXPLORING OPTIONS THROUGH DIGITAL EFFECTS

Some painters cringe at the thought of using a computer to aid them in their visual explorations. Yet this modern technical tool—as far removed from the organic experience of painting as one might imagine—can actually help the artist see the world in painterly ways. The simple techniques shown here are specific: They produce effects that suggest ways to simplify, reveal value zones, find patterns of light and dark, or repair the "unpainterly" flaws and characteristics of the photo.

If you are intimidated by computers or digital cameras, or you find yourself resisting using them, remember that you need not be a techno-wizard or learn the software in great depth to learn the techniques that are of benefit to painters. Knowing how to use your camera and image-editing software will also help you take better photos of your artwork, so they can be used on your Web site or submitted to galleries and competitions.

Adobe Photoshop is the de facto standard for both professionals and amateurs, but it is quite expensive. Adobe also offers a slightly less sophisticated version of the program that is called Photoshop Elements, which is nearly as capable at only a fraction of the cost of Photoshop. Many digital cameras also come with software that offers basic image-editing capabilities. If working with a computer is not possible, you can still reap the benefits of the digital camera by simply taking the camera's memory card to your local processing center and printing out the pictures yourself.

For those without image-editing software, there is still quite a lot that can be accomplished with traditional reproduction methods. Photocopy machines can make enlargements, and a black-and-white photocopier can convert a color print to black and white. Experiment with the light/dark and the contrast settings to produce high-contrast prints, which are very similar to the results achieved with the Threshold filter in Photoshop.

Note that the menus and commands indicated in the examples that follow are for Photoshop. Photoshop Elements offers many of the same filters, but they may be located in different menus. As software is updated over time, the placement of the filters, and even their names, may change. Check your software documentation.

**Lighten photographic values with the Shadow/Highlight filter.** It is not uncommon for photographs to make shadows overly dark, especially in direct sunlight. The original photo (far left) has extremely dark shadows within the tree and along the walkway. It is difficult to make out the colors and structure buried in the darks. Applying the Shadow/Highlight filter lightens the values of the dark shadows, which reveals more color and detail.

**PHOTOSHOP INSTRUCTIONS:** Go to Image Adjustments Shadow Highlight. A dialog box with a slider will come up, along with a preview of the change to the photo. By default, the amount it uses in Shadows is 50%, which is usually too much. Usually, lowering that amount to about 25% or less will give best results, but each photograph is different.

**Simplify shapes with "artistic" filters.** There are many "artistic" filters in Photoshop, with names like Watercolor or Palette Knife. These filters don't actually render those painterly effects, but they do something even better: They help group shapes and colors together in a way that suggests simplified masses. I refer to them as my "shape" filters. The Watercolor, Cutout, and Poster Edges filters are particularly good at converting an image into simplified shapes. Poster Edges breaks the image down into a specified number of color and value zones. Try some of the other filters under the Artistic option, or experiment by applying more than one filter to the same image.

**PHOTOSHOP INSTRUCTIONS:** Go to Filter > Artistic > Watercolor. A dialog box will appear with controls for Brush Detail, Shadow Intensity, and Texture. Be sure Shadow intensity is set to 0, otherwise the shadows will get overly dark. Adjust the Brush Detail settings to control how fine or chunky the shapes become. The effect of this filter varies according to the resolution of the image; its effects are more pronounced on lower-resolution images. If the Watercolor effect is too pronounced, back off a bit with Fade. After applying the filter, go to Edit > Fade Watercolor. A dialog box will appear with a slider that lets you reduce the effect all the way back to 0, allowing you to apply the effect by degrees. Fade works with any filter.

**Limit values and reveal value zones with posterization.** Posterization is a powerful way to break the image down into a specified number of values, which can help you map the value structure of the painting. Posterization can be applied to color images, but it is more useful with black-and-white images, so first convert the image to grayscale.

**PHOTOSHOP INSTRUCTIONS:** Convert your color image to grayscale by going to Image > Mode > Grayscale. Then select Image > Adjustments > Posterize. A dialog box will appear that allows you to set the number of value levels. Four or five levels usually works well, although with some images, you may need to use more levels for better results.

**Find the underlying abstract value pattern with the Threshold filter.** Threshold produces an effect similar to Posterize but restricts it to only two values, black and white. This is helpful in suggesting the value plan that serves as the underlying framework of a painting (see page 53).

**PHOTOSHOP INSTRUCTIONS:** Select Image > Adjustments > Threshold. A dialog box with a slider will appear, and you will see a high-contrast preview of the image in strict black and white. Moving the slider to the left or right determines how much of the lights fall within white and how much the darks fall within black, which is the key to making this effect successful.

---

TIP: Reverse the image for a new perspective. Sometimes, because of the directional energy and the placement of the large masses, the reverse of the original image makes a more effective composition. It would be almost impossible to paint an image in reverse while working on it live, but it's easy to "flip" the image with image-editing software. Select Image > Rotate Canvas > Flip Canvas Horizontal.

---

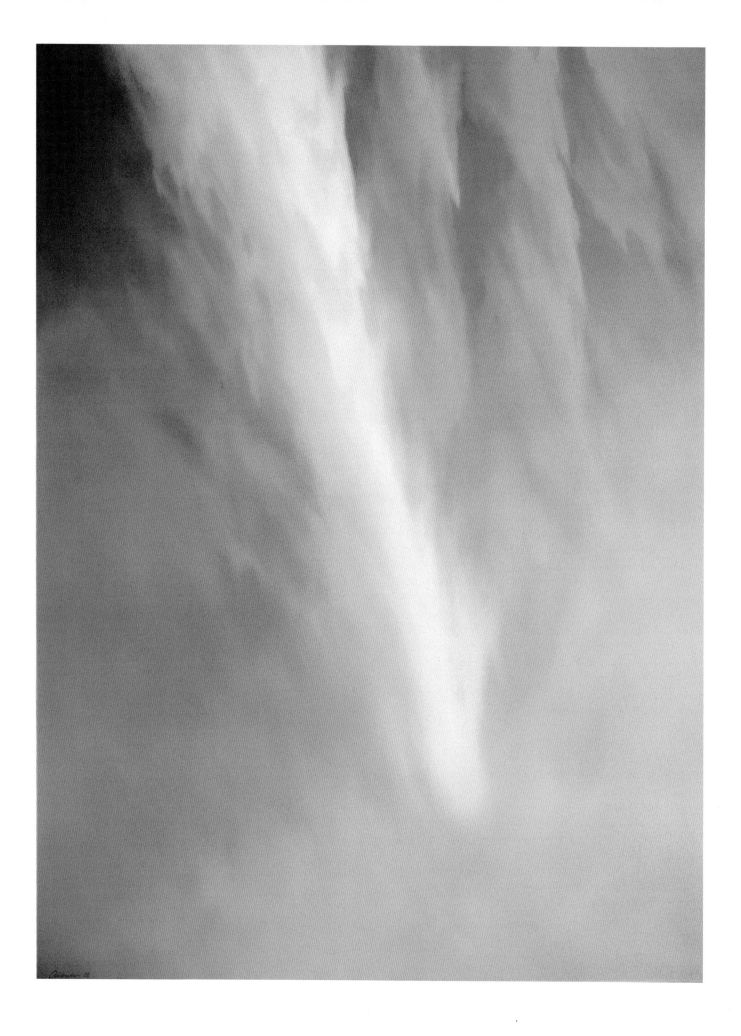

CHAPTER ELEVEN

# ABSTRACTING NATURE

I hardly need to abstract things, for each object is unreal enough already, so unreal that I can only make it real by means of painting.

—MAX BECKMANN

Abstraction is not unique to landscape painting, but landscape painting does wonderfully lend itself to the approach. When we consider nature's exquisite light and atmosphere, its many colors and textures, we realize how much of nature is inherently abstract, from diaphanous clouds to rock formations, from dancing waves to branching filigree, from crystal-clear light to form-dissolving fog.

An abstract sensibility has always had special importance in my own work. I have always been intrigued by the abstract or "secondary image" that emerges when I search beneath the surface of a subject. When a painting becomes not just about the subject matter but emphasizes the aesthetics of *painting*—color, movement, pattern, shapes, and texture—it is inherently more interesting to me. Like an optical illusion, the painting can be experienced in multiple ways. It conveys discernable content while also bringing greater attention to the aesthetic experience.

Mitchell Albala, *Plunge*, 2008, oil on canvas, 32 x 24 inches (81.28 x 60.96 cm).

A landscape painting moves toward abstraction when its focus is less on descriptive content—identifiable things, such as a house or a waterfall—and more on the aesthetics that are the building blocks of image-making. *Plunge* never entirely departs from its originating subject matter—it is still a waterfall—but by limiting the focus to a small segment of the cascading water, the aesthetics of pattern and movement become the primary visual event. The "subject" dances between the recognizable and the abstract, existing in both realms simultaneously.

# WHAT IS ABSTRACTION?

Every work of art—whether strictly realistic, completely abstracted, or somewhere in between—relies on certain aesthetic devices: value, color, composition, shape, and the texture of the paint itself. In a representational work, these aesthetic devices are firmly attached to the subject, giving it the descriptive structure necessary to be perceived as the actual subject. But as a painting becomes more abstract, and the narrative subject becomes less obvious, the visual experience shifts increasingly toward the aesthetic devices themselves. Thus, an abstract or semiabstract landscape painting may be more about movement or color than it is about a waterfall or a sunset. The paintings shown in this chapter never fully detach from the landscape motif, but they clearly make statements that have more to do with the aesthetics of painting than with narrative content.

It is often said that all paintings and drawings, even the most realistic depictions, are abstractions. This is because whether painters use realistic imagery or abstract imagery, they use the same aesthetic devices all artists use—value, color, composition, shape, and the texture of the paint itself—which are fundamentally abstract.

## FLAT AND AMBIGUOUS SPACE

A convincing spatial illusion is usually an important goal in representational painting. In abstract or semiabstract painting, however, the space implied is sometimes much flatter. This is an intentional choice on the part of the painter. The painter negates the illusion of three-dimensionality by emphasizing the reality of the flat picture plane, which can enhance the abstraction. The flattening of space is not a requirement for abstraction, though. It is just one of several means the painter uses to induce abstraction. Depth is an aesthetic energy that can always be useful in painting, whether the subject is abstract or representational.

Some painters explore *ambiguous* space—the expression of flat space and dimensional space simultaneously. Rebecca Allan's *Multnomah Falls* (opposite) and John Cole's *Steamboat Creek* on page 181 exemplify this approach. The space in both is considered ambiguous because it can read as flat or dimensional, depending on how you perceive it.

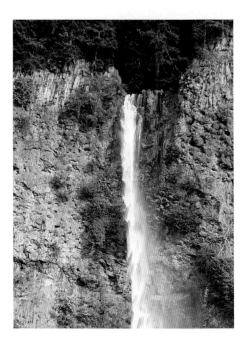

Rebecca Allan, *Multnomah Falls*, 2004, egg tempera and acrylic on canvas, 52 x 43 inches (132.08 x 109.22 cm)

Rebecca Allan embraces the essential beauty and natural power of Multnomah Falls in Oregon's Columbia River Gorge through an investigation of color and expressive brushwork. When struck by sunlight, the rock wall over which the water cascades (above) becomes an earthy, brilliant orange. Color becomes the central element around which pattern and movement are explored, while vigorous brushwork becomes a metaphor for the energy of the cascading water. Allan also explores ambiguous space, in which certain passages can be read as either dimensional or flat.

The painter can and must abstract from many details in creating his painting. Every good composition is above all a work of abstraction. All good painters know this. But the painter cannot dispense with subjects altogether without his work suffering impoverishment.

—DIEGO RIVERA

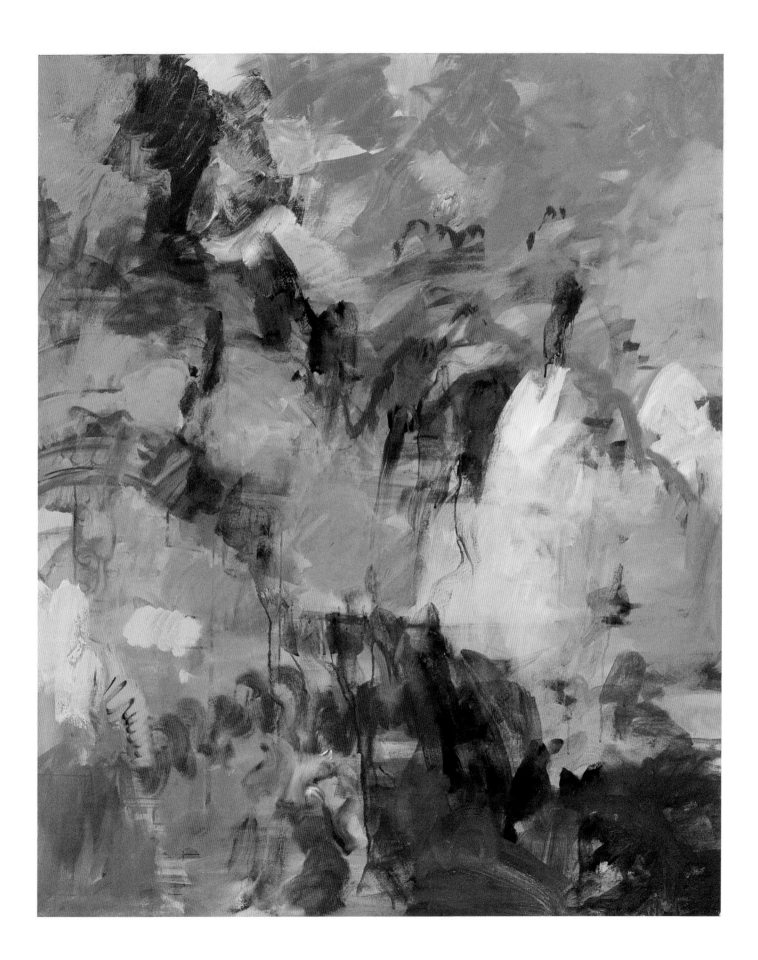

# KNOW YOUR REALITY BEFORE YOU DETACH FROM IT

Abstraction is an approach in which the phrase "You must walk before you can run" definitely applies. Good abstract painting requires a thorough command of aesthetic principles, and the best way to learn those principles is through an interpretation of reality. Learning how to draw, compose, build space, and manipulate color teaches you the grammar of the visual language. It is a misconception that abstract painting can be "anything." It certainly doesn't have to be a recognizable thing, but it does have to be driven by the same visual principles by which all good art is driven. The notion that an abstract approach somehow exempts the painter from knowing how to work with the aesthetic devices has led to a great deal of poor abstract art. A good abstract painting will still have effective color, well-conceived design, well-orchestrated values, and perhaps even form and space. It has everything the greatest works of "classic" representational art have, but it is less hinged to narrative form. That abstract painting can communicate as strongly as representational painting is a testament to the fact that good painting is not dependent on subject matter but on the skillful implementation of artistic principles.

Stuart Shils, *Greys Ferry and Federal Streets, Philadelphia*, 1991, oil on paper mounted on board, 6¾ x 10 inches (17.14 x 25.4 cm). Private collection

Two works (above and opposite) by the same artist, painted nearly two decades apart, reflect an evolution from a more literal, representational interpretation of nature to one that is more formally abstracted. *Greys Ferry and Federal Streets*, like all Shils's work from this time period, was painted directly from nature. Although the brushwork is quite painterly, it remains faithful to "place" as evidenced by the attention to perspective and to the values and colors of the shadows.

Stuart Shils, *A Villa Close to Montefalco*, 2008, oil on linen, 12 x 16 inches (30.48 x 40.64 cm). Courtesy of Tibor de Nagy Gallery.

Shils's attitude about the construction of form within painting shifted in 1994 when he began painting on the Irish coast for thirteen summers. The fleeting weather—rain, wind, and intermittent sun—required a different "direct response fiction," as he puts it. "Gradually, I became comfortable with the idea that extended invention was the issue, not point to point perceptual accuracy. Accuracy is a much larger issue than 'correct' drawing; it's more rooted in broader abstraction in which detail is not about small parts of things but about the particular qualities of large, evolving relationships between things." By comparison to his earlier work, *A Villa Close to Montefalco* indicates a more subjective orchestration of elements and brings greater attention to aesthetic decision-making on the surface of the painting itself. "Rather than replicating a set of spatial relationships transferred from 'out there,' I'm now more involved with examining the qualities of space, light, and surface as they relate to making a painting and to creating an emotional mood that is not limited by an idea of naturalism."

# INDUCING ABSTRACTION

How, then, does the artist tip the visual scales in favor of the underlying aesthetic event? It must first be understood that abstraction is not a quantifiable skill like drawing, value relationships, or compositional principles. It involves those principles, but an abstract sensibility is also guided by one's artistic personality. Some artists instinctively see the world in abstract terms, while others naturally prefer to explore the aesthetic language of art through concrete representation. It is not a right or wrong, good or bad choice. That said, there are a number of ways that painters can consciously push their work toward abstraction.

**FOCUS ON AN AESTHETIC.** If abstraction places more emphasis on aesthetics such as value, color, pattern, shapes, and brush-work than it does on the narrative subject, then making one of these aesthetics the "subject" can move the painting toward abstraction.

**APPLY ULTRALIMITED FOCUS.** Landscape painters must regularly limit their focus to select a much smaller slice of the scene than what is actually visible to them. As the painter increasingly winnows away portions of the larger subject, through an ultralimited focus, an entirely different world can emerge that can lead to greater abstraction. *Plunge* on page 168 is such an example.

**ADOPT PAINTERLY AND EXPRESSIVE MARK-MAKING.** Brushstrokes are multifunctional. They assign color, texture, and movement, as well as describe subjects and forms. When those brushstrokes become extremely vigorous or loose, greater attention is brought to the painting surface. Recognizable forms begin to dissolve, and abstraction is induced. Rebecca Allan's *Multnomah Falls* (page 171) is more about energized shapes and patterns than it is about an "accurate" depiction of Multnomah.

**EMPLOY EXTREME MASSING AND SIMPLIFICATION.** By definition, simplification eliminates extraneous information to reveal essential shapes and patterns. If we simplify in the extreme, we also eliminate in the extreme, which ultimately leads to the dissolution of the subject matter and, in turn, to greater abstraction.

Mitchell Albala, *Yakutat Valley*, 2003, oil on paper, 9 x 9 inches (22.86 x 22.86 cm). Courtesy of Lisa Harris Gallery

The abstract qualities of the painting to the left are induced largely through extreme simplification and massing, and a very limited focus. The small scale of the piece also allows strokes to have more individual character and bring attention to the surface.

Kathleen Earthrowl, *Brimfield Pond*, 2005, oil on canvas, 60 x 48 inches (152.4 x 121.92 cm)

*Brimfield Pond* (opposite) retains clear ties to nature yet embraces an abstract sensibility by bringing attention to several aesthetic devices. Earthrowl's color choices take precedence over reality, becoming more about her emotional response to the subject than what she may have actually seen. The looseness of her brushwork, combined with the softening of edges, contributes to the overall dissolution of the subject matter (and heightens the sense of atmosphere). "It's always about the *painting*, as opposed to a literal depiction of place and objects," says Earthrowl.

CHAPTER TWELVE

# STYLE, INSPIRATION, AND LIFELONG LEARNING

It's so fine and yet so terrible to stand in front of a blank canvas.

—PAUL CÉZANNE

Most of this book has been devoted to practical concepts and approaches intended to help you solve the biggest challenges faced by the landscape painter. In this final chapter, some of the more personal issues that touch our practice will be discussed. How do we deal with the challenges of the artistic life, such as inspiration and frustration? What makes us choose a certain subject? How does our own unique style emerge from all the influences to which we are exposed? And how do we stay motivated and maintain a commitment to lifelong learning? Although these concerns are not measured and analyzed in the same way other visual problems are, they are issues every growing artist deals with every day.

Robert Marchessault, *Kumada*, 2007, oil on canvas, 60 x 48 inches (152.4 x 121.92 cm). Courtesy of Bau-Xi Galleries, Toronto & Vancouver

A landscape painting can project a mood and style that transcends formal subject matter. *Kumada* does far more than tell a story about a tree; it projects a dreamlike mood that immediately touches the viewer. Robert Marchessault achieves this in his work through a combination of aesthetic choices: The low horizon line and central placement of the tree give it heroic strength, the golden-green color scheme lends an otherworldly light, and the cloud shape that surrounds the tree suggests a kind of meaningful mystery. "I occasionally do on-site drawings or photographs, but I don't generally refer to them while making a painting," says Marchessault. "I use memory as a filtering agent to distill an image, discarding useless details. When a painting is complete, it must reflect an emotional sensation that calls to mind some aspect of my remembered perceptions."

# SUBJECT AND VISION

Every good painting is about something, and that "something" is much more than the literal subject matter—a mountain, a river, or Main Street. The most exciting paintings do more than report on landscape content; they offer a unique interpretation of the world by focusing on an aesthetic experience that becomes the painting's raison d'être.

On the most basic level, every representational painting is, in part, about content and subject matter. On another level, the subject is a vehicle for the artist to explore the visual language of painting: color, composition, value, form, movement, and the paint itself. Is the subject a barn sitting at the end of a field, or is it about a color experience—a red shape poised against a green field? Is the subject a forest, or is it the abstract patterns of light created between the vertical tree trunks? Which event is the dominant statement—the barn or the color experience, the woods or the patterns of light?

In college, after several years of drawing and painting mundane props, such as vases and white cardboard boxes, I eventually learned to see past the boring exterior of these objects and discovered magic. I broke through my fixation on the identity of the things I was painting and began to see them in terms of the visual language of painting. That is when I became an artist. Suddenly, there was excitement in the process no matter what the subject matter was. This is why the landscape painter doesn't necessarily have to be in the Rocky Mountains or the Grand Canyon to find good source material. With an eye tuned to the visual language of painting, worthy subjects can be found almost anywhere.

When contemplating a view, always ask yourself what it is about it that excites you and makes you want to paint it. *That* is what the painting is about. That is the main idea that will lead you on a journey of discovery and carry you to a successful conclusion. Is the main idea a color event? Is it a powerful arrangement of shapes and patterns or an abstract sensibility? Is it about a profound sense of space? Is there an ambiguity or an "aha!" experience, an unexpected visual turn that surprises and delights the viewer? And if the subject *is* simply a barn, then how can the visual language be used to capture the "barn essence"? You must also consider whether the subject will convey meaning to the viewer on more than just a visual level. For instance, clear-cut hilltops might make a statement about the degradation of the environment.

If you aren't immediately aware of an outstanding aesthetic event, you may need to dive in and start working. The best way to get to know a subject is to paint or draw it. Often, the process of painting itself—composing, mixing colors, exploring value patterns, and pushing paint around—reveals visual dynamics that were not apparent when you first saw the subject.

There is no such thing as good painting about nothing.

—MARK ROTHKO

## EMBRACE YOUR INFLUENCES

Artists often acknowledge their influences and then apologize because their work shares something in common with that of the mature artist who inspired them. Yet that is exactly how it should be. Artists are not merely *influenced* by others; they recognize in the work of others something of their own emerging vision. The "influencing" artist's work is like a signpost that says, "Yes, you see something of yourself in me. This way!" Acknowledge your influences. Regardless of what aesthetic predilections you might share with other artists, rest assured that your own style will emerge.

Glenn Raschick, *Breaking Fog*, 2008,
oil on board, 8 x10 inches (20.32 x 25.4 cm)

Yes, there are descriptive elements that tempt the artist and
that often add to the uniqueness and charm of the image,
but woe to the artist for whom these elements become primary,
who thereby loses sight of the larger issues that alone guarantee
that the resulting work represents the artist's thought and energy,
not merely his copying instinct or his descriptive facility.

—WOLF KAHN

A painter's consciousness and personality are
channeled through his (or her) brushes and into
the painting itself, producing a style that is
uniquely his own. Raschick's painterly "hand-
writing" is generated through his use of extremely
simplified shapes combined with animated,
painterly strokes. Note that Raschick also uses
alizarin permanent as his underpainting tone;
it is still visible in between the other, thicker
strokes, and has a unifying effect on the overall
color harmony of the painting.

# STYLE

If ten artists, or even a hundred, were asked to paint the same scene, no two would produce paintings that looked the same. Their compositions would organize the content differently. They would interpret the colors with different strategies. And they would all apply the paint in different ways. Ultimately, one's experiences and personality direct a set of aesthetic energies that converge to create what we call a painting style. That personality influences every choice, from the color approach to whether the subject is depicted realistically or abstractly, loosely or tightly. Every painting in this book falls within the category of landscape painting, yet no two are done in the same style. The painters may explore similar ideas and visions, but their conclusions are unique.

## STYLE THROUGH BRUSHWORK

Perhaps the most characteristic aspect of style, and the one most people think of when they consider style, is the unique way the painter applies paint to the canvas—their "painterly handwriting." Are the strokes applied thinly and smoothly or laid on in impastolike fashion? Does the brushwork describe a journey that had many course corrections or one without detours? Was it a fierce and vigorous battle or a long, steady negotiation? The way you handle paint is a record of your thinking process and methodology.

As you practice, one of the most satisfying developments you will see is the maturation of your brushwork, from tentative and awkward to something that reflects confidence and a unique identity. Just as a child's handwriting is awkward at first and later takes on a unique personality of its own, so too will your own painterly handwriting take on a consistent, confident, and professional quality. This is something to be desired, yet it

cannot be forced; it emerges naturally at its own pace as experience and skill build.

That said, you can facilitate the maturation of paint-handling through *observation*. Like a meditation upon your breath, you must learn to be conscious as you apply each stroke. You have to evaluate your work not only in terms of the usual criteria (color, composition, values, drawing) but also in terms of the quality of the mark-making itself. How are you applying the paint? What is the paint doing, and why is it doing it? How do your strokes compare to those of more accomplished painters? What's the difference? What is it about a master's brushstroke that gives it its maturity and finesse? The more awareness you apply to your strokes, the more sensitive you will become to their quality. And the more sensitive you become, the greater control you will have as you fashion each stroke.

## STYLE THROUGH INTERPRETATION OF FORM

Style is also reflected through the way the artist interprets form. A realistic and tightly rendered landscape makes a different visual statement than one in which the forms are exaggerated or intentionally distorted. Some painters also apply a certain stylization to the shapes. They deviate from the literal rendering, perhaps simplifying in the extreme, elongating the forms, or distorting the shapes in some way. Such an interpretation is not random; the painter consciously chooses to alter the drawing and shapes, perhaps to get at the underlying geometry or to make a conceptual statement about the subject. The precisely delineated trees in Craig Kosak's *Poplars* (page 66) makes a different statement about the natural world than John Cole's *Steamboat Creek* (opposite), in which forms take on a monumental and symbolic simplicity.

### VISION AND TECHNIQUE

At times, we might paint skillfully but find that the painting lacks soul. It is missing a vision. At other times, we have a bold vision, but our technique and execution may not be skillful enough to realize that vision. The inescapable truth is that the artist is both a technician and a visionary. Painters are engaged in a constant struggle between their ideas and their ability to execute them. In my estimation, it is better to have great visions and struggle to technically execute them than to have brilliant technical skills but lack a defining vision.

**"Painterly handwriting."** Each brushstroke channels some aspect of the artist's personality into the painting. This "painterly handwriting" is in large part responsible for the formation of a unique style.

John Cole, *Steamboat Creek*, 1998, oil on linen, 30 x 36 inches (76.2 x 91.44 cm).
Courtesy of Lucille Cole and Lisa Harris Gallery

John Cole's treatment of form and space creates an almost symbolic representation of his subject. Blending a modern and a traditional approach to describing space, he constructs a painting that is simultaneously flat and dimensional. He establishes strong contrasts within the rocks and foliage and outlines many of the shapes, which makes them very solid but flat. Then, as if to defy the flatness, he injects a very traditional spatial construction: a vivid zigzag of linear perspective as the river cuts through the rock shapes.

# STAYING MOTIVATED AND INSPIRED

In a perfect world, we would always experience boundless enthusiasm for our projects and our progress would be measured in positive numbers. In reality, however, a life in art has ebbs and flows; there are moments of ecstatic inspiration and creative stasis. In my experience, there is no foolproof method for continued artistic growth—except to consistently put yourself in front of projects that interest you and to keep painting. Most artists will testify to the fact that whatever skill and success they have achieved, they achieved largely through tenacity, consistency, and hard work. Momentum is powerful. The longer I don't paint, the more inertia I must overcome to pick up my brushes and get restarted. When I paint more frequently, I gain momentum and am more inspired to continue.

## NEGOTIATING INSPIRATION

It is always preferable to be excited and enthusiastic about your work, but when the inspiration is not there, you are faced with two choices. The first is to wait for the inspiration to return. Taking the time to incubate an idea or disengage from the process for a time can recharge your creative batteries. On the other hand, if you only work when you are inspired, you may work inconsistently. The other choice is to "do it anyway." There is more inertia to overcome with this approach, but those who paint consistently will tell you that they paint even when they aren't inspired. Often, just putting yourself in front of the easel can reenergize your passion about the work. As your painting practice deepens, and you get to know the ebb and flow of your creative energies, you will be able to tell when you really need to disengage from your work for a while and when you should push through the resistance and do it anyway.

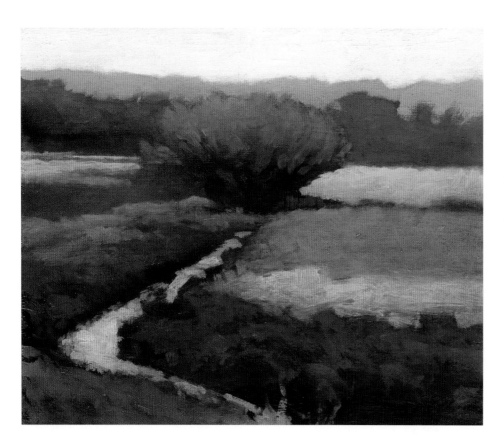

Marc Bohne, *An Iowa Morning*, 2006, oil on panel,
6 x 7 inches (15.24 x 17.78 cm)

An artist can spend a lifetime painting a single subject and never repeat himself. Marc Bohne frequently incorporates trees and fields into his landscapes, yet he finds new inspiration in each and every painting. "I like it when the image is strong enough to pull you toward it (place has a hand in this stage), and at successively smaller distances you are given new things to interest you until you are nose up to the painting and are marveling at liquid paint and messy strokes and lots of colors migrating from under glazes."

I know well enough in advance that you'll find my paintings perfect. I know that if they are exhibited they'll be a great success, but I couldn't be more indifferent to it since I know they are bad, I'm certain of it.

—CLAUDE MONET TO
PAUL DURAND-RUEL

## DEALING WITH FRUSTRATION

If you don't occasionally experience frustration, then you're not fully engaged in the creative process. Painting can be rewarding and extremely inspirational, but it is also difficult and, at times, downright frustrating. Conventional wisdom says that you should regard your failures as lessons. This may be true, but a bout with frustration often feels at odds with learning and progress. There are a number of actions (and in-actions) I find helpful when I am feeling frustrated or stuck:

**Take a break and incubate.** It's no secret that taking a short break can be therapeutic, especially when you're stuck. For the painter, taking a break and "incubating" can be a particularly effective strategy for problem solving. Creative solutions don't always come to us in a linear fashion. Sometimes, they are resolved in stages. We work inten-sively for a time and then enter a period of rest and incubation, during which the sub-conscious mind may continue to work toward a solution. How many times have you looked at a painting a day after working on it (or even after lunch) and seen things you didn't see before? An incubation period can provide invaluable perspective and time to allow new solutions to come to you.

**"I'm as good as I am."** Perhaps the most common frustration of painters is the feeling that their work is not good enough or that their progress is too slow. All artists, even the most successful ones, doubt themselves at times. Take comfort in the fact that artists for generations have felt the same way. I always tell students who become frus-trated with a difficult painting that I'm *glad* they know there's a problem. I would be more concerned if they *didn't* realize it. Identifying a problem is the first step toward fixing it.

**Set yourself up for success.** If you are frustrated or immobilized by fear of creating "bad" art, then it may be time to put your current project aside and do something that you know you can succeed at—something that will allow you to feel the joy of success. If you are good at drawing, do some drawing. If doing value studies gives you positive results, do some value studies. Choosing a less challenging project isn't a waste of time if it gets you back on track and jump-starts your inspiration. It can also be helpful to do something to which your attachment is low. You are less likely to feel intimidated doing a sketch to which you are only dedicating an hour than starting that 50 x 70–inch studio masterpiece!

**Return to the source.** Returning to nature, even if only with a camera in hand, can jump-start low inspiration. So can spending time with your art books and magazines or visiting galleries and museums.

I try to construct a picture in which shapes, spaces, colors, form a set of unique relationships, inde-pendent of any subject matter. At the same time I try to capture and translate the excitement and emo-tion aroused in me by the impact with the original idea.

—MILTON AVERY

# SELF-EVALUATION AND NEW LEARNING

At the start of my classes, I tell students that I am still learning. The only difference between them and me is that I have been in the learning mode longer. Success with landscape painting isn't about having all the answers; it's delighting in visual problems and finding solutions to them.

We want to paint well and produce satisfying results, but the sooner we realize that the learning never stops, the sooner we will be able to maintain an attitude of exploration. I have found each of the following practices to motivate and inspire me toward new learning.

### REALITY CHECKS: SEEING YOUR WORK WITH NEW EYES

We look at our own work for long hours, days, weeks, even months. And yet we must find a way to evaluate the work objectively, to see it with fresh eyes. There are several tried-and-true methods painters use to gain new perspective on their work:

**Make use of time and distance.** Nothing gives a fresher perspective than time and distance. The longer you separate yourself from a painting, the more it will be like seeing it for the first time. If putting the work away for a few days is not practical, then even a few hours can help. If your studio is in a place where you can see it often, such as in your home, be sure not to leave the painting out and exposed. No peeking!

**View the painting in a mirror.** Because we are accustomed to seeing the painting one way, viewing it in a mirror invariably provides us with a fresh perspective. A well-organized composition will remain well organized, whether it is seen normally or in reverse. Many painters hang a mirror behind themselves so that they can turn around frequently and get the reverse view. Outdoors, carry a small pocket mirror.

**Turn the painting upside down.** Similar to viewing in reverse, turning the painting upside down gives you temporary detachment from the subject and a fresh orientation. The composition should hold together just as well upside down as right side up. For double the detachment, turn the painting upside down *and* look at it in a mirror. You might even try working on the painting while it is upside down.

**Stand back frequently.** We see colors and shapes at a distance in ways we simply cannot see up close. If you are comfortable working with the brush extended at nearly arm's length, this will help. Standing while you work also encourages you to step back more frequently. Looking at the painting as viewers will, from a distance, really helps.

**Don't work in continual solitude.** The ultimate fresh perspective is that offered by another pair of eyes. One of the most valuable exercises I engage in—and one of the most enjoyable—is receiving critiques from my peers. They are visually astute and can point out things I have completely missed. Artists who rely exclusively on themselves for feedback are working in a vacuum and miss a huge opportunity for growth and learning.

**KEEP CHALLENGING YOURSELF.** The temptation to fall back on what is easy and convenient can be strong, especially if it is producing acceptable results. Yet your struggle to express your vision is expressed in every brushstroke that you make. If the painting challenges you, then it will likely challenge and engage the viewer. If you are falling into a pattern, shake things up. Paint a different type of subject. Try a different palette of colors or a different color strategy. Work in a different medium. If you work large, do a small painting and vice versa. Find a balance between working in your comfort zone and exploring new challenges.

**FORM A CREATIVE NETWORK.** Form a critique group that meets regularly. Knowing that you have a date to present work will help push you to keep producing. Form a painting group that plans outdoor excursions. Not only will you gather inspiration from your fellow artists, but you will learn things from them and get to share your common successes, struggles, and concerns.

**CLASSES AND WORKSHOPS.** Classes can give you valuable training and help you commit to painting in a structured way for a period of time. Workshops force you to show up and paint. And nothing can be more helpful than the encouragement and support of an inspiring instructor.

**ADMIRE, THEN ANALYZE.** Study art books, visit museums and galleries, and surf the Internet. When you see a painting that moves you, recognize it as the gift of inspiration and knowledge that it is. Take the opportunity to ask yourself exactly what it is about the painting that makes it work. Ask yourself what it is that evokes your emotional response. The answers will be educational and will inform and inspire your work.

Photo: Maddine Insalaco

When I was young I painted the trees and the clouds just as I saw them. As I grew older and learned something about art, I realized that I couldn't paint the trees and clouds as I saw them, and so I painted them differently. And when I became much older, and looked back on a lifetime of painting trees and clouds, I realized that I had always painted the trees and the clouds as I saw them.

—VARIATION ON A TRADITIONAL BUDDHIST SAYING

# GLOSSARY

**Alla prima.** Derived from the Italian term for "at the first," alla prima refers to the direct painting style in which the painting is completed in a single session.

**Analogous harmony.** Colors adjacent to each other along the spectrum (or color wheel) are innately compatible and therefore analogous (for example, yellow and orange or red and violet). Analogous harmony is an effective strategy for achieving the illusion of a unified color-light within a painting.

**Broken color.** A form of direct painting in which small individual strokes of color—for example, small spots of yellow and blue—are laid side by side and, at a distance, are optically mixed by the eye to form green.

**Color-light.** Because of the way light is dispersed in atmosphere, landscapes are often dominated by a single hue that pervades the entire scene. The color-light is not the local color of the subject but the overall color of the light that surrounds the scene, or the "envelope of light."

**Color priority.** A painting in which the illusion of natural light is achieved by relying more on color contrasts than value contrasts is said to use a color-priority system. Impressionist paintings exemplify a color-priority approach.

**Complementary color.** An essential color relationship that can be used to create color emphasis (radiant complements) or make colors duller (neutralizing complements). Complements sit at opposite each other on the color wheel (for example, red and green, blue and orange, and yellow and violet).

**Crosslight.** Also commonly called sidelight, this is light that strikes a form from the side, creating a distinct pattern of light and dark. Crosslighting is a very desirable condition for landscape painters because it generates important cues for volume.

**Differentiation.** The ability to distinguish values, colors, and shapes from one another. An essential requirement in site selection, differentiation helps the painter establish an illusion of depth within a "flat," two-dimensional painting.

**Direct painting.** A method of painting in which the painter endeavors to mix a color of the correct hue, value, and intensity and apply it directly to the canvas, so a single stroke of opaque color is as close to the final color as possible.

**Dome of the sky.** An imaginary series of contour lines applied to the sky, like latitude and longitude lines, that help suggest the curving (domelike) nature of it.

**Edges.** In painting and drawing, edges are formed where one shape differentiates itself from another through value or color. By controlling the relative hardness or softness of an edge, painters can bring greater or less attention to an area, suggest the physical nature of different elements, and imply different degrees of spatial advancement or recession.

**Expressive color.** As opposed to naturalistic color, an expressive color model explores color in more subjective ways, often by raising the color intensity to what might be considered outside the bounds of reality.

**Eye path.** A path of movement within a painting, which may be described by an unbroken line, such as a hilltop or the side of a house, or may be *implied* by establishing connections between separate forms, such as a line that connects the tops of several trees.

**Flat light.** A condition in which there is no crosslight and shadow patterns are at a minimum, such as might be found on overcast days or when the subject is backlit or frontlit by the sun. With fewer volume-generating cues, forms tend to appear flatter.

**Glazing.** An *indirect* method of painting in which paint is applied in thin, transparent glazes that are built up in layers, usually over a thin, monochromatic underpainting, to produce the final effect. *See also* indirect painting.

**Grid.** A compositional device in which horizontal and vertical lines form an (unseen) grid upon the surface of a painting. By aligning elements along the lines or placing them on the intersections of the lines (power points), the grid helps the painter organize a composition.

**Hue.** One of the basic attributes of color, hue describes the general family to which the color belongs; for example, violet and green are different hues.

**Impasto.** The manner of applying paint thickly, such that it achieves a visible relief on the surface of the painting.

**Indirect painting.** A method of painting in which the color seen by the viewer is not held within a single stroke, as it is in direct painting, but is built up through a series of transparent glazes, usually over a detailed monochromatic underpainting. *See also* glazing.

**Intensity.** One of the attributes of color, intensity describes the relative brightness or dullness of a color. Also called *chroma* or *saturation*.

**Limited focus.** An essential practice in site selection and composition in which the painter imposes a *picture window* around the larger scene that captures a smaller section of the overall scene. Through a limited focus, the painter eliminates superfluous information and brings greater focus to the most important aspects of the composition.

**Linear perspective.** *See* perspective.

**Local color.** As opposed to perceived color, local color is the color of something uninfluenced by a light of a particular color. It corresponds to our preconceived idea of what color something is, such as green grass, blue skies, or brown tree trunks.

**Medium.** In painting, *medium* refers to two different things. The type of medium one works in might be oil, acrylic, pastel, or watercolor. *Medium* also refers to substances added to paint to make it flow easier, dry faster, or become transparent for glazing effects.

**Naturalistic color.** A color strategy in which the painter attempts to emulate the colors seen in nature as closely as possible to create a more "realistic" or natural harmony.

**Neutralizing complements.** When complementary pairs of colors are mixed together, they begin to cancel each other out and create grayer or more neutral colors.

**Neutrals.** Colors that are duller and less intense than pure colors are said to be neutral. Neutral colors are also referred to as grays and sometimes by laypersons as browns.

**Overlap.** One of the essential cues artists use to imply space. Overlap (or interposition) occurs when a shape is partly obscured by another.

**Perceived color.** As opposed to local color, perceived color is the color of something as it actually appears to our eye, under the influence of a particular color of light. In representational painting, perceived color is the color the landscape painter is most interested in.

**Perspective.** Linear perspective is the suggestion of depth as lines converge toward a vanishing point on the horizon. Perspective is particularly effective in overcoming the inherent horizontality of the landscape and pulling the eye *inward*.

**Picture plane.** The flat, two-dimensional surface of a painting or drawing. It can be thought of as an imaginary pane of glass behind which the artist arranges the compositional elements.

**Picture window.** The flexible frame or "window" imposed by the painter around the larger view that defines the boundaries of the composition.

**Plane.** A plane is a flat surface. By analyzing a subject in terms of planes, the painter is better able to understand the structure of irregular and curvilinear forms within nature. Planes also help the painter perceive value changes. Where a plane changes, there is a corresponding change in value.

**Plein air.** Derived from the French term for "open air," plein air refers to the time-honored tradition of painting outdoors.

**Radiant complements.** When placed side by side, complementary pairs of colors create a vibration that heightens the visual intensity of each.

**Representational.** Art that depicts subject and content that is recognizable to the viewer is called representational art. As opposed to abstract art, a representational approach is the most effective means through which to gain a working knowledge of the principles of art.

**Ruling hue.** The dominant hue within a painting, usually corresponding to the overall color of the light. The ruling hue affects all other hues within the painting.

**Scale.** An essential spatial cue in which an object's position in space is reinforced by its relative size. Scale also refers to the size of a painting.

**Site selection.** The essential ability to evaluate a potential subject in terms of the conditions necessary to make it translate well into paint, such as clear patterns of light and shade, spatial cues, and adequate differentiation.

**Temperature.** One of the attributes of color, temperature describes the relative coolness or warmness of a color.

**Transparency.** A physical quality of pigment in which light is able to pass through it and be reflected off the surface below. Pigments are rated as transparent, semitransparent, and opaque. Passages that are painted transparently have a natural tendency to recede.

**Underpainting.** A method of beginning a painting in which a monochromatic version of the painting is created first to establish a foundation of placement, value, and composition.

**Value.** One of the descriptive attributes of color, value describes the relative lightness or darkness of any given area within a painting or drawing.

**Value plan.** The underlying framework of a composition formed by the shapes and patterns created by the major light and dark values. The value plan determines how shapes are distributed within the picture and how the eye is directed through the composition.

**Value priority.** A painting in which the illusion of natural light is achieved primarily through value contrasts is said to use a value value-priority system. Paintings by the Dutch landscapists of the seventeenth century exemplify a value-priority approach.

**Value zones.** The wide range of values within a landscape can be organized into general areas or zones. In landscape these zones roughly correspond to full-light, half-light, half-dark, and full-dark. Establishing zones helps achieve consistency by ensuring that the values within a given zone never vary so much as to break with the continuity of the overall zone.

# RESOURCES

## CONTRIBUTING ARTISTS

Peter Adams
americanlegacyfinearts.com

Mitchell Albala
mitchalbala.com

Rebecca Allan
rebeccaallan.com

Rodger Bechtold
rodgerbechtold.com

Marc Bohne
marcbohne.com

Richard Bowman
bowmangallery.com

Gavin Brooks
gavinbrooksstudio.com

Jennifer Carrasco
carrascostudio.com

Russell Case
russellcase.com

Russell Chatham
russellchatham.com

John Cole
lisaharrisgallery.com

Kathleen Dunphy
kathleendunphy.com

Kathleen Earthrowl
earthrowlart.com

Michael Ferguson
Americanartco.com

Jerry Fresia
fresia.com

Barbara Fugate
barbarafugate.com

Larry Gray
larrygraystudio.com

Christopher Martin Hoff
christopherhoff.com

Tim Horn
horndesign.com

Craig Kosak
craigkosak.com

Jim Lamb
jimlambstudio.com

T. Allen Lawson
tallenlawson.com

Kent Lovelace
kentlovelace.com

Peter Malarkey
petermalarkey.com

Robert Marchessault
sentex.net/~bmarche/

John McCormick
johnmccormick.com

Richard McDaniel
richardmcdaniel.com

Terry Miura
terrymiura.com

Jay Moore
jaymoorestudio.com

Joseph Paquet
joepaquet.com

Edgar Payne
derusfinearts.com

Daniel W. Pinkham
americanlegacyfinearts.com

Glenn Raschick
glennraschick.com

Stuart Shils
stuartshils.com

Kurt Solmssen
kurtsolmssen.com

Jill Soukup
soukupstudios.com

Michael Stasinos
stasinos.biz

## FURTHER READING

Bayles, David, and Ted Orland
*Art and Fear*

Carlson, John F.
*Carlson's Guide to Landscape Painting*

Chard, Daniel
*Landscape Illusion*

Curtis, Brian
*Drawing from Observation*

Edwards, Betty
*Drawing on the Right Side of the Brain*

LeClair, Charles
*Color in Contemporary Painting*

Payne, Edgar
*Composition in Outdoor Painting*

Quiller, Stephen
*Color Choices: Making Color Sense Out of Color Theory*

Roberts, Ian
*Mastering Composition*

## SUPPLIES

**Ampersand**
ampersandart.com
*Manufacturer of prepared wood painting panels.*

**Artwork Essentials**
artworkessentials.com
*Maker of portable plein air easels and
pochade boxes.*

**ASW Art Supply Warehouse**
aswexpress.com
*Online retailer with an extensive Web site
through which you can place orders.*
*(800) 995-6778*

**The Color Wheel Company**
colorwheelco.com
*Maker of the ViewCatcher viewfinder
and other color aids.*

**Daniel Smith Art Supplies**
danielsmith.com
*Manufacturer of fine-quality oil paints
and other artist's materials with retail loca-
tions across the country as well as a Web site that
also handles orders. You can also request a
printed catalogue.*
*(800) 426-6740*

**Dick Blick**
www.dickblick.com
*Retail art supply store with locations across
the country and an extensive Web site through
which you can place orders.*
*(800) 828-4548*

**Fredrix**
taramaterials.com
*Manufacturer of fine-quality canvas
and other painting surfaces.*

**Gamblin Artist's Oil Colors**
gamblincolors.com
*Manufacturer of quality oil paints.
Their Web site offers a wealth of information
about artist's materials and processes.*

**Golden Acrylics**
goldenacrylics.com
*Manufacturer of a complete line
of quality acrylic paints, mediums, and gels.*

**Jerry's Artarama**
www.jerrysartarama.com
*Retail art supplies both online and in stores
throughout the country.*
*(800) 827-8478*

**Masterson Art Products Inc.**
mastersonart.com
*Maker of sealable palette boxes for oils
and acrylics.*

**Open Box M**
openboxm.com
*Maker of portable plein air easels
and pochade boxes.*

**Pearl Paint**
www.pearlpaint.com
*Retail art supply store with locations across
the country and an extensive Web site through
which you can place orders.*
*(800) 451-7327*

**Testrite Visual Products, Inc.**
testrite.com
*Manufacturer of the Model #500 aluminum
classic easel.*

**Utrecht**
www.utrechtart.com
*Retail art supply store with stores across the
country. Orders can also be placed through
their Web site.*
*(800) 223-9132*

**Wind River Arts**
windriverarts.com
*Seller of wet-canvas carriers and other
equipment for artists.*

**Winsor & Newton**
winsornewton.com
*Manufacturer of quality oil paints and
a complete line of alkyd colors.*

# INDEX